For my father

Best Regards,

Kathleen Bagley

Published by

DOWER PRESS

7 Eccleston Street
London SW1 W 9LX
England

Copyright © 2004 Dower Press

Library in Congress Cataloging-in-Publication Data available on request.

ISBN # 0-9547676-0-8

Cover photo © by Nancie Battaglia

Designed by AdWorkshop, Lake Placid

Distributed by Syracuse University Press, Syracuse, New York 13244-5160

Printed and bound in Hong Kong by AmericanBook.Net
on acid-free paper

LADIES OF THE LAKE

Women Rooted in Water

Kathleen Bagley

With Photographs by Christine Thomsen

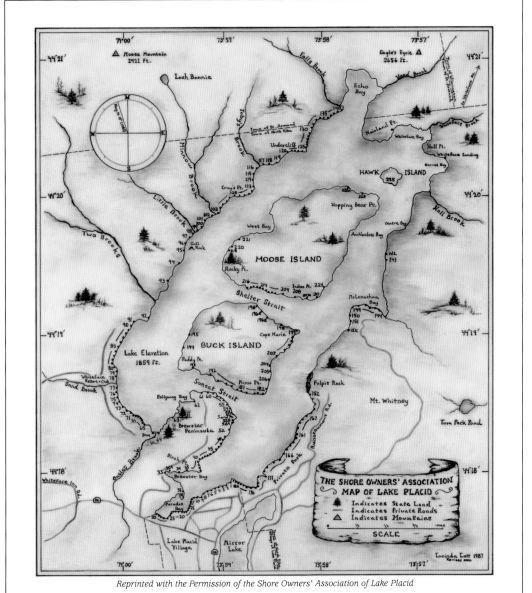

Reprinted with the Permission of the Shore Owners' Association of Lake Placid

DOWER PRESS

CONTENTS

CONTENTS *(continued)*

ACKNOWLEDGMENTS

I would like to thank my husband, Colt, for bringing me to Placid Lake in the first place. Because of Colt, I became infected by the lake's beauty and character. I also owe great gratitude to my children, Forth and Sarah, for loving Placid Lake in ways that continue to surprise and delight.

I would especially like to thank all the Ladies of the Lake for the gracious way in which they embraced my project in its many stages. Without them, this book would not be possible. Due to space limitations, some stories were not able to be included in the book. My thanks and apologies to those ladies. And to the many interesting Ladies of the Lake whom I was unable to interview, more apologies.

Much gratitude to each and every one of the photographic contributors for adding spice; the photographic credits are listed under *Resources*. A big thank you to Linda Friedlander and the Shore Owners' Association of Lake Placid for pertinent information and for allowing me to publish their map. And to John Kettlewell and the Adirondack Mountain Club for permission to use their map excerpt. John Rosenthal and David Ackerman provided details concerning Placid Lake.

Thank you to Bill McKibben for critiquing my work with grace and style. To Nathalie Thill of the Adirondack Center for Writing for introducing me to Bill. And to Mary MacKenzie for historical details.

Other friends and family members deserve mention too. My sister, Betsy Hall, for her professional editing. Sandra Kister, for her photographic eye and for being my objective reader. Nancy Boulicault and Penny Pilzer, for juggling ideas. Maryann MacDonald, for her common sense about writing. Mara Jayne Miller, for inspiration and a Lake Placid edit. Sue Guiney, for her encouragement.

A special word of thanks to Sharon Williams, Linda Jones and Adèle Connors for their patience. And much gratitude to Greg della Stua of American Book, my production guru, and the team at Syracuse University Press, especially Mary Selden Evans, Executive Editor, Mary Moore, Manager of Design and Production, John Fruehwirth, Managing Editor, Theresa Litz, Marketing Manager and Therese Walsh, Publicity. And to all those folks who kept after me to keep on writing, thanks for believing.

PREFACE

The spark that ignited this book came from a photograph my friend, Sandra Kister, took of Helen Murray, one of the Ladies of the Lake. I wanted to find the language behind the singular look Sandra had recorded, to discover why it seemed so universal. Helen is standing in the dining room of her Camp Menawa on Placid Lake. Her face is relaxed, yet her stare is ferociously self-assured. She seems defiant, as if she were telling us, through the photographer, "Here I am. This is me, in my dining room. I know who I am, and this is where I want to be." Something more than a portrait of an older woman remained in my mind, long after my eye left the photograph. I began to think about the lake and the ladies, like Helen, who live around it.

I first came to Placid Lake in the summer of 1982. My husband, Colt, and I were looking for somewhere to escape on weekends with our two small children, Forth and Sarah. A friend recommended a lake in the heart of the Adirondacks in upstate New York, Placid Lake. (Throughout the book I will refer to the lake by its less used name, Placid Lake, to differentiate it from the town of Lake Placid.)

Helen Murray in her Camp Menawa dining room

The first time I laid my eyes on the view of Whiteface Mountain from the dock of Camp Midwood, I was hooked, and so was Colt—so hooked we purchased the camp that very day. Don't ask me why. The feeling was visceral. I was a Midwesterner who had never driven a boat, much less landed an antique Century speedboat in a pencil-sized boat slip. I had never climbed a mountain, certainly not one higher than 4,000 feet. Nor had I cross-country skied on a frozen lake, or negotiated a tipsy guide boat. But over the next 20 years, I learned to do all these things, and more, and so did our children. When we moved to London in 1988, we made the decision to keep Camp Midwood and it became our center—the place where we celebrate family and friends.

For me, Placid Lake represents all that is good and right about life. In more ways than one it is my compass.

When I studied the photograph of Helen in her dining room, I suspected she too had a compass. And, I wondered if hers was the same as mine. Over the years I've met many ladies of Placid Lake like Helen. I began to think about their sense of place, their relationship to the lake and the hold it has on each of them. Since the late 1890s, women have been coming here steadily and in increasing numbers. They came alone, with partners, and with families, from different economic, cultural and educational back-

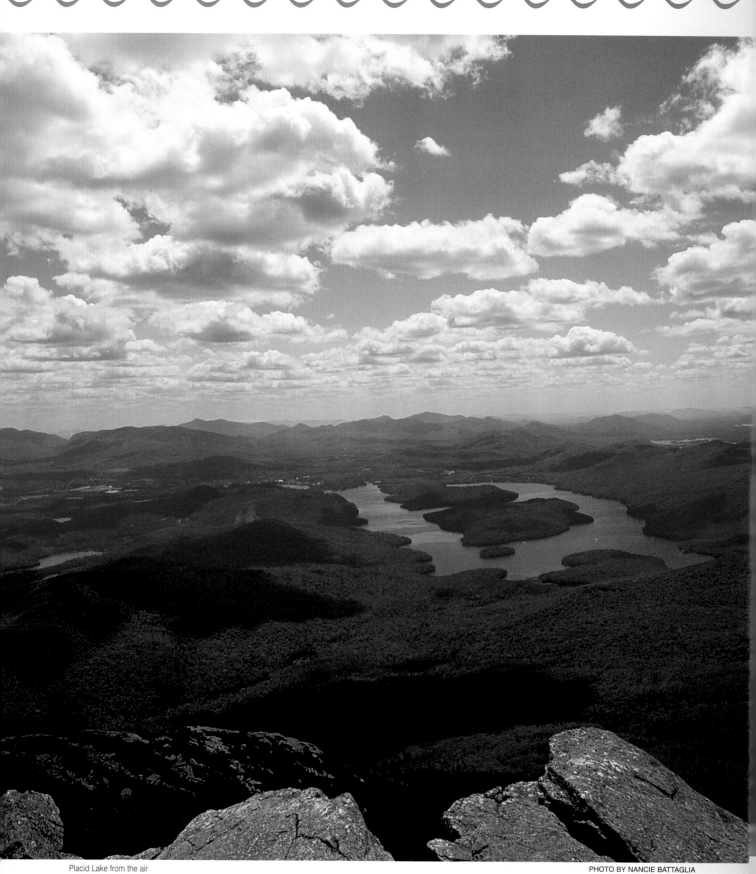

Placid Lake from the air

grounds, to create permanent homes and part-time refuges. But what did they have in common? I began to wonder.

One thing was certain. Once they arrived, these women immediately identified with Placid Lake. Things were revealed to them at camp that weren't revealed back home. The lake was important to these Ladies of the Lake: often it became the main character in their lives. But why? Was something missing? Were they trying to invent a life they were unable to invent elsewhere? Were they escaping from the ordinary? Or looking for a connection? I felt there were stories to tell about how and why they came, how and why they stayed, and what made them special—because of the lake.

I began to interview many of them. I found that the Ladies of the Lake were drawn to Placid Lake by the solitude of its nature, by the sheer spectacle of mountains and water, and the changing seasons and moods. What they had in common was a love of the peace, beauty and timelessness of an area considered by many to be one of the natural wonders of the world. Most stood on the shore of the lake and called it "my lake," or looked out at Whiteface and called it "my mountain." By getting back to nature, they grew closer to themselves and closer to the values they held as fundamental.

Sometimes Placid Lake was also their highway, their path to wholeness in a time of crisis or tragedy, a refuge during illness, divorce or death. Others saw it as a venue, a place to make a difference or embrace a cause. Some craved the attention and limelight of the lake's social scene, perhaps unavailable for some reason in their other lives. A surprising number of them hunkered down and stayed private. Most were consumed with family, adamant about the importance of tradition, and concerned about leaving traces

for the coming generations. There is a mandatory family closeness at camp that everyone liked and wanted to preserve. All of them recognized how privileged they were to be on the lake and not one of them was ungrateful. The Ladies of the Lake rarely wanted much to change. They adored Placid Lake just the way it was—and is—and will be.

This lake in the heart of the Adirondacks called Placid Lake has its own history, much of it ancient and wild. Most of its history is told in more detail in books other than mine, including Gary Randorf's *The Adirondacks, Wild Island of Hope*; Paul Schneider's *The Adirondacks*; *A History of the Adirondacks* by Alfred Donaldson; and David Ackerman's books, *Lake Placid Club* and *Placid Lake: A Centennial History*. I include here a brief overview of the area and the lake, only to provide context for the following chapters.

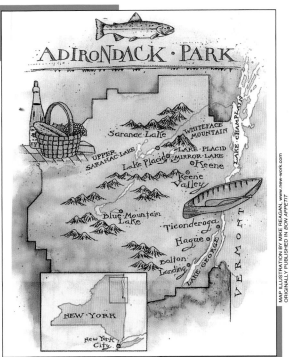

The Adirondack Park

The wilderness surrounding Placid Lake, the Adirondacks, was named after a local Native American tribe, the Algonquin. Because the Algonquin were poorly fed, the neighboring Mohawk tribe contemptuously called them "Tree-eaters," implying they survived the harsh winters by living off the bark of trees. The Adirondacks were a disputed territory, claimed by both the Algonquin of Canada and the Mohawk, one of six nations of the American Iroquois. Both tribes were hunters, fishers and farmers. Both roamed the northern part of New York State, creating 2,000 miles of paths and foot trails still in use today.

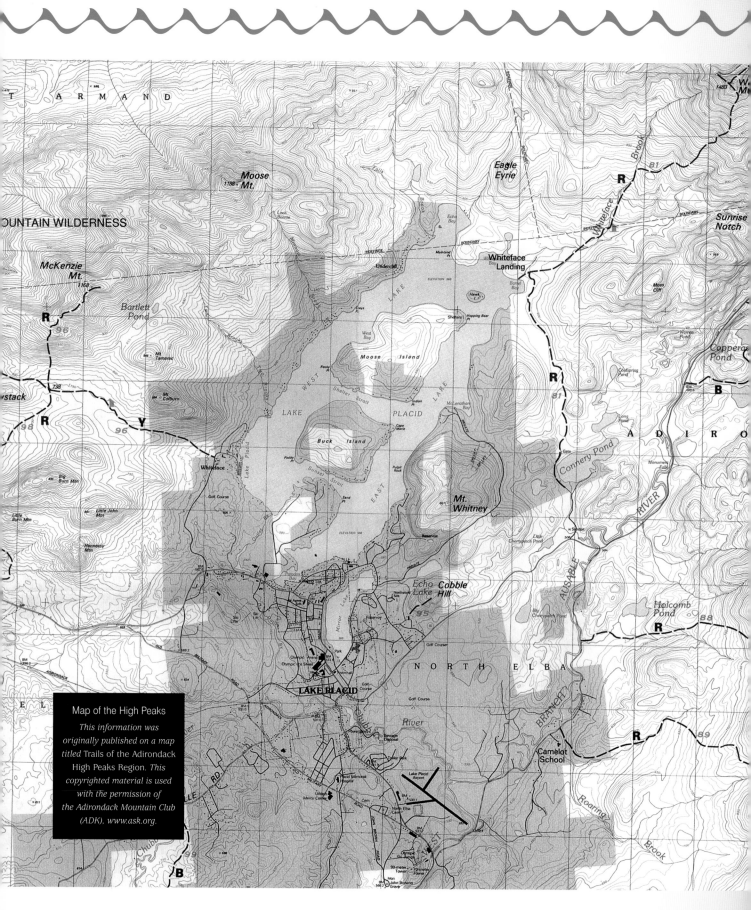

Map of the High Peaks

This information was originally published on a map titled Trails of the Adirondack High Peaks Region. *This copyrighted material is used with the permission of the Adirondack Mountain Club (ADK), www.ask.org.*

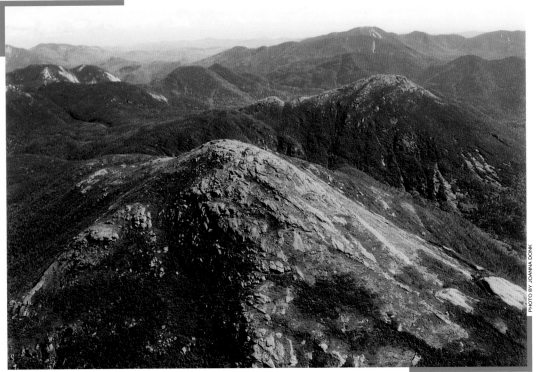

View of the High Peaks

In the first half of the 1800s, professional trappers from Europe discovered beaver and mink in the Adirondacks. Soon after, miners of ore and charcoal arrived with their forges and blast furnaces. In the ensuing years, giant lumber companies gobbled up huge tracts of land, and commercial forestry became the primary industry. By the latter part of the 19th century, destructive clear cutting and the resulting fires laid waste to the land.

With tremendous foresight, the New York State Legislature created the Adirondack Park in 1892, which authorized the purchase and sale of state park land within counties in the forest preserve—the so-called Blue Line. The preserve was designated "Forever Wild" in an 1894 state constitutional convention. Perhaps the word "foresight" is too generous. The truth is, the park was considered pretty worthless back then because of the mindless logging policy of "cut and get out."

With its six million acres, the Adirondack State Park is the size of Vermont, larger than any federal or state park in the U.S. excluding Alaska's, and is larger than Yellowstone, Grand Canyon and Yosemite combined. Over half the acreage is privately owned and there is a permanent population of 130,000. Situated in the park are several federal and state prisons, a myriad of farms and mines, and many private homes and businesses. The region is dotted with 2,300 lakes and ponds, 46 peaks higher than 4,000 feet (although three of the High Peaks are technically a few feet under 4,000), 1,500 miles of rivers and 30,000 miles of brooks and streams. In summer, there is hiking, swimming, boating, canoeing, sailing, fishing and water skiing. The region is populated with 220 species of birds, 50 species of mammals and 66 species of fish. Winter days can be spent skiing, skating, tobogganing and snowshoeing. And if you choose to do nothing, there is always the glorious landscape simply to enjoy.

Ever since the area's Forever Wild designation in 1894, a delicate balance has existed in the park between public and private interests. The Adirondack Park Agency, which regulates the use of land via

13

its master plan, didn't come into existence until June of 1971. Three and one-half-million acres of the park are privately held, so there are inevitable clashes between the private sector and the government. It is a continuing challenge to support both human life and wilderness in the spirit of the state's mandate. And the battle goes on. As Bill McKibben, Adirondack resident and author, says in the foreword of Gary Randorf's *The Adirondacks, Wild Island of Hope*, "It's like a painting by Vermeer. A scarce few exist. The Adirondacks are a second-chance wilderness and as such, a hope that the damage caused by humans is not irreversible."

By the 1900s, the Adirondack State Park had become a major summer destination, primarily for well-to-do Northeasterners. August was the favored month, as there were no black flies or mosquitoes. Most came to the higher elevations to escape the heat of the cities via steam trains heading north, continuing their journeys on steamships and wooden motorboats. In the beginning, they stayed in tents or local hotels; later, after falling in love with the area, they bought land to build on or existing log camps and cabins. The houses today are still called "camps," because that is how they were originally built—as tents pitched along the shore of the lake or tucked into the wilderness, where gentlemen of wealth came to fish and hunt before the era of the almighty automobile—in the days when one had to work hard for one's leisure.

William West Durant, owner of the Adirondack Railroad, controlled a sizeable portion of central Adirondack land, some 700,000 acres, more land than the state of New York controlled, and most of it tax exempt. It was Durant, and his wealthy friends and clients, who are mostly responsible for the "construction boom" in Adirondack style camps that started in the late 1800s and lasted for several decades. By the 1930s, there were dozens, if not hundreds, of elaborate camps sprinkled along the shores of the region's pristine lakes. The super rich, mostly East Coast industrialists, were lured to the area by the packaging and selling of a "gentlemen's" wilderness. The concept of "Great Camp" was born.

Wealthy seasonal regulars arrived for the summer in private sleeper cars with dozens of staff and scores of steamer trunks and set up elaborate camps, where life was formal and stylized, where they could be one with nature while "roughing it" in style. It was considered *de rigueur* to cart as many amenities to camp as possible, and then disguise them as part of the natural order of things. The owners were household names like Alfred Vanderbilt, J.P. Morgan, William Rockefeller, William Whitney and Marjorie Merriweather Post. Guests were lavishly entertained—not just business leaders but politicians like Teddy Roosevelt, and writers like Upton Sinclair and Mark Twain. Local economies flourished—the camps needed fishing and hunting guides, caretakers, maids, cooks and butlers. And, plenty of good food and wine.

A typical Adirondack camp was built of native logs and stone, with touches of birch bark and rustic twig in erratically shaped patterns in what has become an Adirondack signature. Many were grand compounds of eight to ten buildings connected by covered walkways, some with chapels, billiard rooms or bowling alleys. Among other things, the lodges often featured fireplaces built with local fieldstone and trophy rooms stuffed with local wildlife, bearskin rugs and antler chandeliers. Most camps were decorated with twig railings and intricate rustic furniture built by fishing guides and camp caretakers in the off-season. This kind of architecture has become synonymous with the Adirondack culture.

Many of these original camps can be seen in Harvey Kaiser's *Great Camps of the Adirondacks* and Craig Gilborn's *Adirondack Camps: Homes Away from Home*. Ralph Kylloe has written a series of Adirondack architecture and furniture books, including *Rustic Style*. Ann Stillman O'Leary's *Adirondack Style* is another excellent resource for viewing the area's unique decorative design.

The job of chief caretaker was—and is—an honored profession in the Adirondacks, often handed down from generation to generation. So too was the work of the caretakers' wives, who often provided the

cooking, housekeeping and childcare. Perhaps they are the true Ladies of the Lake, for without them, many of the women in my book would not have been able to invent their own lives on the lake.

Over time, the Adirondack tradition of caretaking has been somewhat diminished in its scope. In the past, it was not unusual for an entire family to live in a detached cottage during the off-season, while caring and tending for a camp. Times have changed and this arrangement now is rare. Families are smaller and camps are easier to run. The amenities of camp life have been

Adirondack porch

scaled down and modern conveniences have taken the place of manual labor. The remaining caretakers on Placid Lake are a valued and respected lot, and so are their wives. The fact that my book omits the stories of these special Ladies of the Lake in no way denies their importance.

Nor does it deny the existence of thousands of other lodges and clubs and cabins that grew up all over the Adirondacks in the last 100 years. In the space of just 20 years, from 1880 to 1900 alone, 100 camps were built on the shores of Placid Lake—mostly rustic cabins. Life for these and most other Adirondack residents, whether seasonal or regular, was simple and modest.

Just as it is now. Adirondack residents ski and ice skate in the winter, swim in the cool lakes or go camping in summer. They climb mountains and hike on wooded trails. They barbeque on the 4th of July or paddle a canoe on a moonlight night. It is still possible to enjoy the Adirondacks in an unpretentious fashion, and many residents do. For these folks, the grand elements of camp life have never been and never will be considered a requirement for the "good life."

✧ ✧ ✧

Tucked between the High Peaks and Whiteface Mountain, Placid Lake became its own unique paradise. Formed by an ancient glacier, the lake stretches five miles end to end, with 12 miles of shoreline. Situated at the foot of Whiteface Mountain, which has an elevation of 4,876 feet, the lake (at a base elevation of approximately 1,800 feet) surrounds two sizeable islands—Buck and Moose—and a smaller one—Hawk. (In his classic book *The Adirondacks Illustrated*, published in 1874, Seneca Ray Stoddard describes the islands as…"so large that the lake resembles a large river sweeping around them rather than a lake with islands.")

Thousands of acres of New York State land encircle the shores of Placid Lake. According to the Upstate Freshwater Institute, the lake is 44 meters (144 feet) at its deepest. And, according to the October 2003 Supplement to the Shore Owners' Association of Lake Placid map, there are currently 225 property owners/camps along the shores. Ninety-one percent of these properties are vacation or secondary homes; 45% are water-locked, with no road access.

Because of this lack of road access, water transport is, and has always been, crucial. In 1898, Henry Stephens, captain of a line of steamers on Placid Lake, launched and piloted a double-decker tour boat

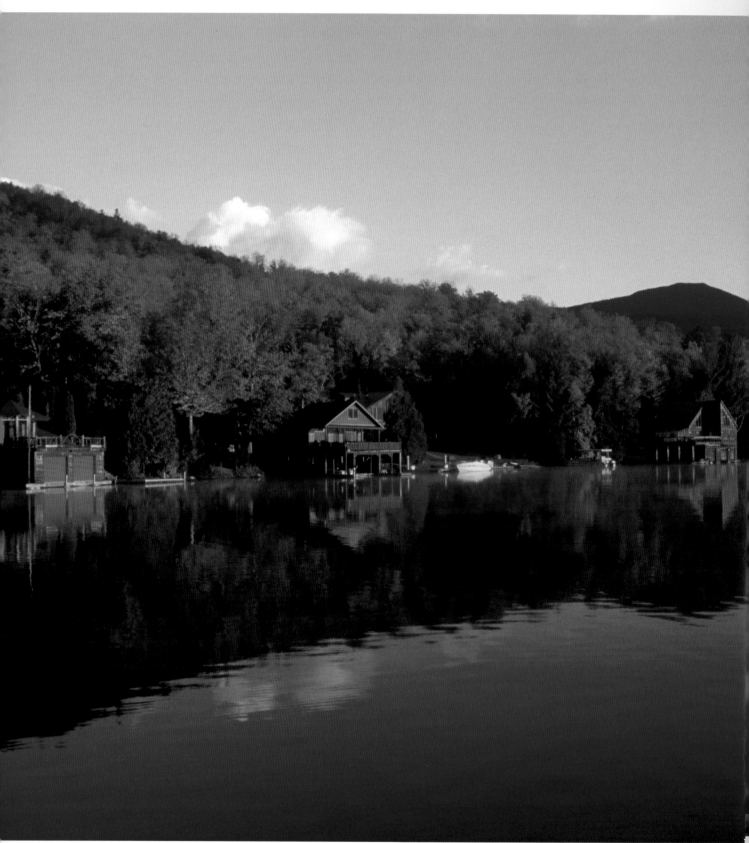

Adirondack camps dot the shoreline of Placid Lake

called the *Doris*, a fixture on the lake until it was retired. In 1919, Captain Stephens sold out to George & Bliss. The *Doris* was damaged by fire in 1951, and George & Bliss launched the *Doris II* in order to continue the excursion tradition. The *Doris II* provided other services to camp residents around the lake, such as mail delivery and party hire.

In due course, the landing name George & Bliss was changed to Lake Placid Marina. Another tour boat, the *Lady of the Lake* was brought onto Placid Lake by Charles (Chuck) Grote who ran an excursion service from the old Stevens House Hotel boathouse in Paradox Bay. The *Doris II* and the *Lady of the Lake* still make their tour rounds from the Lake Placid Marina every day.

All camps on Placid Lake enjoy the protection of a fireboat. Considering that shore owners pay a sizeable and significant portion of the area's property and school tax (around 15%), it is not unreasonable to have this proprietary service. Each season, an issue arises—like garbage removal or proposed shoreline development—that pits the residents of the Town of North Elba and the Village of Lake Placid (there are approximately 2,800 full-time residents) against the shore owners on the lake.

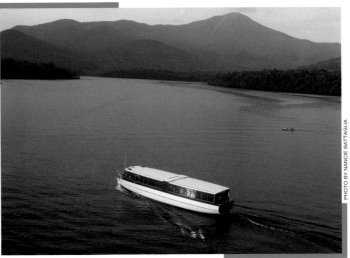

The tour boat Doris II as viewed from the air

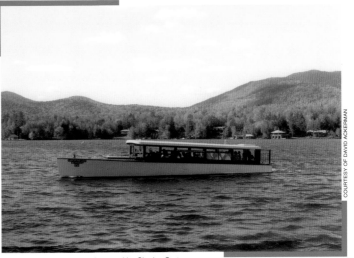

Lady of the Lake tour boat, imported by Charles Grote

Lakeshore property is "hot" at the moment and prices have gone through the roof (appreciating 30% last year). The latest issue to face Placid Lake shore owners is the dramatic increase in waterfront property assessments. The resulting outcry from lake owners has not yet turned ugly, but there is much heated debate about perceived inequities between town and lake taxpayers. It is not surprising that the shore owners decided, back in 1893, to create an entity to represent their special interests.

The Shore Owners' Association of Lake Placid (SOA) was initially formed to secure control of the outlet that regulates the water level of Placid Lake. Before that time, the shore owners were at the mercy of a nearby mill, which owned the outlet and alternately stored and released water for its own use. Understandably, the shore owners were frustrated by the result—a fluctuating water level on the lake that alternatively swamped their docks and boats, then left them sitting on dry land.

In addition to purchasing the dam at the outlet and rebuilding it, the SOA also monitors the lake's water use and quality and pays attention to the beauty, safety and health of its shores. Most of the residents

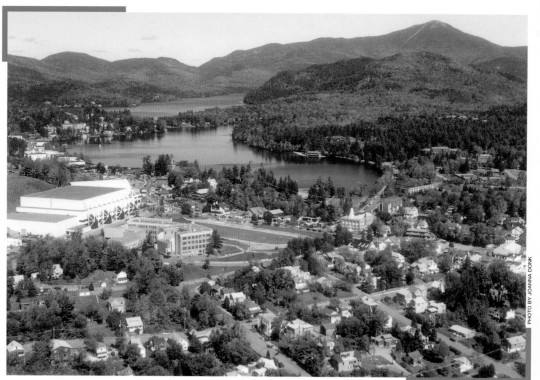

Town of Lake Placid with Mirror Lake and Placid Lake in the distance

take their drinking water from the lake—no filter, no nothing. Up until now, the water has been crystal clear and tastes good.

But recent tests of shore owners' tap water have yielded some disturbingly poor results, and there are genuine concerns about the quality of Placid Lake's water. Some have labeled it a crisis. The Town of North Elba and the Village of Lake Placid also draw their drinking water from the lake (albeit via a treatment plant) and both municipalities benefit from the lake's high tax base, so there is a huge incentive for cooperation. The most logical solution is enforced and regular inspections of septic systems, which of course costs money. So the controversy continues.

And so does the need for continued attention to the shoreline. In 1993, 100 years after the formation of the SOA, the Placid Lake Foundation was created "to further the preservation of the remaining open space along Placid Lake's shorelines," according to David Ackerman, its current chair. The foundation actively seeks land gifts and conservation easements to be held in perpetuity as Forever Wild.

The original creators of the Adirondack Park would no doubt approve. But, convincing modern day Placid Lake shore owners to be as foresighted with their own property as New York state was in 1894 may be an entirely different matter altogether.

✧ ✧ ✧

These are the irrefutable facts about the lake. There are other more refutable realities that figure in the shape of its history, namely the Lake Placid Club. In 1895, Dr. Melvil Dewey founded his "experiment in intelligence" on Mirror Lake. Mirror Lake is south of Placid Lake; although the two lakes are not connected, they nearly touch each other. Lake Placid, (referred to as Placid Lake in this book), for which the

town is named, is sometimes called the "Big Lake" to differentiate it from Mirror Lake, which is one mile long and one third of a mile wide.

Mirror Lake is often assumed by weekend visitors to be Placid Lake, because the village of Lake Placid is located on its shores; in reality, Placid Lake is tucked away from tourists and out of view. (As an aside, there was at one time a proposal to join the two lakes together. It was resoundingly defeated.)

Dr. Melvil Dewey was a librarian and educator who was once the librarian-in-chief at Columbia University. Famous for designing the "Dewey Decimal Classification System" for libraries, he loved abbreviations and even shortened his name—Melville Louis Kossuth Dewey—to Melvil.

An allergy sufferer, Dewey and his wife, Annie, found relief in the village of Lake Placid, where they founded a private club—a place to relax and exchange ideas with their fellow academics. Dewey intended, and mostly succeeded, to create a recreational and cultural center, a year round family resort with "standards" and "club customs," a place to recharge in style and comfort with one's own. It functioned as a kind of university club, where every guest was rated on a Lake Placid Club Grade Card. No one was allowed entrance without an introduction or an invitation from a fellow member.

In 1906, the "Club," as it was called (and will be referred to in this book), had 646 members. By the 1930s, the Club boasted 1,500 members and was in its heyday, as was the rest of the area in general. With 10,000 acres and 1,000 employees, there were a host of activities offered—golf, tennis, swimming, sailing, riding, Saturday night dances, lectures and concerts. The Lake Placid Club was a self-sufficient marvel with a gigantic, sprawling infrastructure. In addition to the hotel, there were power plants, laundries, gardens and farms, a day camp, boats, fleets of automobiles, a library, saw mills, medical units—even a downhill ski park on nearby Mt Whitney, a shooting range on River Road and a riding stable with its own trails.

The popularity of the Club continued for several more decades. The opening of Highway 87, the "Northway" from Albany to Canada, in the mid 1960s, meant that the Lake Placid Club was within a day's driving distance for more than 70 million people. 1967 was a record year for the Club. The capital improvements just kept coming—a new heated pool, improvements at Mt. Whitney, new attached lodges and condominiums, modernization of the golf house, a new skeet and trap field, and a new $400,000 maintenance facility. The Village of Lake Placid and other nearby towns profited from the Club's growth and prosperity. There were high hopes that the good times would continue.

But all was not so rosy. In 1973, Club members learned that the Lake Placid Club had been operating at a deficit for 16 of the last 20 years and had been quietly selling off its land to fund its operations. In desperation, the Lake Placid Club opened its doors to the public in 1977 and initiated a new marketing program.

Despite several refinancing packages, the Lake Placid Club continued its financial decline. In 1980, the Club defaulted on a $3.5 million loan and went into bankruptcy, finally closing its doors in March 1980, shortly after the end of the XIII Winter Olympic Games, despite being designated the International Olympic Committee headquarters. (The Village of Lake Placid was the site of the 1932 Winter Olympics—thanks to the efforts of Melvil Dewey's son, Godfrey—and again was host to the Winter Olympics in 1980.)

The demise of the Lake Placid Club was an economic shock to the area, as well as to the Club itself. And, unfortunately, the 1980 Winter Olympics failed to stimulate the region economically, as planned—and hoped. Many of the village stores were forced to close. Real estate prices plummeted. Hotels changed

hands, restaurants folded. Without the Lake Placid Club, the region began to loose its focus. (Over the next 20 years Lake Placid and the surrounding area would struggle to find a new identity; eventually it would regain its former viability and transform itself into one of the most successful sports and cultural centers in the Northeast.)

After a series of fires in several of the cottages and in the Club's Forest wing, much of the original Lake Placid Club was dismantled and demolished. In 1996, Caroline and Serge Lussi, owners of the Holiday Inn in Lake Placid, purchased what was left of the defunct Club and are currently operating it as a Destination Resort. (A Lady of the Lake, Caroline Lussi relates her story later in this book.)

Despite its complicated history, there is no doubt about the Lake Placid Club's influence in the region. The Club spawned several offshoots that developed into going concerns in their own rite. Dewey bought the Adirondack Loj, an adjunct to the Club known as the Forest Branch. Built by Henry Van Hoevenberg at Heart Lake, the Loj operates to this day under the auspices of the Adirondack Mountain Club. In 1921, the Club purchased land on Placid Lake's Moose Island for picnics and overnight camping; the site eventually became part of the state's forest preserve system. The Lake Placid Skating Club, the Ski club and the Sno Birds, all of which supported gifted winter athletes, were sponsored by the Club and are considered precursors to the Winter Olympics games. Northwood School, originally founded in 1925 as the Lake Placid Boys' School, and the Lake Placid Sinfonietta, a small resident orchestra that began as a quartet, are still operating today.

Of all these, however, the Lake Placid Club itself stands out for the profound mark it made on the area and its residents. The Club was decidedly exclusive, cliquish and select. Excerpts from *LPC Notes* reveal an exhaustive list of duties and expectations for its members. Despite the fact that formality in attire was discouraged, there was a strict but unwritten dress code. There were restrictions on noise levels, and smoking was forbidden to women in public.

> *"The Club does not want…the following classes, even tho in other respects they meet Club standards: the ultra fashionable or fast set…those who care more for the bar or grill room, late suppers and city vices…chronic faultfinders and born pessimists…bargain hunters."*

> The Club's rules were also distinctly racist. The Club's charter instructed that *"It excludes rigorously every person against whom there is a social, race, moral or fiscal objection…From its founding the invariable rule is to admit no Hebrews…"No one is to be received as member or guest against whom there is physical, moral, social or race objection, or who would be unwelcome to even a small minority…This invariable rule is rigidly enforced; it is found impracticable to make exceptions to Jews or others excluded, even when of unusual personal qualifications…Except as servants, Negroes are not admitted."*

The historical and cultural implications of the Lake Placid Club's selectivity are best addressed at length in another book. For my purposes, it is germane that the existence of the Lake Placid Club features largely in the minds of some Ladies of the Lake. Many had close ties to the Club, having summered there with their parents and/or children for years—or golfed, played tennis or dined there as outside members.

Some Ladies of the Lake are more nostalgic about the Lake Placid Club than others, for obvious reasons. Their memories of the Club are happy ones; most claim to be blithely ignorant of Dewey's policies, and indeed, given the times, it is possible they were. A few refused to be drawn into any discussion at all, most likely because they knew what was going on and accepted it, maybe even sanctioned it. Several apologized for the Club's policies, even acknowledging they had asked their Jewish friends to forgive

them, then later retracted their interviewed words when they were confronted with them in writing. Others were more forthright and their stories are honest and thoughtful. Decades later, the reactions of these Ladies of the Lake are intriguing, if only for one reason. Like Placid Lake, the Lake Placid Club, one way or another, still has a hold on them.

There are other intangible realities that surfaced as I interviewed the Ladies of the Lake. Most of the Ladies were remarkably courageous, unafraid to tell their stories no matter how personal, no matter what the world might think of them, and I admire their fearlessness. This thread of female courage and spirit came through time and time again. I also was struck by their individuality and their diversity. Taken as a group, the Ladies of the Lake represent quite a cross section of human nature and each story is remarkably different.

Yet, in significant ways, the stories remain the same. Each Lady of the Lake has a definite hold on her own destiny, starting with her destiny on the lake. Her belief in what Placid Lake represents to her and her sense of place on the lake transcend practically everything else in her life and greatly influence her. Her camp may be a sanctuary, or a place to recharge her batteries, but it is also the place that gives her identity.

Not surprisingly, there are some charming matriarchs in the group, starting with Jane Ackerman's and Georgia Jones' great-grandmothers. Often, it is the women who inherit the camp, who fight for ownership in a divorce, who pass the title on to a daughter, or a sister. In other words, it is the women who run the show. I'm not talking about housekeeping or tending the fires or chopping wood, though a Lady of the Lake may do some of these chores too. There is something deeper, something a Lady will go to great lengths to protect, something worth fighting for. (She may even make the leap from seasonal to permanent resident in order to keep it.) For when a Lady of the Lake speaks of home, Placid Lake is what she really means.

Here is another truth I discovered, another of those intangible realities: a Lady of the Lake is empowered. She has a visible strength, and she knows it. This strength puts her firmly in control and in charge, on Placid Lake, and off. A Lady of the Lake loves every aspect of the world she has created for herself and cares deeply. And, because she cares deeply, she passes this passion on, consciously or subconsciously sensing its importance. Placid Lake has a hold on her like nothing else. A Lady of the Lake will always be "rooted" in water.

FOREWORD

Legend of the Lady of the Lake

The story of the Ladies of Placid Lake must begin with the first recorded Lady of the Lake, the legendary Vivienne who raised her stepson, Sir Lancelot, beneath murky waters. Best known for presenting King Arthur with the miraculous sword, Excalibur, Vivienne learned magic from her lover, the wizard Merlin, and became so skilled and powerful that she eventually imprisoned him in her glass tower. A Celtic water-goddess, Vivienne has been immortalized in the poetry of Sir Walter Scott and for centuries has been an inspiration to women who are drawn to the power of water.

ANNA MABEL SMITH DOUGLASS

First Lady of the Lake

The first recorded Lady of Placid Lake was Anna Mabel Smith Douglass. Like Vivienne and the Ladies in this book, Mabel was drawn to the power of water—albeit more tragically, and, certainly more literally.

In 1963, members of the Wreck Raiders Diving Club exploring underwater cliffs near Pulpit Rock on Placid Lake lifted Mabel's body from 100 feet of ice-cold water. A longtime summer resident, Mabel had disappeared in her guide boat some 30 years earlier. When the divers found her, there was a rope around her neck; the rope was attached to a small anchor buried in the silt and sludge. Because of the extremely cold temperature at that depth, Mabel's body was intact and preserved, though it quickly decomposed when raised from the bottom of the lake. Mabel's death was ruled accidental by the Essex County Coroner in New York State, who relied almost entirely on the remains of her bones and teeth for identification.

Mabel Douglass may not have risen from her lake sword in hand, but her skills were equal to Vivienne's. At the time of her death, Mabel was a prominent educator, the recipient of two honorary doctorate degrees and the first woman to receive a Columbia University Medal for distinguished public service. A *Phi Beta Kappa* graduate of Barnard College, Mabel was a member of the New Jersey Board of Education and founder and first dean of Douglass College, the college for women at Rutgers State University. One September day in 1933, Mabel ate lunch, launched her guide boat, and was never seen alive again.

Mabel and her Placid Lake compound, *Camp Onandaga*, no longer exist. But there are other women, also drawn to the power of water, as accomplished as Vivienne and Mabel, still living on the shores of Placid Lake. In their rustic camps, sprawling compounds or simple log cabins, they summer there year after year, or are lucky enough to reside year round—women who paddle or motor past the granite cliffs of Pulpit Rock where Mabel's body was found; women who hike the lake's pine-scented trails and swim in its crystal clear waters; who steer their mahogany boats around its wooded islands.

They are today's Ladies of the Lake and each of them has a compelling story to tell.

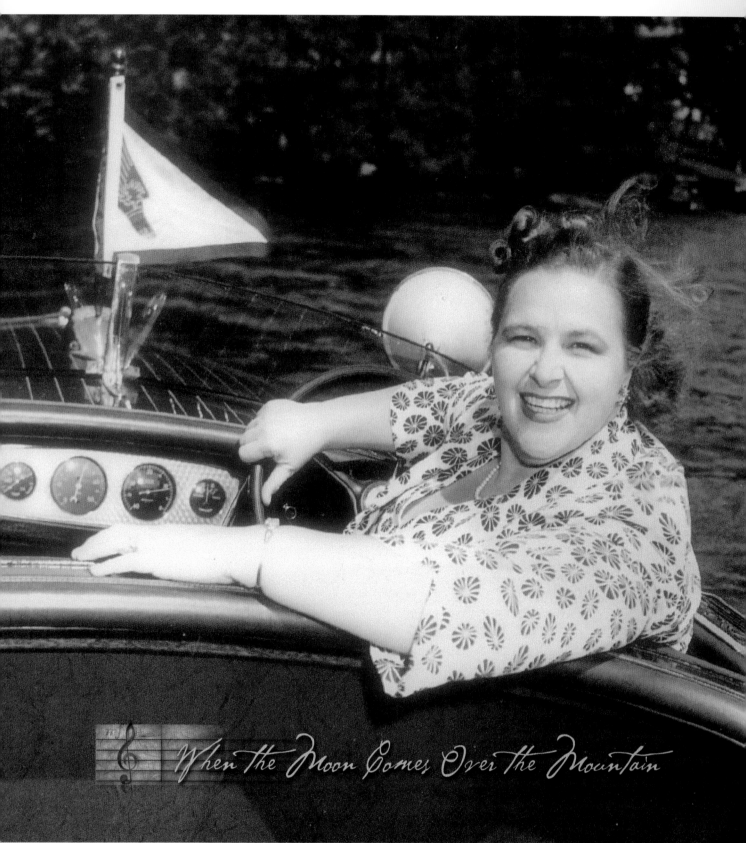

When the Moon Comes Over the Mountain

INTRODUCTION

KATE SMITH
Honorary Lady of the Lake

Without a doubt the most famous Lady of Placid Lake, Kate Smith spent 45 long summers at Camp Sunshine on Buck Island, from 1936 to 1979. Time and again, Kate claimed Placid Lake her paradise, her favorite place on earth and always on her mind when she wasn't there. Although it is widely believed that Kate's theme song, When the Moon Comes Over the Mountain (the lyrics of which Kate composed herself), was based on a poem she had written as a child about the Blue Ridge Mountains, some on Placid Lake (including me) prefer to think it was the view from Sunshine's dock that sparked her inspiration. Kate Smith will always belong to Placid Lake.

Kate is often called the First Lady of Song—and for good reason. Discovered by a New York producer at the age of 19, Kate was rediscovered on Broadway four years later by Ted Collins of Columbia Records, who became her lifelong business partner and manager. Although she made hundreds of recordings, Kate is best known for her theme song, *When the Moon Comes Over the Mountain*, and for making famous Irving Berlin's *God Bless America*. Kate had her own variety shows on TV and radio and became a popular personality. Besides giving dozens of live concerts, Kate also performed in several movies. Considered by some to be one of the most beloved women of her century, Kate was honored by many presidents as an "American Treasure." Her career lasted five decades.

Kate first discovered Lake Placid in 1932. On doctor's orders to recuperate from a nasty case of laryngitis, she stayed at the chic Lake Placid Club with Ted Collins and his wife, her mother and the entire radio orchestra. Despite her laryngitis, Kate and her orchestra performed at the Club's annual Charity Ball. "There in Lake Placid, I fell completely in love with the mountains reflected in the lake, the fir trees standing along the edge of the water, the clearness of the blue sky," she wrote. (1)

For the next four summers, Kate returned to the Lake Placid Club. In 1936, Kate bought what she called a "shack" on an acre of waterfront property on Placid Lake where she renovated a "very comfortable rustic farm house situated on a good-sized island."(2)

Eventually, Kate would create a compound at Camp Sunshine that included a main house, a guesthouse, a maid's quarters and two boathouses. She painted them a spanking clean white with green trim, spurning the original, traditional Adirondack brown. Given the smallish scale of the camp with its relatively low ceilings and Kate's wide girth, it is easy to imagine Kate moving from room to room like an over-sized Alice in Wonderland.

George and Elsie Billings had purchased the land under Camp Sunshine in 1901. According to Kate, they sold it five years later to Reverend Norton, a Methodist minister in Brooklyn. At that time the property (then named Camp Sunset) included the "shack," a boathouse and an icehouse. When Kate bought the

property 30 years later, she irritated her new neighbors by announcing in an article printed in the local newspaper, somewhat grandiosely, that Buck Island was now "her island." Kate also changed the name of the camp to Camp Sunshine and told Richard Hayes, her biographer, why:

"Reverend Norton believed in having a view of the lake no matter where you were in the house. I had never seen this before. We have the sunrise in the east…and we have the sun all day long. Not only that, but the same thing happens with that big beautiful moon when it comes up over those mountains!"

Kate Smith's boathouse painted its original brown color, circa 1940

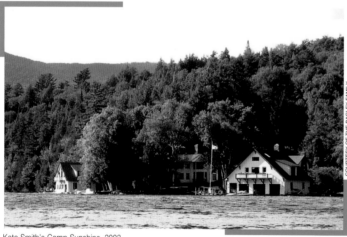

Kate Smith's Camp Sunshine, 2003

So much for those Blue Ridge Mountains…

In her 1938 autobiography, *Living in a Great Big Way*, Kate Smith spoke about her longing for Placid Lake and her homesickness in typically dramatic terms, claiming that Hollywood frightened her terribly. Sitting near the window of a luxurious suite at the Ambassador Hotel in Hollywood, Kate mused about Camp Sunshine: "Flames leaping on the hearth…A great wood fire in the big kitchen stove…I wanted to feel the rush of cold air on my face. I felt a terrible longing for home."

To her credit, Kate appears to have genuinely enjoyed the routine of a simple life on Placid Lake. In the mornings she would swim off her dock, sometimes across to the mainland. Then she would drive her pride and joy, a 24-foot mahogany 1938 Chris Craft called *Sunshine I*, to Holiday Harbor. It was the favorite of her four boats. After parking in her special reserved spot, Kate would head for the village in her white Volkswagen to market or visit her friend, Flora Donovan, who ran the Lavender Shop.

If Kate came to Lake Placid during the winter, she often stayed in Flora's guest room when Camp Sunshine was closed down. Mrs. Donovan was a converted Catholic, and she and Kate were often seen in the company of the Franciscan nuns who lived nearby on Hillcrest Avenue. A local resident remembers how Kate would sweep into Flora's store with her overpowering presence, "She had a huge booming voice. I used to be embarrassed because she was so loud, and her voice was so big. Everything about her was larger than life."

In the afternoon, Kate would sit in a wooden rocker on the camp's front porch and chat with her guests, or perhaps play a hand of rummy. In the early evening, she would cruise—or rather zoom—around the "Big Lake" at 35 miles an hour, waving to the passengers aboard the tour boat *Doris II* as she sped by.

Georgia Jones, current president of the Lake Placid Shore Owners' Association, remembers how Kate would complain at SOA meetings about the speed limit in the strait in front of Sunshine. "Kate's boat slips were lined with dock bumpers, and year after year she claimed the wakes of the boats were ripping them apart. The paradox was, she drove her own boats *very* fast. If you got in her way, she would run you over."

Georgia isn't the only one who was impressed with Kate's heavy hand on *Sunshine*'s accelerator. Kate's niece, Suzanne Andron, recalls: "Aunt Kathryn loved to drive her big mahogany boats on Lake Placid. I can picture her smiling face as she raced across the lake's surface, for she had only two speeds: idle and full open. How she loved those boats." (3)

Kate was usually on Placid Lake in the summertime, but also enjoyed wintering in the area. Despite her considerable weight, Kate was remarkably light on her feet. She loved to ice skate and bobsled, even to downhill ski. "Most of us end up in a snow-bank, our long skis sticking up in the air, our mouths full of snow." (4) The sight of Kate Smith upside down in a snow-bank, although never actually recorded, is one worth conjuring.

Camp Sunshine was Kate's summer home for 45 seasons, and the scene of many live radio broadcasts. Because of the popularity of her radio show, *Kate Smith Speaks*, CBS Radio insisted the show continue to be broadcast during the summer months. Richard Hayes talks about how Kate managed to broadcast from Placid Lake in an article entitled "My Sunshine," in the October 2002 issue of *Adirondack Life*. According to Hayes, Kate had the guest cottage converted into a playground for the engineers, sponsors and advertising agencies. "It was strictly a rumpus room. There was a bar, a ping pong table, a pinball machine, a jukebox and a one-armed bandit," reports Hayes.

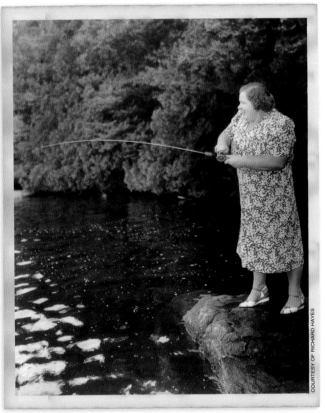

Kate Smith fishing off the dock of Camp Sunshine, circa 1948

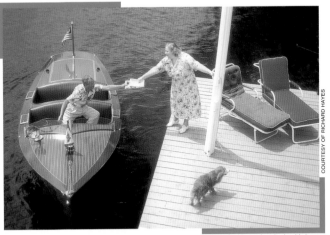

In his Chris Craft, Sunshine III, Ted Collins delivers the mail to Kate Smith on the dock with her cocker spaniel Freckles, circa 1948

The cottage also contained the original broadcast studio, featured in *Ripley's Believe It or Not* as the world's smallest broadcast booth—notable, because at times Kate weighed 300 pounds. There was one small room where Kate and her manager could sit across from each other and also look through a small

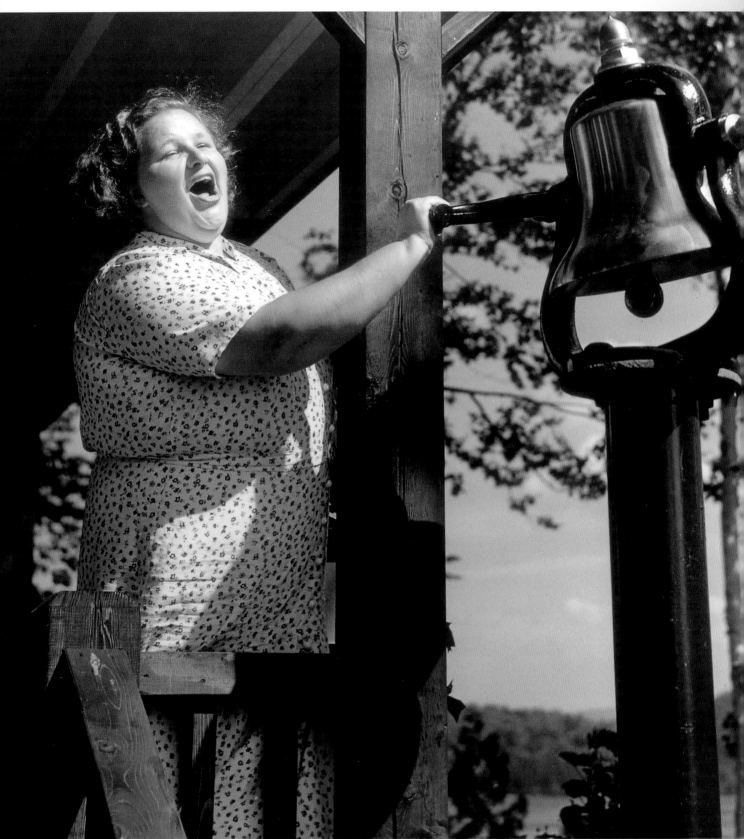

Kate Smith announces dinner with a locomotive bell at Camp Sunshine, circa 1948

glass window into the engineer's booth. At high noon, the engineer would give a signal to Ted through the window. "And then Ted said, 'It's high noon in New York and time for Kate Smith—and here she is,' and we went on the air." (5)

Kate Smith was a big star and definitely used to getting her own way. And, she had a reputation as a bit of a "primadonna" in Lake Placid. Unlike some celebrities, Kate wasn't particularly philanthropic and didn't contribute much to local Lake Placid charities. During World War II, when she showed up for dinner at the local Whiteface Inn, Kate was turned away because she refused to surrender her meat ration coupon. Kate wasn't always kind to her help, and many considered her demanding—though not as demanding as her manager, Ted Collins. According to the locals in Lake Placid, Kate didn't tip at all well. Some called her cheap.

But Kate loved Placid Lake, and Camp Sunshine. In the foreword of *Living in a Great Big Way*, Kate Smith tells us, in theatrical language, how strongly she felt about her retreat. "Money, fame, excitement, and activity—all these material things of life may be important. What have they of value compared to this magic of deep woods, and splendor of setting sun? There is no success like peace of mind, and the contentment that comes with a little house in the country—a garden sweet with growing things—a hearth fire gleaming bright."

When Kate Smith died in 1986, her body was eventually laid to rest in a pink granite mausoleum in the St. Agnes cemetery on the outskirts of the Village of Lake Placid. As one of the most famous summer residents on Placid Lake, Kate left a legacy that was legendary, if not mixed. Kate's story has been told and retold by the residents of town and the shore owners on the lake. Some felt her relationship with business partner, Ted Collins, was more than platonic. Others were more than miffed by the way she treated them. Many were awed by her voice, her audacity, and her sheer size. But one thing is certain—Kate Smith loved Placid Lake.

And she could belt out a song. The Ladies of the Lake who follow have their own stories to tell. During her career, Kate Smith has sung about each of them. In her own big way, Kate will introduce each chapter with lyrics from her multitudinous collection of recordings, starting with,

Upon My Lips a Song (1960)

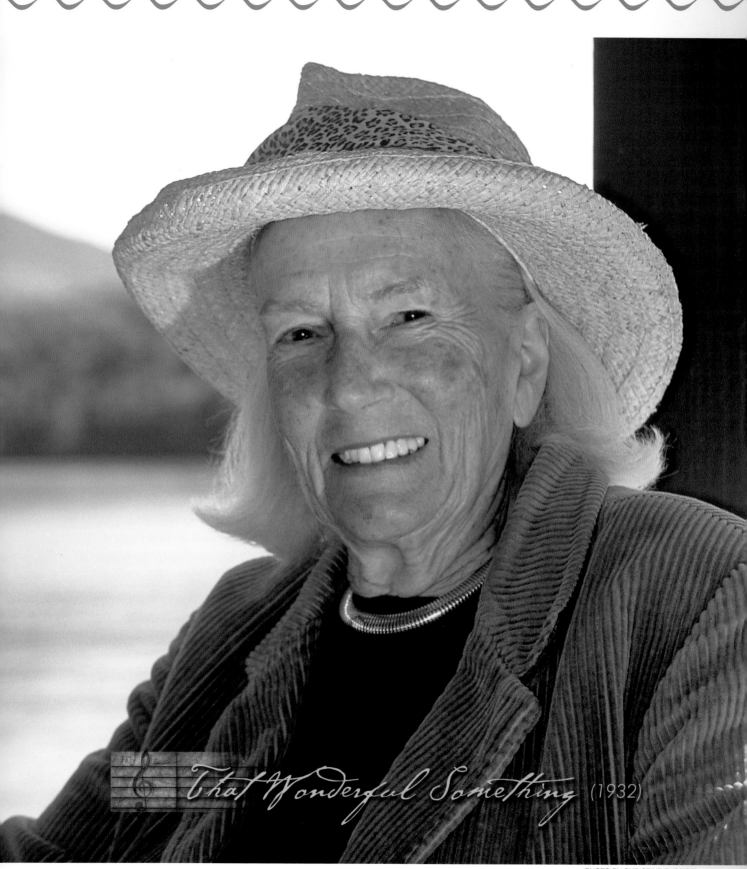

That Wonderful Something (1932)

PHOTO BY CHRISTINE THOMSEN

HELEN CATCHINGS MURRAY

The One True Thing

I first met Helen while walking the trail that runs along the entire shore of Placid Lake, a 12-mile hike through private camps and state land. My husband, Colt, and I had just bought Camp Midwood and we were exploring the environs with visiting friends on a fall day in September of 1982. As the four of us rounded the trail on the north side of the McCutchen property, we came upon Helen's property next door. Shortly thereafter, we came upon Helen, herself, who seemed to have appeared out of nowhere.

"Can I help you?" Her voice had just enough ice in it to indicate she wasn't pleased to see us. "I think you've lost the path," she said. We knew we'd deviated from the trail, deliberately trespassing in order to get a closer view of Camp Menawa with its diamond-shaped, lead glass windows and its quaint log guesthouses. Helen stood in blue jeans and gold necklace, hands on hips, straw hat at a just-so angle, dogs yapping at her feet, her eyes fiercely intelligent. "Uh, we just bought a camp down the lake," I stammered. She had this look about her. Like she not only owned Menawa, but the entire lake too.

Helen's story began one September morning in 1919 when Helen's father and mother launched a canoe from Whiteface Inn and paddled down the west shore of Placid Lake past what is now Camp Menawa. Her father, Waddill Catchings, noticed a wooden "For Sale" sign tacked to one of the cedar trees. He whisked his wife back to the inn, then made his way, by himself, to a realtor in town, and bought the property that afternoon, sight unseen. Helen's mother was not charmed when she learned of his purchase. She was pregnant with Helen, had a four-year-old son named Waddill Junior, and was concerned about having access to the camp only by boat.

Helen Catchings Murray was born on April 21, 1920, and first came to Placid Lake six weeks later, making her quite possibly the summer resident with the longest history on the lake. Her first memory is of

the *Solong*, "an old long skinny black boat with a small inboard motor that used to ferry us back and forth from George & Bliss landing to our camp."

Camp Menawa's 60 acres were, as they still are, accessible only by boat. Today the journey can be made in 20 minutes, but back then it took much longer. Boats were slower then, and so was the pace of life. "It was exciting, that first step off the *Solong*," said Helen. "And a real haven from hotel living."

During the early years of Helen's life, the Catchings family led a rarified existence in a terraced suite on the seventh floor of the Plaza Hotel, and Helen was raised à la Eloise. In the late 20s, Helen hardly knew there was a Depression. "We had two cars and two chauffeurs," she remembers. "It was a pretty charmed life."

The original camp was named Shawandassee, an Indian name for East Wind. The camp had one bathroom. Between 1923 and 1925 the main house was torn down, and local architect William G. Distin replaced it with a grander one, named Menawa after a Tennessee Indian chief. (Distin, a well-known architect who designed and built several Adirondack camps, once had a client who approved the plans, then took off for Europe, announcing he wanted the camp finished by the time he returned. To Distin's credit, he not only managed to finish the construction on time, but also had dinner waiting on newly purchased china the night of his client's return. Such was the grandeur of the era.)

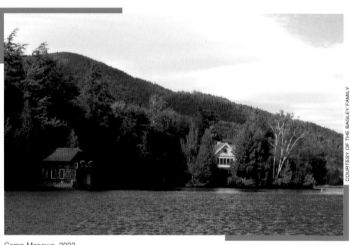

COURTESY OF THE BAGLEY FAMILY

Camp Menawa, 2003

Camp Menawa had a main house, a caretaker's house, guesthouse, barn, tennis court, and large boathouse with ping-pong and pool tables and a piano for rainy days. Two huge glass windows on either side of the fireplace looked out over Placid Lake.

When she was a child, Helen's life centered around the lake. Most of the camps were inaccessible by road, so everyone traveled by boat. Friends came to play tennis, scavenger hunt, swim and water ski. They drank soda pop and had cookouts. Helen was a real tomboy. She hung around the water and hiked the woods surrounding the camp. "Why would I leave?" she asked. The Catchings family had two cows and chickens and their own vegetable and flower gardens in the meadow. They drew their drinking water from Two Brooks, a nearby stream. The pipe leading to the house was six feet below the ground, so the frost couldn't get to it, and a quarter of a mile long. It was all dug by hand.

Every day, groceries would be delivered by boat from Billy Ryan's store in town. Helen remembers Billy carrying her back to the dock in an empty carton, and the *Doris* doubling as a passenger boat, as well as a mail boat. "If you raised your special flag on the dock, the *Doris* would make an unscheduled stop to pick you up and drop you at George & Bliss," said Helen. From there, she could walk to town.

Menawa was the first of the camps on the lake to be winterized. The Catchings family spent Christmas at the camp. As the lake was almost always frozen, they were driven across the lake by car to the front door of the camp. When the lake wasn't frozen, the alternate way in was over the back hills in a horse-drawn sleigh filled with fur rugs and woolen blankets, with hay on the bottom of the sleigh. "It was very cozy,"

Camp Menawa in the winter (aka Moosehead Lodge Club), circa 1946-7

remembers Helen. Their caretaker cut ice out of the lake by hand with a big saw. The ice was stored in the icehouse between layers of straw and provided refrigeration for the summer. Most camps the size of Menawa had an icehouse, and a walk-in cooler fortified with thick wooden planking.

When Helen was nine, her parents divorced. Her mother liked to travel, which meant Helen spent a lot of time with governesses. Helen lived in two different hotels in New York City, the Plaza and the Pierre, and attended the Brearley School for five years. Helen and her mother lived in France for a while where Helen was tutored on the French Riviera and together they toured Europe for part of the year. From France, Helen went to school in Litchfield, Connecticut, with her brother, Waddy, nearby. The next year Waddy moved to the Evans School in Tucson as a boarder, so Helen moved to the Hacienda del Sol, a school for girls in the hills behind Tucson, and later, to Shipley, where she was a boarding student for three years.

"The only thing that stayed the same, the only thing that was always there, was Camp Menawa," said Helen. "This was where my roots were. It was my lifeline, my home."

At about this same time, the Lake Placid Club on nearby Mirror Lake was in full swing. Helen recalls that she was pretty much divorced from their activities. "The lake group was the lake group, and the Club group was the Club group."

Helen does remember taking tennis lessons at the Lake Placid Club and loved going to dances there as a teenager. Helen's mother insisted she travel across the lake at night with her brother Waddy. "Waddy would tap me on the shoulder at 11:00 p.m. and say, 'It's time to go,' and I was always ready to kill him," Helen remembers. "Back and forth we went together, like Siamese twins, in our 1936 Chris Craft, the *Squaw*—which I still drive today."

In 1938, Helen's mother decided to spend one full year at the camp. Eighteen years old and recently graduated from Shipley, Helen joined her mother at Menawa in the fall and stayed with her that winter. There wasn't another soul on the lake. Her mother was served breakfast in bed by the maid. "I would see mother for lunch, and then she would take a long afternoon nap and appear downstairs only for dinner," said Helen. "I also was served breakfast in bed. All of my friends were in college, and I almost became an introvert." It was not a happy year for Helen, except for one experience that provided some comic relief.

There was a typical seasonal thaw and the ice was covered with six inches of water. An insurance adjuster was scheduled to come to Camp Menawa to discuss some insurance matters. Helen's mother met the rotund gentlemen at George & Bliss' Marina and proceeded to drive him across the ice in her 1938 Ford. The waves were sloshing from the car like the wake of a boat, but she acted like nothing was wrong—never bothering to tell the insurance adjuster there was four feet of ice under the water. "The poor guy was such a jelly belly when he got to the camp, he asked for two stiff brandies and signed off without further discussion." Helen laughs. "Mother had to pour him into the back seat of the car for the return trip across the 'ghastly' lake."

After the winter of 1939, Helen went to work for *Vogue* magazine in New York City. She started as a secretary after announcing she wasn't terribly qualified because she couldn't type or do shorthand. That didn't seem to bother her boss, who was Helen's age. "She'd never had a secretary before, and I was on my way," said Helen.

In 1944, Helen married Radford Bascome and they moved to Boston. Four years later, she returned to New York and worked again for *Vogue*, later becoming managing editor of *Simplicity Pattern Book*. "Luckily for me, the editor let me do everything—the layouts and the trips with the models and the photographers," said Helen. After a while, Helen returned to *Vogue* and became the editor of Vogue *Pattern & Knitting Book*. She worked there, on and off, until 1962.

During those working years, Helen faithfully came to the camp every summer to open it for the season and arrange for its maintenance (which was sizeable and growing). The camp was sometimes rented, but Helen spent as much vacation there as she could. Helen's Aunt Nora had a camp just down from Menawa near Whiteface Inn, which Helen describes as a great comfort.

In 1944, the U.S. Army, under the direction of the War Department, took over the Lake Placid Club and for over a year used the Club as a Redeployment Center. "I'm sure my Aunt Nora didn't like the idea of those soldiers so nearby," remembers Helen. The arrangement suited the Club though, as it otherwise would probably have closed, due to lack of staff and clientele. During the war, large numbers of men from the area had been drafted into various arms of the service—the working staff at the Club as well as many Club members. Like Helen's Camp Menawa, the Lake Placid Club needed maintenance—and welcomed the extra money.

In June 1945, Helen summered at Menawa with her friend Joannie Richards. (Older brother Waddy and husband Radford were still in the service overseas. Younger brother Henry Werner had died of leukemia in his teens at Deerfield Academy.) Joannie brought her dog Violet to the camp. That summer marked the beginning of Helen's passion for dogs, especially ones with mixed backgrounds.

"I found my first dog on Tibet Road on Route 35 in Red Bank, New Jersey," said Helen. "He was lost, covered with ticks, and to me his pedigree was quite mysterious. So I called him a Tibetan Terrier because Tibet was so far away, no one could ever check the breed." Helen's Lhasa Apso, Griffin, and her Egyptian Spider dog, Cleo, now travel with her everywhere, confusing onlookers with their fancy pedigree names.

Helen Murray with her dog Griffin on the dock of Camp Menawa, Whiteface Mountain in the distance

By the time Radford came back from the Marine Corps later that year, it was clear that Camp Menawa needed even more work and that it would be up to Helen to figure out a way to pay for it. Radford and Helen moved for a brief time to Detroit, where he worked for Cadillac in the promotion department. That winter, Helen and her brother came up with a brainstorm to "save the camp," which by now was becoming a financial strain. Brother Waddy, too, had returned recently from overseas. Waddy moved into Menawa's boathouse on the mainland and Radford and Helen moved into Menawa's guide cabin (that has since been pulled down). The three of them used to walk in over the trail or across the ice that was always frozen by Christmas, carrying their groceries in pack baskets to the camp—where they plotted and planned a project that would save Camp Menawa.

Hence the birth of the Moosehead Lodge Club, a *very* exclusive club that required a $25 membership fee, but not much else. Helen was 26 years old. "If I had just kept notes for the next two years, surely I would've had a bestseller. I had no idea what I was getting into," said Helen.

Before the war, Radford was involved in public relations and had an entrée to all the society editors in New York. "In those days there was real society and a real society section of the newspaper," Helen explained. Helen and Radford decided to use his connections and clout to attract clients. And, if the Moosehead Lodge Club was operated by real society types, well, Helen and Radford and Waddy would definitely have a success on their hands.

And so, the Baron and Baroness Von Wrangel, titled expatriates from Russia who were living in New York City and close friends of Helen's mother, were recruited as club managers. Because the camp was pretty much closed up during the war, except for the occasional renter, it needed a lot of elbow grease.

Waddy, Radford and Helen worked like dogs for weeks, scrubbing and vacuuming, cleaning and painting, while Charles the Baron watched them, a great long cigarette holder in his hand. Ten days before the opening, the Baron and Baroness announced it was all going to be too much, and they left.

The Baron's friend, Alexis, himself a Georgian prince, had agreed to be their chef and luckily remained after his friends had departed. Helen remembers him well. "Alexis was a wonderful cook, plump and marvelous," said Helen. "He didn't drink until 11 in the morning, after which he didn't stop. And he smoked. Incessantly."

Helen Murray on Placid Lake in her 1936 Chris Craft, the Squaw

COURTESY OF HELEN MURRAY

In spite of all this, their little club became quite chic and successful. For $3.50, the Moosehead Lodge served a buffet on Thursdays and Sundays that attracted up to 60 people. Because the lodge had no liquor license, it offered $.25 setups to members who stored their bottles in Menawa's boathouse bar. People sat everywhere, on the terrace, in the living room and dining room, on the fireplace hearth. "I don't remember setting up any tables," said Helen. "Everyone seemed to love the ambiance. And we enjoyed entertaining."

Indeed, Waddy, Radford and Helen had created a social scene of their own, separate from the Lake Placid Club and the Whiteface Inn on Placid Lake's western shore. Helen now wonders how all those people got there. "I suppose most of them had to be boated in by us," she laughed.

Years before, in the 1930s, the camp had a fleet of boats: two Chris Crafts and two older speedboats. In the Camp Menawa tradition, all the boat names started with the letter "S:" the *Scarab*, the *Sphinx*, the *Skinnamaring* and the *Skeezix*. The *Squaw*, a 1936 Chris Craft, was a much later addition to the fleet. During the era of Moosehead Lodge, Waddy and Helen were the only drivers; they made a lot of round trips every night, bringing guests to and from the lodge.

Helen remembers one frightening incident when she and Waddy were shuttling guests. Waddy was ahead of her in the *Skeezix* with his red stern light on, when suddenly a fog descended and the stern light vanished. Lost in the mist, Helen was in the *Squaw* with 10 strangers, all of who were becoming more and more anxious as the minutes wore on. After an hour of puttering around very slowly in circles, Helen was hopelessly lost. A woman seated next to Helen, who was at this point almost hysterical, took off her rings and popped them in her mouth, fearing they would float from her fingers as she headed to the bottom of the lake. Eventually, Helen found her way to the dam near the waterfall at the end of the lake and, once she realized where she was, followed the shoreline very, very slowly.

"I ended up back at Whiteface Inn where all the guests were grateful to be on shore," said Helen. "I never saw the lady with the rings at Moosehead Lodge again."

When it came time to add up the profits, Moosehead Lodge Club was not a roaring success. The club lost $5,000 the first year. Helen's mother saved the camp by paying the shortfall. The second year, the lodge lost another $5,000. That was a lot of money in those days and Helen's mother was not pleased. "Although we made her president of Moosehead Lodge, my mother didn't appreciate having to fund our project," said Helen.

After two consecutive years of financial losses, Moosehead Lodge Club was dissolved. The following summer Helen went back to work, tried to rent the camp, then put it up for sale with *Previews* in New York. Camp Menawa wouldn't sell. Waddy stayed in the boathouse until 1950, when he moved to Aspen, which eventually became his favorite location.

There were a series of years in the 1950s when Helen didn't come to Camp Menawa much. The camp continued to be listed in *Previews* magazine for $68,000—including the furniture, boats and accessories. Still, it did not sell.

The boathouse began to fall down, its chimney crumbling. The tennis court became overgrown. Helen tried to open the camp every summer for the two weeks of her vacation and the other weeks, she rented it out. In 1957 Radford and Helen divorced. She continued working for *Vogue*, trying desperately to put Camp Menawa out of her mind. "There was nothing else I could do."

Luckily for Helen, things changed for the better when she married Andrew Murray in 1961. In 1962, she retired from *Vogue*. Together, Helen and Andy opened the camp that summer and Camp Menawa was taken off the market. The following summer, Andy and Helen started restorations to the camp. Andy liked the Placid Lake lifestyle—shopping for brown eggs in Essex and sweet corn at the farmers' market, puttering around the lake in one of the wooden boats—always in a tie and blue blazer with a white handkerchief in his top pocket.

Until his death in 1993, Helen's brother, Waddy, continued to visit Camp Menawa for two weeks every summer. "I was fortunate that Waddy visited me so often, but I knew his heart was in Aspen," said Helen. "Waddy never interfered with my love for the camp, and he never forced us to sell. I know the arrangement we had was special, as was Waddy. There are many stories of siblings who own property together on the lake, who can't share or operate their camps without friction or argument. Waddy always knew that Camp Menawa was my anchor."

Helen's relationship with her camp and Placid Lake has remained unchanged for decades. The lake has never let her down, and in some ways is her true partner. Despite the challenge of keeping the camp over the years, she doesn't view herself as a savior of Camp Menawa. To her the description is unwarranted.

"I just feel very privileged," explains Helen. "I've been coming to Placid Lake every summer now since 1962—even after Andy died in 1996. For 82 years, my heart has been attached to this place. It gives me a sense of belonging. Lake Placid is where my roots are."

In this day and age, Helen Catchings Murray knows that values change quickly and continuity in life is often lacking. People are not always able to come to the same place year after year anymore. It's the reason Helen put her Placid Lake property into a life estate.

"I want to make sure Camp Menawa is protected and loved and cared for the way it has been," said Helen. "I want it to stay special."

Dear Mom (1941)

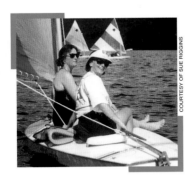

COURTESY OF SUE RIGGINS

SUSAN RIGGINS

My Mother Made Me Do It

Not long after the encounter with Helen Murray in the woods, Colt and I were invited to a cock-tail party at one of the camps on West Lake. As we walked through the camp's foyer, my eye was drawn to a pile of dark mink coats lying on a bed in the guestroom. I looked down at my hiking boots, and then at my husband's plaid flannel shirt. Clearly, we had taken the "casual" invitation a little too literally. Colt and I took a huge collective breath and walked in. The men were dressed in sports coats, most with a tie. The women wore heels, long skirts and gold earrings. This was the Adirondacks?

Our hostess introduced us as newcomers on the lake and several guests gave us a silent once-over. But not Edie Schneider. She walked straight over to me, shook my hand and started talk-ing, never once glancing down at my attire. I remember feeling an instant rapport and when Edie insisted I meet her daughter, I could hardly wait. Even though it was years before I final-ly had a chance to meet her daughter, Sue Riggins, we hit it off right away. No wonder. Her mother had paved the way.

Sue Riggins came of age on Placid Lake because of the impetuousness of her mother, Edie Schneider. The family first came to the area in 1955 to visit Sue's brother, Ralph, who was working as a lifeguard at the Lake Placid Club. The family stayed at Camp Cavendish with the Barrett's from Garden City, Long Island, the Schneiders' hometown. It was Sue's initiation to the lake.

Sue was only five or six years old, but she remembers running around in the woods and jumping in the water. "It was a blast, the perfect combination of adventures, so of course I got hooked on life at the lake," remembers Sue. After two or three summers the family wore out their welcome at the Barrett's, so they rented the Frank camp, renamed Camp Schnook by the Schneider's and their friends, the

Cook's, who stayed there together. In the summers to follow, the family rented the McNealy camp and Breezy Point, also on the lake.

During the summer of 1963, Sue was sixteen and in love with one Lake Placid Club caddie or another. "It was such a good idea to import those cute caddies to date Club members," she laughs. "Of course, I wanted the summer to last longer, so I managed to convince my mother to stay into the fall." However, the lease at Breezy Point was about to run out, so Edie called Mrs. Maloney, the owner of Covewood Lodge next door, who said, "Covewood is empty through Labor Day. I won't charge you rent. Maybe you'll like it so much, you'll make me an offer."

Covewood Lodge is wrapped around a sheltered bay on the east shore and is so close to the water you can hear waves lapping against the rocks from every room in the house. The main floor is at ground level and the second story is not very high, so the sounds and smells of the water are very immediate and become an intimate part of your personal landscape. The minute you walk into Covewood, you feel a connection to the lake, one that doesn't exist in camps that are set farther back from the water's edge. Although it is only a 20-minute walk to town, the camp is secluded and quiet, with all the charm of a bygone era. Not surprisingly, Sue and her mother fell in love with Covewood that August.

When Sue's mother returned to Garden City, she sent Mrs. Maloney a thank-you note, enclosing—on a whim—a check for half the asking price. When she received notice that the check had been cashed, Edie experienced a sense of buyer's remorse, mainly because she hadn't bothered to tell her husband about the offer. His reaction was not unexpected. "Edie, what have you done?" he asked. Sue told her mother not to worry, just to put the camp in her name. Needless to say, Edie didn't think it was such a good idea for a 16-year-old to have title to an expensive piece of real estate. "Mom had a rough winter, answering lots of questions from dad and friends," remembers Sue. "But by spring, when we all got here, no one had any more objections. And no one's ever questioned her judgment since then."

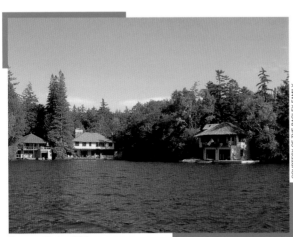
Covewood Lodge, 2003

COURTESY OF THE BAGLEY FAMILY

Covewood was built in 1926. There is a picture of the camp from the lakeside in a "post card book" published years ago. The photo shows the visible sides of the house surrounded by lake. "No wonder we've always had water under the house," says Sue. Additions to the camp were most likely made in 1939 because the family recently found crumpled *New York Times* papers from that year in the insulation. The house was redecorated in 1948 (Sue still has the 1948 operating manuals for the kitchen appliances!) and has not been redecorated since.

In the 1970s, roofers working in Covewood's attic found a curious contraption—a candleholder in a shallow wooden box filled with tinder, with its candle burned down to an inch of the kindling. Apparently, Covewood Lodge had been burglarized in 1962 and the Maloney's were so upset, they put the camp on the market. Perhaps the burglar lit the candle to give himself time to get to a public place and create an alibi? Maybe he wanted to burn the camp down after he burglarized it? Maybe he was someone known to the Maloney's? All of this is speculation, but the candle and its story have become part of Covewood's folklore.

Burglars notwithstanding, the Schneider family settled in and Edie set about making Covewood home. A natural-born hostess, Edie loved to throw parties. There were many noteworthy evenings at camp, but

Sue remembers one particular event most vividly. "Now we can't have too many people in case it rains," Sue remembers her mother saying. "Covewood isn't big enough."

In the end Edie invited more than 200 people. Of course, it rained that night. The Schneider's moved all the furniture out of the living room and the fireplace bedroom upstairs and set up a bar on each floor. With all those people milling around, a beam broke under the living room and the weight of so many guests caused the floor to give way. The floor caved in a full foot, but no one left. "They just moved to another room and carried on partying," remembers Sue. "Or, they stood against the wall for the rest of the party. Mom loved it," said Sue. Unfortunately, as a result of the weight of the party guests, the floor was turned into a trampoline until it could be replaced the following fall with stronger, pressure-treated lumber.

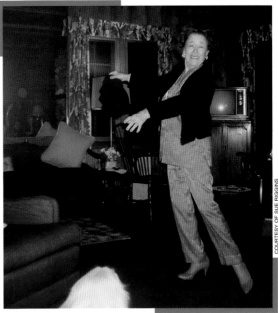

Edie Schneider dancing in Covewood Lodge's living room, 1986

Edie Schneider also loved to shop. One summer, she went to a bazaar at St. Agnes Church in the Village of Lake Placid and came home all excited about her new purchase. She'd found a set of beautiful dinner plates, 24 of them—just like the ones she'd had before she was "robbed" the summer before. Sue recalls her mother's famously selective memory: "It was ridiculous of course; we'd never been robbed," said Sue. "It was the *Maloney's* who were robbed." And their summer housekeeper, Anne, could hardly contain herself. "Mrs. Schneider," she said, "those are the plates you told me to donate to the church last fall." Edie was nonplussed. "I knew I liked them," she said and walked out of the room, putting a definitive end to the dinner plate conversation.

Placid Lake was the scene of many rites of passage for Sue. Back in Garden City where she'd been president of the student council, Sue was known as a serious student and a very conscientious young woman. She always tried to plan ahead, think things through and do a good job at everything. But when she got to Placid, Sue was a free spirit.

"Growing up on the lake was 99% fun for me," said Sue. "Luckily for me, my mother pretended not to notice the things we got up to at the lake. Most likely she knew what we were up to, and I think she secretly approved. I was pretty much a dork back home in Garden City. I could be much cooler on the lake."

Sue liked being on the lake a lot better than she liked the Lake Placid Club. "I have some good memories, but I miss it less and less," said Sue. By then, Sue was becoming aware of the Club's tradition of anti-Semitism and racism and finding it increasingly awkward and embarrassing not to be able to invite her Jewish friends to the Club's golf tournaments. She also remembers how angry her father became when one of his Jewish friends was turned down for Club membership.

Sue spent her early summers at the Club's day camp where there were planned activities, and she remembers most of them were fun. But the day camp counselors "made" her climb Cobble Hill, which she hated—except for the cold cheese sandwiches that were served at the top of the mountain. "The only reason I climbed in the first place was to get one of those sandwiches."

Sue also remembers climbing Cascade Mountain at the age of 16 and still hating the experience. "And Cascade is one of the easier mountains in the area," said Sue. "I was practically 20 years old before I could stand to climb any mountain—anywhere."

Sue's best friend in Garden City, Martha Beebe, and her family also had a camp on East Lake—a lot of Garden City families did, including the Barrett's in Camp Cavendish. Martha called Sue "Susu" and Sue called Martha "Marf," nicknames that have affectionately stuck, even today. Susu and Marf met at a birthday party in Garden City when Sue was five or so; their parents knew each other. Marf and Susu discovered they had a few things in common, including pesky older brothers. "The second thing we discovered was we were both much more 'with it' in Lake Placid than we were at home," remembers Sue. "When we weren't on the lake, we were at Lawrence Beach on the Atlantic shore of Long Island, about half an hour from where we lived. It was an uphill battle to be cool in Lawrence Beach, but Placid Lake was always fun."

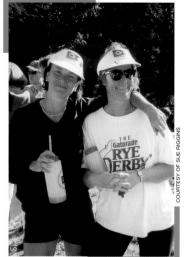

"Marf" Knowles and
"Susu" Riggins at a Clamato Regatta, 1994

As a teenager, Sue had a midnight curfew most nights, but she would often climb out her bedroom window after she came home to meet Marf and Marf's brother, Jack, who were waiting in the woods. The three teens would make campfires and drink smuggled beers. During the day, Marf, Sue, Jack and their friends would water ski until they were exhausted. Whoever won the coveted Tri-Lake Interstate Water Ski Championship every afternoon was usually the one who had consumed the fewest beers. "My mother used to watch me swagger tipsily into the kitchen at four in the afternoon and ask 'Why don't you take a nap, dear?'" she laughs.

Marf and Susu hung around with their friend Ned Scudder a lot. It was Ned's idea to "steal" Shea's delivery truck. Ned had a key because he'd worked as a delivery boy for Shea's Grocery that summer. Marf, Susu and Ned followed the truck on its rounds, waited until the new delivery boy was at the door, ran up and moved the truck 20 yards down the road, then hid in the bushes. "We'd follow him around his entire delivery route, moving his truck every 10 minutes, driving him crazy," laughed Sue. "When we got tired of that charade, we painted giant footsteps on Victor Herbert Road going backwards up Signal Hill."

One day, Sue and Marf dreamed up the idea of an "Indian" raid on the *Doris*, the sightseeing boat on the lake. Together with a dozen friends, Sue and Marf rounded up a fleet of wooden canoes and anchored them at the Beebe family's dock, the designated meeting place. With feathers leftover from their Friday night campfires at the Lake Placid Club, they disguised themselves as Senaca and Mohawk warriors. The teens fashioned tomahawks out of cardboard, armed themselves with an arsenal of rubber knives and painted war paint on one another. "And drank firewater, of course—most of the events were drinking events in those days," added Sue.

Jay Rand, and his friend, Mike Raymaley, worked that summer as drivers of the tour boat. Jay and Mike were friends of Sue and Marf, and in cahoots with the whole plan. When the "Indians" paddled out to the *Doris* in their war canoes, Mike and Jay cut the engine and threw ropes over, allowing the "Indians" to board the *Doris*. A lot of New Yorkers were on the tour boat, and at first they were frightened and alarmed.

"We were doing war dances on the roof, hooting and hollering like the 'Indians' we were pretending to be," said Sue. "Then the tourists started saying 'Hold it, sweetie, let me take your picture,' while we danced around trying to look fierce." As the *Doris* cruised into the harbor, its owner, Fred Schwartz,

came out of his office, cursing and shaking his fist. "He was not pleased," Sue remembers. The "Indians" dove off the *Doris* and swam out to their parents, who had driven their boats out to the rescue. "Our parents thought it was pretty funny," said Sue. "When I look back on it, we were given a lot of slack." Later, Fred Schwartz was heard to remark that regular "Indian" raids on the *Doris'* daily excursions might be good for business.

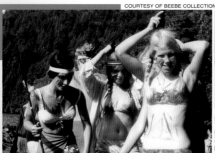 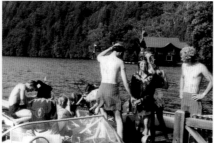 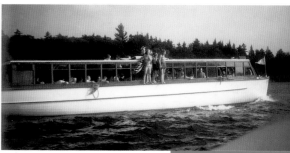

The "Indian raid" on the Doris II, 1969

Marf and Sue's next adventure, a sailing race, was another excuse to drink. Marf and Sue raided their parents' liquor closets and scrounged up a couple of bottles of Clamato juice for Bloody Marys, hence the name of the race was coined—the "Clamato Regatta." Sue and Marf made jugs of the stuff and invited a handful of east shore families to Covewood Lodge. "I was captain of the committee boat because I had cramps that day and couldn't sail," said Sue. "It was my job to hand out the cocktails when everyone came around the first buoy. My little sailfish won the first annual Clamato Regatta without me."

A hundred years earlier, in the early 1900s, the Lake Placid Regatta was an established and elaborate sailing contest between members of Whiteface Inn and guests of the Ruisseaumont Hotel. Around 1942, the once-popular race started to fizzle out, and by the end of World War II, it had ceased to exist. By starting up the Clamato Regatta in 1976, Sue and Marf were unwittingly carrying on the spirit and essence of the original Lake Placid Regatta.

Today the Clamato Regatta, now renamed the Lake Placid Regatta, is no longer an East Lake activity; it is a full-blown annual Placid Lake tradition enjoyed by the entire lake community. From all sides of the lake, some 40 to 50 boats and their sailors/captains gather the day before Labor Day to race around three strategically planted buoys. There is a barbeque, an awards ceremony, and, of course, gallons of Bloody Marys, all made with Clamato juice, now purchased, but at one time donated by the race's sponsor, the Mott Company.

Over the years, Sue learned to play tennis and eventually became a 10-handicap golfer. She sailed, swam and water-skied. She got into downhill and cross-country skiing. Even High Peak climbing. "I feel very lucky and privileged for this life," said Sue. "And somewhat guilty, because I feel sorry for anyone who couldn't grow up here. The Maloney's came to visit us last weekend for the first time since we bought Covewood from them. I was apprehensive, because I ended up with this place and they didn't. But they were lovely people with a perfectly lovely life. Although I still can't see how is it possible to have a perfectly lovely life without being on the lake."

In the 1970s, Sue's father became ill. He spent his last years enjoying Covewood and Placid Lake with his wife, Edie. "The two of them would hold hands and sit on the deck chairs watching the lake and the stars at night," remembers Sue. Sue's father died in June 1980. Sue's husband at the time, David (the father of her daughter, Tonia), and Sue took more time to be with Edie that summer. 1980 also marked the waning days of the Lake Placid Club. By then, the Club had declared bankruptcy, but John Swain, a

Sue Riggins relaxes on Covewood's porch

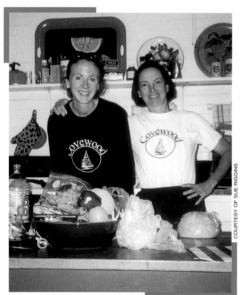
Tonia and her mother Sue in Covewood's kitchen

Florida land promoter (who was eventually indicted and convicted of a number of fraudulent selling practices), was trying to keep it alive by selling timeshares. Swain also was promoting amenities that went along with the timeshares, such as live entertainment at the Club.

A singer/musician/comedian from St. Petersburg named Kim Charles was working in the Lake Placid Club's *Adirondack Room.* One night Sue's friend, Lou Higgins, suggested she go hear Kim perform. Lou was living in Lake Placid year round and knew everything that was going on in town. Little did Sue know how that one suggestion would change her life.

Sue became friends with Kim—and his wife. What began as a rather sad summer for Sue ended up being quite momentous. Kim and Sue became attracted to each other. "Can't we just sneak off together?" Sue finally asked Kim one night. "Everyone knows me," he said, which they both knew was a solid "no." After an equal amount of soul-searching and marriage counseling, Sue and Kim decided their respective marriages had been dead for years. Six months later, Sue and Kim both separated from their spouses and began their new life together. "Kim made me realize there was more to life, and that I wanted that life to be in Lake Placid," said Sue.

After David and Sue divorced, Sue moved her daughter, Tonia, and all their belongings out of Philadelphia and headed for Lake Placid. Sue enrolled Tonia in the local nursery school, and the two of them moved into the boathouse at Covewood with Edie. "It was the best decade of my life," remembers Sue. "Not only was I living with this romantic, fantastic guy, I had my daughter and mother with me too." And, a job in the Village of Lake Placid as the chief financial officer of the Olympic Regional Development Authority.

It was a very happy time for Sue, but unfortunately for Kim, by 1983 the Club had met its demise and there weren't many opportunities in the area for him professionally. For a while, Kim played piano for dinner guests at the Woodshed, a local restaurant in downtown Lake Placid. Eventually, Kim and Sue moved with Tonia to Florida. Sue found work as the CFO of a real estate development company that eventually went bankrupt. Sadly, Kim died in St. Petersburg at the age of 40, the victim of alcoholism. "It was the risk of being in the entertainment business," said Sue. "But he was wonderful. Kim was an angel."

Sue's last years with Kim were difficult. After Kim died, Sue once again returned to Placid Lake to be with her elderly mother. When her mother died in 1993, Sue's life ground to a halt. She didn't know what she would do next. All she knew was that she wanted to stay on the lake. "But I looked around the camp and thought, 'Oh my God, what a lot of work.'"

Sue and her brother, Ralph, met that spring, as they now do every year, to discuss Covewood's operations. "I wanted to prove to Ralph we could keep the camp," said Sue. The first year they rented it out and there was a lot to do before the renters arrived. In June, Sue moved into the boathouse to make room for the renters. "I was their next-door neighbor for the summer," remembers Sue. "The boathouse is so small and confining that I spent a lot of time out and about that summer, reconnecting with a lot of Placid Lake buddies."

After that summer, Ralph and Sue worked out a budget and figured out how much they had to spend on the camp each year. Little by little they made the necessary improvements, spending their summers at Covewood, without having to rent it out again. In the last 10 years, Sue and Ralph have redone every floorboard and every beam. They've re-mortared the stonework, repainted the walls and rewired the electricity. "We do some of the work ourselves and are well into restoring the second floor now," Sue said proudly.

Thirteen years ago, Sue remarried and now spends half of the year in St. Petersburg and the other half on Placid Lake. "I know people always say that their home has the 'best people' and 'ours is the best;' it's human nature," said Sue. "But I really believe that about Placid Lake."

Covewood Lodge continues to be the place where Sue comes to shape her identity. "Some of the best times of my life have been here with my daughter, Tonia," said Sue. "My mother loved it up here, and I love it much more than she did. And, Tonia loves it more than both of us put together."

Now that Sue can spend more time on the lake, she has become more involved in the community. For several years she served as treasurer of the Lake Placid Institute and is active in the Lake Placid Center for the Arts. She supports the Placid Lake Foundation and the Adirondack Park Agency, both of which are working to preserve the land. In July of 2004 Sue will become the president of the Lake Placid Shore Owners' Association.

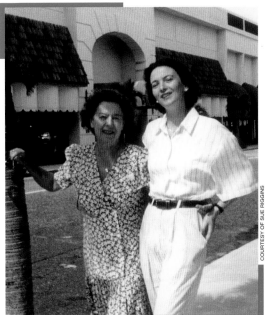

Sue Riggins and her mother, Edie, in Palm Beach, Florida, 1989

"When I drive through North Carolina, I feel sorry about their high-rise condos and their billboards and car heaps," said Sue. "I don't want a 10-story monolithic condominium on the top of McKenzie Mountain. We used to shampoo our hair in the lake and dump our construction debris overboard. We weren't very enlightened. Now we pay eight cents a pound to dredge our old dock supports rather than leaving them to pollute the lake. And, we fight those developers who care about personal profit and nothing else. We have to save the lake, if only for our offspring."

Sue Riggins believes these battles are worth fighting. And, if she decides to spend even *more* time on Placid Lake, chances are Sue will continue to be a force to be reckoned with.

"If my mother, Edie, were still alive, she'd be doing the same thing," said Sue. "Edie would be stirring it up and fighting the good fight. I'm sure of it."

Always Yours (1944)

COURTESY OF THE DIVINE FAMILY

DIDDY SCHOONOVER AND SUSIE DIVINE

Who Inherits What

After the encounter with the mink coats, Colt and I consciously avoided cocktail parties on Placid Lake for several summers, and concentrated on entertaining our family and friends at Camp Midwood. We ran a self-contained little compound, littered with children of assorted ages who usually could be found in or near the water. One August day, we were hosting a marathon water ski session when one of our young guests managed to chip her front tooth in a spectacular fall. After a series of flustered phone calls, I located the name of a local dentist, Joe Schoonover, who also happened to live on the lake at Unterwalden, on the north side of Buck Island. We whizzed our patient over to Unterwalden's dock and were greeted by Joe's smiling and effervescent wife, Diddy.

It seemed like every time I ran into Diddy after that, she was always smiling.

And then, several years later, her daughter, Ketti, died, in an airplane crash. To her credit, Diddy is still smiling. The laugh lines are still there, but there is a sadness in Diddy's eyes that never goes away, and also an unwavering compassion—as if she understands your discomfort with her daughter's death, your reluctance to open old wounds, your incapacity to talk about it.

Diddy Schoonover and Susie Divine are sisters-in-law who summer in camps with no road access, on the edge of the water. Diddy can't see Susie's Camp St. Armand from her camp, Unterwalden. But that doesn't matter—Diddy knows every inch of Camp St. Armand with her eyes closed. Diddy's parents, B. Dalton and Norma Divine, purchased St. Armand in 1947, and Diddy summered there with her family for almost 40 years.

The Divine family first came to the Whiteface Inn on Placid Lake in the early 1940s. In 1945, they rented Camp St. Armand, then purchased it two years later from Stanley Wilcox, who himself had purchased it from the Dangler family in 1925. Henry and David Dangler built the camp around 1906 after buying the land from the Leggett family. All of the existing buildings are original.

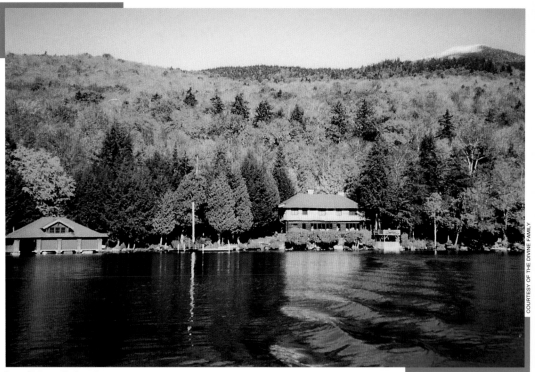

Camp St. Armand in the autumn

Although it was remote and isolated, Diddy loved growing up at Camp St. Armand, especially because it was so close to the water. "We could all swim very early on and I basically lived on the lake," remembers Diddy. By the age of five, Diddy's ability to swim to the island and back qualified her to drive a boat. At age 10, Diddy was showing off on one ski in front of the Doris. As the smallest teen on the lake, she was often the top skier in a human pyramid.

For entertainment, the Divine family used to build ski jumps all over the lake and ski over them dressed in formal dresses and tuxedos. "We'd put a chair on a piece of board, stand on one leg and get pulled around the lake behind our wooden boat called the *BDD*, my Dad's initials," said Diddy. You didn't need a license to drive a boat in those days. Diddy learned to drive a boat on a huge inboard, despite her small size. "My parents never once denied me the privilege of driving a boat. I lived on the lake. I knew every boat by the way it looked and the sound it made."

During her teens, Diddy started to feel constricted by the camp's isolation. Her parents wouldn't allow her to go to girls' camp. "Dad couldn't understand why anyone would possibly want to go to a camp when they already had one." Diddy wasn't allowed to get a job and she was pretty lonely as a teenager. During the day she would go to the library to get books. At night she'd read them. Unlike other teens, Diddy wasn't one to hang out in town—this was the era before the disco Sassafras and the movie theatre at George & Bliss Marina became fixtures on the lake.

"I had no social life," said Diddy. "Every so often I'd have a friend up for the weekend. That's it. It got very lonely." The Divine family was not part of the Lake Placid Club at that time, so Diddy didn't have the built-in friends that Club life brings. "My mother used to like to be taken by boat to the Whiteface Inn and its beauty salon and dining room," said Diddy. "The inn wasn't as grand as the Club, but it was prettier. I'd tag along on the shopping runs and meet a few of the local kids who worked at the inn."

Diddy now looks back on those years as fortuitous ones. "I'm lucky I was lonely, because I guess it motivated me." A few of Diddy's friends from New Hartford worked at the Lake Placid Club. Diddy would meet them after work. You weren't supposed to fraternize with the help—it was another of Dewey's rules—but Diddy did. "I'd drive myself back and forth at night in the *BDD*," said Diddy. "The night watchman at George & Bliss Marina and I became good friends. I used to sit on the dock and talk to him until the fog lifted." Diddy soon realized that most of the other kids her age on the lake didn't have as wonderful a life style as she did on Placid Lake.

After Diddy met Joe Schoonover in 1959, she introduced him to Camp St. Armand. "There was a big Labor Day bash—that sold him on the lake," Diddy recalls. Joe, a dentist from Andover, Massachusetts loved Lake Placid and Placid Lake (and Diddy) so much he considered moving his practice there in the early 1960s, after they were married. On the advice of Diddy's local Lake Placid friends who told Joe he'd starve to death for lack of business, Joe and Diddy decided to postpone the move and just continue to summer there instead.

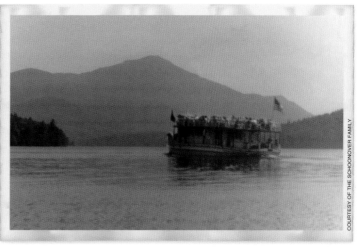

Sightseeing boat Doris I on Placid Lake, taken from the dock at Camp St. Armand in the summer of 1948 by Scott Garfield. The Doris I was taken out of commission at the end of the 1949 season and replaced by the new Doris II which was launched in July of 1950

For years Diddy and Joe—and eventually their four girls—shared the camp with the Divine family, alternating the months of July and August with Diddy's brother Lees, his wife Susie and their growing family. In 1976, Diddy's father B. Dalton died. Diddy's mother Norma died in 1982. The following year Diddy learned that her brother Lees—alone—had inherited Camp St. Armand. She does not admit to being furious, betrayed or bitter. But she does remember being disappointed.

"I wasn't shocked," said Diddy. "Just disappointed. When I started looking around for another place on Placid

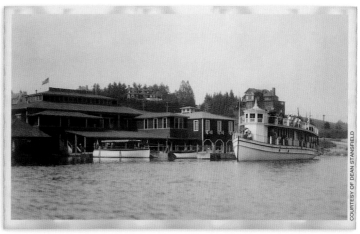

George & Bliss Marina, circa 1930

Lake, I realized how spoiled I'd been at St. Armand. Joe and I wanted to be right on the water, close to shore, in a camp with no road access. Just like St. Armand."

That kind of property wasn't easy to find. It took Joe and Diddy awhile, but eventually they bought Unterwalden, part of the old Highwall compound. The original owner, William Sumner Benson, had built Unterwalden for his daughter, using stone from an overgrown quarry on the back of the property. Joe and Diddy bought the camp from its previous owner, Bernie Connors, who wrote the novel *Dance Hall*, a fictionalized version of the tragic death of Anna Mabel Smith Douglass, the First Lady of Placid Lake featured in the foreword of this book. (The true account of her death and discovery was

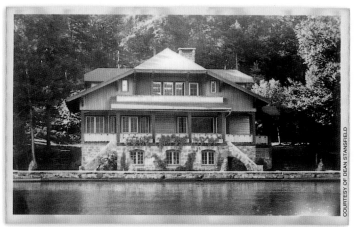

Camp Unterwalden, circa 1935

Diddy with her dog, Cassie

told in George Christian Ortfloff's 1985 book, *A Lady in the Lake*.)

"That's a little history for you," said Diddy. "And, we're lucky to have the footprint of Unterwalden, the way it sits on top of the water. Nowadays, you couldn't build this close to the lake." The shoreline of Placid Lake goes right under the middle of Joe and Diddy's living room—they are literally living on stone fill. When she sits on her front porch, Diddy has a view of the lake from all three sides of the house. To the rear of Unterwalden are acres of woods, just as there are in her old Camp St. Armand. (In fact, Unterwalden means "among the woods" in German.)

About six years after they purchased Unterwalden, Joe and Diddy decided to move permanently to Lake Placid. They purchased a house in town and Joe started his dental practice all over again. Their four daughters went away to school—triplets Karen, Kirsten and Ketti to Philips Academy, and older sister Kim to Andover—but they returned each summer to Unterwalden. "They have always considered Lake Placid their home," said Diddy.

After college the triplets settled in Seattle and Kim moved to San Francisco. In 1994, tragedy struck the family when Ketti was killed in an airplane crash. "It was nine years ago, but I'll never get over it," said Diddy. "We scattered her ashes on Whiteface Mountain and at our camp. Ketti loved the sports here. She was a terrific athlete—a triathlon cyclist. She loved the High Peaks and the lake. This was her place."

After Ketti's death, Diddy's girls gradually moved back to the Lake Placid area. All of them live close by now, in nearby Burlington or Malone, and, together with their own children, often join Diddy and Joe at Unterwalden. This is what is important to Diddy—that her family is nearby. The fact that the family now gathers in Unterwalden, rather than Camp St. Armand, seems immaterial to her. "The girls know Placid Lake is the closest thing to heaven—and Ketti—that they can get," said Diddy.

It took Colt and me seven years to venture out to another Placid Lake cocktail party and this time we were rewarded for our efforts. By now, the glamorous attire formerly associated with a typical Lake Placid Club cocktail party had started to disappear a little. The guests didn't come in hiking boots, but at least they weren't wearing four-inch Gucci shoes. We heaved a collective sigh of relief when we walked through the door. There was a woman in a chic pants suit, no diamonds. There was a man with a sweater and tie, but no blazer. Whew. This felt more like our idea of the Adirondacks.

I recognized one of the women there, but I didn't know her. I had seen her boat, the Susie, almost daily, as it traveled along West Lake, past our dock, through the straights and into the marina. The boat's owner turned out to be Susie Divine, the sister-in-law of Diddy Schoonover and the inhabitant of Camp St. Armand. The thing I remember most when I met Susie was her smile. I almost always see Susie smiling.

Shine On Harvest Moon (1941)

Susie Divine

When Susie Divine first arrived on Placid Lake as a young bride, she wasn't sure what to think (though I'm sure she was smiling). Susie had been a little reluctant about coming to the Adirondacks in the first place. Camp St. Armand is located on the west shore of the lake and is accessible only by boat—or by hiking in on the long trail from Whiteface Inn. Susie had grown up on the seashore in Cotuit near Hyannis, Massachusetts, where everything was open and bright. Cotuit held all her childhood memories. Susie felt comfortable in that community.

Susie loved the open sea, the salt water and the quaint Cape Cod towns. When she came to Camp St. Armand in 1960, all she saw were wall-to-wall trees and windows blocked by cedar trees. "There was no light," said Susie. "I felt very claustrophobic in the woods. I thought it was silly to drive around and around in circles on so small a body of water. Where was the open sea?" Susie found the smells foreign,

the woods frightening, and the water too cold. She didn't know anything about Placid Lake and wasn't sure she wanted to. It all seemed pretty foreign and she wasn't comfortable at first. "It was a real adjustment for me," said Susie.

But this was where the Divine family spent their summers, and Susie ultimately would do the same. As the family's new daughter-in-law, she worked hard to live up to the family concept of life on the lake. "I remember being taken around the lake and introduced as the new bride at all the cocktail parties," said Susie. "We were always the first to arrive and the first to leave—just when things were starting to get fun." In the Divine family, the dinner bell rang exactly at seven every night. There was live-in help to serve the formal dinners, to bury the ice in the sawdust and keep the coal-burning hot water heater going in the kitchen. Life was pretty formal and structured.

Susie wasn't used to life without a road. She couldn't just run down the street to visit a friend, play a game of tennis, or buy a bag of groceries. With four kids in tow, there was always a ton of things to haul in and out of camp, all of it by boat. Everything was planned in advance, as transportation was a big issue. Since the only way in and out was by water, it was crucial that the fleet of boats be kept operational. And critical that there was always someone around who could drive them. Her mother-in-law didn't drive a boat and had to rely on the staff. Her father-in-law was uncertain of Susie's boat driving skills. "I was new on the scene," said Susie. "I can understand his concern."

Over time, Susie learned to drive the wooden boats and negotiate the lake. Slowly she became used to the woods. In the 1970s, Susie's mother-and-father-in-law gradually began relinquishing control of the camp, mostly because of illness. Susie and Lees, together with Joe and Diddy—all of them part of the next generation—began making changes. They cleared out trees and cut away branches, opening up spectacular views of the lake. They converted a maid's house into a guesthouse and rebuilt a playhouse to accommodate their growing families. They shored up the porch and painted the windows a brighter green. Later, a deck on the playhouse and a barbeque pit for campfires and clambakes were added.

Still pining for the ocean, Susie would pile her young children in the car and take them to Cape Cod for a week to give them a taste of the seashore. "I'm not sure any of them would remember that now," said Susie. "Today, they're all died-in-the-wool Lake Placid fans."

Gradually, as she let go of her memories of the seashore, Susie started to adapt to life on the lake. She eventually got motivated to climb the High Peaks with Lees and her four children. "I hated the bugs, but once I got to the top of those mountains, I was hooked," she remembers. Lees restored a 1946 Chris Craft runabout and renamed it the *Susie*. It became one of Susie's favorite pastimes to drive the boat to the village each day.

When Lees inherited the camp in 1983, Susie was in the tenuous position, through no fault of her own, of living in a house she had not only shared with her sister-in-law, Diddy, but also inheriting, via her husband, Lees, the house where his sister, Diddy, had grown up. It must have been difficult for Susie and for Diddy. The fact that both women were drawn to the lake and had close-knit families, helped.

"The Divine family were members of the Lake Placid Club, but it was not their main focus," said Susie. "The lake was. Our social life was—and is—centered on family and friends."

Susie and Lees now have family here year-round. Family members come up from Barneveld, outside Utica, even during the off-season. Diddy and Joe have a place in town, and Susie's brother, Al, and sister-in-law, Elaine, bought a house in Lake Placid in the 1980s. Susie's cousin, Tom, and his wife, Barbara, spend a lot of time there. With increasing numbers of grandchildren, Susie and Lees share great family

time together, especially the cookouts around the campfire. "I love watching my grandchildren grow up here," said Susie. "As soon as they learn to swim I'm overjoyed—I don't have to worry so much about them being near the water."

Over the years, Susie and Lees have had their share of camp-related adventures. One August night, it was a hot evening and Susie and Lees had left the kitchen door open to let in the cool night air. Lees awoke to hear thrashing and the crashing of falling objects. He made a tour of the camp in pitch-black darkness. As Lees passed the fireplace, he grabbed a poker as a weapon—just in case.

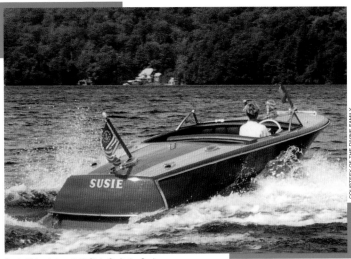

Susie Divine in her 1946 Chris Craft, the Susie

When he got to the back stairs leading to the kitchen, he turned on the lights and called for Susie. The kitchen had been completely trashed. The microwave was in the middle of the floor, along with overturned spice racks, garbage cans and the trampled contents of the refrigerator. "The next day we saw the bear tracks," said Susie. "Needless to say, I now lock the kitchen door every night."

Susie is convinced a ghost haunts the Divine camp. The ghostly visits started in the 1970s when Susie was in camp with girl friends. The women would come up to St. Armand during the week and their husbands would join them on the weekend. The first night at camp, one of Susie's friends heard a noise in the house—the heavy front door opening and shutting, another door opening and shutting. She got up and searched the camp, but couldn't find anything. So she let it go. The next night Susie heard it—the same sequence of doors opening and closing. Someone seemed to be in the house.

Aftermath of a bear's uninvited visit to Camp St. Armand's kitchen

When the men arrived that weekend, the women told them what had happened. The men laughed and teased. Sure enough, later that night, Lees heard the same sounds. "His hair literally stood on end," said Susie. But again, there was no trace of anyone.

Theses mysterious noises continued off and on for 10 years and occurred even when Diddy and Joe were at camp. "They were as mystified as we were," said Susie. "We never really knew what happened

Diddy and Joe Schoonover, Susie and Lees Divine

and we never found out who was causing the commotion. Whoever it was never harmed us, or disturbed anything. So we concocted the Ghost of Bill."

As mentioned, Bill Wilcox was the former owner of Camp St. Armand. After he was discharged from the Army in World War II, Bill returned to St. Armand for a while. When he went back to Staten Island, he dropped dead of a heart attack. The Divines convinced themselves that Bill had came back to check on his camp because he had died so suddenly. So far, Susie has not reported feeling the presence of either of the camp's previous owners, Henry or David Dangler, or the Leggett family.

Despite these two episodes, Susie feels secure about staying at the camp with her dog when Lees is working down in Barneveld. She concedes she has come to feel comfortable at St. Armand through a process of osmosis. The more often she came, the more at ease she felt. Susie will never get the love for the sea out of her veins, but she knows she can always go there. "I've come to appreciate the beauty and magic of the lake," said Susie. "The camp is a counterbalance to my busy life. I really unwind when I get here."

When her knees were younger, Susie enjoyed climbing the High Peaks. But she still loves to swim in Lake Placid. "The water is like velvet on your skin," said Susie. She swims all summer long and no longer thinks 64 degrees is cold. "I lie—I would really love it to be 75 degrees, but still, I swim every day," she said.

For Susie, the lake is most magical at night, when it is calm and still. At night, Susie can see the silhouette of Whiteface Mountain and the moon hanging over Moose Island in the reflection of the lake. "I love it when the moon comes up and the stars are bright," said Susie. "There's a path of gold on the lake that leads you right up to the moon."

Susie also loves the romance of camp, being so removed from the hustle and bustle of daily life. The Divines don't have a television and never listen to the radio, so they aren't influenced by the news all summer long. To Susie, there is purity in that silence. "And did I tell you the loons are back?" she asked.

It took almost 30 years to transform Susie from an ocean person to a lake person. Now that she has a sense of ownership and a connection with Camp St. Armand, it finally feels like home to her. "I have pictures of our camp on the walls back in Barneveld," said Susie. "I carry around my little balsam pillow, so I can remember the woodsy smells of Placid Lake."

The main reason it feels like home to Susie is family. "Looking back, it wasn't an easy life here," she said. "We've had our ups and downs, and our tragedies. When Ketti died, our families pulled together. It was such a horrible thing. And Diddy's been so gracious, making me feel comfortable at Camp St. Armand. I never know how to thank her enough. I painted Diddy a little watercolor of Unterwalden for Christmas. I hope she likes it."

Until Then (1965)

MARGO FISH

Stone by Stone,
One Log at a Time

Before the road became clogged with trucks, I used to run the three-mile loop of Whiteface Inn Road, on the backside of our property. There was only the occasional heart-in-throat moment back then, when a solitary car drifted over the middle yellow line. These days you take your life in your hands to venture that road on foot, either walking or running. In the last eight years, dozens of condominiums and homes have sprung up like giant weeds along Whiteface Inn Road, fertilized by advertising, a buoyant economy and developer money. Construction trucks thunder by, belching a nasty stench in their wake. Delivery trucks zoom in and out all day, thanks to the renovation of the nearby Whateface property. Camp Midwood is no longer in the "middle of the woods."

Often, when I ran, I would see the same woman running on the same circuit. She was older than I, but in better shape, blond, and faster too, despite the fact that she carried a plastic bag filled with litter and trash. I used to marvel at her technique for swooping up gritty beer cans and grimy MacDonald's© containers without loosing speed, barely slowing her pace. I didn't know who she was until I went to a Lake Placid Shore Owners' meeting one July afternoon. The same lithe, blond, woman stood up and delivered a passionate plea to save a stand of trees about to be sacrificed at the hands of a local developer. It was Margo Fish, champion of the environment, conscience of the community and trash collector extraordinaire.

Mac Fish proposed to Marjory (Margo) Evans near the dam on the south end of Placid Lake. Margo was 15 years old. It was 1945. Margo had just arrived by train from Erie, Pennsylvania, after accepting a written invitation from Mac's parents to visit Camp Red Wing on the west shore of Placid Lake. World War II was still on and gas was rationed, so Margo and her friend, Mary Mueller, took the train up through Utica. It was a major event in their young lives, traveling by train, unescorted.

Camp Red Wing's boathouse in the mist

The two girls arrived at the Lake Placid railroad station where Mac met them in a black limousine—at that time the only taxi in town. There was no road to the camp, so the taxi took them to George & Bliss Marina. From there, Mac, Margo, Mary and their luggage were transported across the lake in Red Wing's wooden Chris Craft. "I felt as though I was entering a fantasyland," said Margo. "The lake was all silvery and clean, and the camp was so cared for—it had these wonderful feathery mattresses."

In the morning, there were fires in the kitchen stove and fresh fish from the lake for dinner. At night, Margo and Mac and the family would gather in the boathouse to look at the stars. "We never thought of going anyplace else," said Margo. "The lake was so magical."

For a girl of 15, there was something else magical about the lake. "I was deeply in love with Mac," said Margo. "Mac and I sat on a big rock after walking across the dam; we loved to jump and leap over the stones. He kissed me on the lips. It was so tender and gentle. We were so innocent."

That week Mac asked Margo to marry him, after they graduated from college. Until then, they would be connected through their favorite song, popularized at the time by the legendary Kate Smith, "Until Then—'Til then my darling please wait for me. Til then, no matter when it will be.'"

Six years later, Margo and Mac were married at Princeton University. Howard MacFarland Fish (Mac) did his doctorate at the University of Edinburgh, Scotland, taught there for 10 years, and then became chaplain at Exeter in England. After receiving his divinity degree from Harvard, Mac became a United Church of Christ minister and a chaplain at the Lawrenceville School in New Jersey. Later, the family moved to California for a year, then to Scotland briefly, managing to spend as many summers as they could at Camp Red Wing as the guests of "Mother Fish," Mac's mother.

In the summer of 1957, Mac and Margo arrived at Red Wing with their four children—Katie, Howard, Farland and Peter—and their two dogs. The camp was already overflowing, bursting with relatives and friends—even before Margo and Mac's menagerie arrived. "We began to realize there was just too much family at Red Wing," remembered Margo. "John and Sally had their kids, Henry and Laurana had their kids, and we had ours. There just wasn't enough room for all of us."

Rescue came in the form of a man named Mr. Becker. Mr. Becker owned a small cabin—built in 1929—on a wooded quarter acre just 300 yards south of Red Wing. John Umber, the Fish family's caretaker, had lived there for 10 years with his dogs. The place was filthy and falling down. And, Mr. Becker wanted to sell.

"At first we all looked at it and said 'no,'" said Margo. "But after a summer of living on top of each other at Red Wing, Mac and I reconsidered." Not without anguish. It took $4,500—all of their savings at the time—to purchase the cabin and the quarter acre of land. The following summer, Margo and Mac packed everything they owned into a U-Haul and drove to Placid Lake to begin what would turn out to be a 35-year building project at Tapawingo. "We were young and very excited to have our own house," remembers Margo.

The original cabin sat on a knoll. It had a single bedroom linked by a porch and a breezeway that led to a separate little living room and kitchen. There was a toilet and electricity, but no hot water. Margo and Mac set to work. In the ensuing summers, away from academia, Mac discovered a talent for building. Margo, a painter, provided the artistic vision. "We never had a major construction plan; we just created as we went along," said Margo. Expedience dictated their first construction project—sleeping quarters for their two older children. With the help of an architect, a former roommate of Mac's, they designed a tiny cabin just big enough for two bunk beds.

In the academic world, Margo and Mac had either rented houses or were provided with housing on whatever campus they lived. Tapawingo, which means "house of joy" in Mohawk, was their first and only permanent home. During the next 35 summers, Margo and Mac set about transforming the original cabin into a captivating and imaginative "house of joy" for their family.

At Tapawingo, the outside and the inside merge. There are no hallways or front doors—just fern-lined, open-air walkways leading in and out of magical green spaces. Each building has been constructed entirely by hand—usually Mac or Margo's, or their children's—from natural elements like twigs, bark and local stone.

Tapawingo's study sits on a rock just above lake level and has a wall of windows facing the water. The study was constructed of wood, salvaged from a local hotel that was being demolished. A dining room in floor-to-ceiling glass was added when their youngest son outgrew his highchair. There is a sunning dock at water's edge, hidden from view. Everything is linked by 150 steppingstones set irregularly in cement that Margo hauled in on a dirt path with a wheelbarrow, each bag of cement weighing over 60 pounds. Painstakingly, Margo set the names of each family member into the path, creating intricate mosaics with pieces of glass she had collected from all over the world.

Stonework on Tapawingo's walkway

Mac and Margo built a sitting area around a clump of tamarack trees overlooking the lake and when it was completed, asked themselves how they'd managed to live without it. A music room was soon added; each family member plays an instrument. Margo needed studio space for her paintings; they built a glass room on the roof, accessible only by an outside ladder. The next year a new kitchen appeared, then an outdoor sauna, then a chapel and a guesthouse. Twelve buildings now braid through the woods like a giant cobweb. "At the end, Mac and I stepped back and said to ourselves, 'Did we really build this?'" laughs Margo.

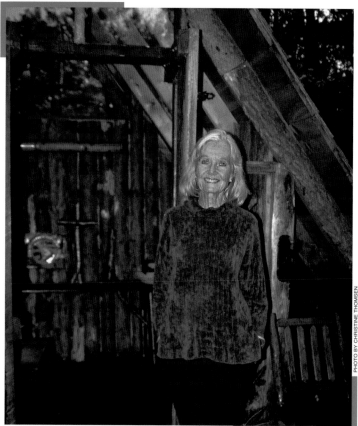
Margo Fish in front of Tapawingo's chapel

Tapawingo has become a metaphor of life for Margo. She gets a dreamy and distant look on her face when she talks about it. "Life is not always easy here," she said. "It's wet, it can be bitter cold, and the black flies bite us when we're working. Because of the way we constructed the houses, we're forced to live outside—which teaches us tolerance and patience. The family—all of us, the four children and the ten grandchildren—learned to be in the woods and not be afraid."

Always respectful of nature, Margo and Mac tried not to move rocks or allow Tapawingo to be too visible from the lake. Nature became a silent backdrop to everything they did. "There's something primal about the act of creating shelter for one's self, something spiritual; it evolves into a holy experience," said Margo. They had to learn to use tools and work with their hands—"which I love." A certain motion is required to live at Tapawingo—in the building phases certainly. "But even in the act of rescuing a little bird from the dining room," said Margo. "I feel a kind of poetry in letting it go." And, Margo is always physically active: "Our bodies are meant for that. It gives us great confidence."

Margo is not exaggerating about being physically active. She still runs every day and just completed her 40th marathon. She has climbed mountains all over the world and on September 11, 2001, was standing on the top of Mt. Olympus in Greece. She has sailed in the annual Lake Placid Clamato Regatta every summer and swims, runs and bikes in local triathlons whenever she can. Sinewy yet strong, Margo can still turns heads.

As an artist, Margo has always looked for ways to express herself, whether on canvas or in her buildings at Tapawingo. She has tried to pass this gift on to her children. "Our greatest blessing was not having enormous amounts of money," said Margo. "It forced us to be inventive, to share our children's childhoods."

The family has always had a strong spiritual and intellectual center, not surprising given Margo and Mac's professions. They read constantly. They made music. The children wrote little family books, converted them into theater, designed the programs and then invited their cousins at Red Wing to watch. They built little wooden houses for their glass dolls and invented stories about trolls and pirates who would try to steal them. "These pirates lived on the second island and we all knew exactly where that was," said Margo.

The family had special rituals. On Saturday nights Margo and Mac would bathe the four children, dress them in formal clothes, then wade in bare feet through the mud to Red Wing for dinner with Mac's family before crossing the lake to attend the Lake Placid Club's children's dance. Every summer, the family

would picnic on Moose Island. Before paddling home in canoes, each of them would gather a handful of moss and put a birthday candle in it, sending the boats out over the water. Whoever's mossy boat sank last got to make a wish.

Music and prayer and art were at the core of their family life. The creation of Paraclete, Margo and Mac's center for non-profit programs in art, religion and education located in the Village of Lake Placid, evolved out of Tapawingo. Margo and Mac liked sharing their environment with other academics and artists and wanted to continue to honor that outside of the summer season. "People come to Paraclete and Tapawingo because they love the connection, the sense of auto-matic belonging, and the continuity," said Margo. "As my son, Howard, says, 'This is the only place in the world where we don't have to tell people This is the way it was, because it still is that way.'"

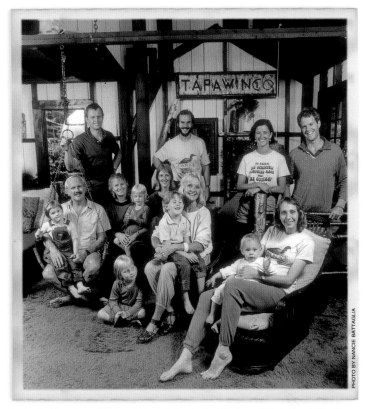

Fish family at Tapawingo, 1986 (from left to right: Maarten Van Dijk, Howard Fish III, Diane White, Peter Fish, Howard Fish, Farland Van Dijk, Celka Van Dijk, Katie Fish, Clara Borders, Margo Fish with Timon, Alexandra Borders, Ciona Van Dijk, Howard Fish IV, Carter Fish)

Margo is in individualist, an outspoken environmentalist, and a social conscience for the community. She has degrees in English, art and theology, and is well versed in many fields. Often standing up for "green" issues at Town Hall meetings, she is not afraid to appear different or think "out-side the box." At times she seems to be living in another world, and her faraway expression can belie her intelligence. The way people view her does not upset her, nor does it lessen her ability to be cir-cumspect and somewhat philosophical about her own life—which she often describes in typically cryp-tic, yet meaningful, language.

"I believe in the power of commitment—to each other and the family, especially commitment that might in its depth point to a truth," said Margo. "I also trust in ritual in this shattered world of ours—that's why Tapawingo is so important. When I'm in its landscape, I feel like I'm standing on the site of a Greek temple. I can feel the energy. To know that these ancient mountains have been here and will be here when all human life disappears—well, that's overwhelming. And there's something about living on water. You can drown in its depths, but at the same time it provides nourishment. Everything is a par-adox. That's why I no longer paint realistically. I'm more interested in capturing the energy inside a fern than painting the fern itself—the unconsciously present, the ever-lastingness of life."

Mac Fish died of a heart attack in the summer of 2001, just yards away from the rock where he pro-posed to Margo some 56 years earlier. In his honor, Margo and her family and friends have constructed a life-sized cairn on the path where he fell. It is a living monument to Mac that continues to grow each time someone adds a stone or a stick. It is also an astonishing work of art.

Two Dreams Meet (1940)

STEFANIE HOLDERIED AND ANNALIE RANDALL

Then Came the Germans

It was 90 degrees when I left Connecticut, but the temperature in Lake Placid was hovering around freezing when I checked into the Golden Arrow Hotel. The hotel seemed a perfect choice: the lights were welcoming, the rooms were heated, and the woman at the front desk was pleasant and friendly. She had a German accent and I remember wondering how she had ended up working in this small hotel on the shores of Mirror Lake in the Adirondacks, far, far from her homeland.

The next morning, I went to Camp Midwood's real estate closing in sandals, the only shoes I had brought with me. I was wearing shorts and a sleeveless top. By the time I finished signing all the documents, my toes were blue. "Is it always this cold in August?" I asked my lawyer, Bob Urfirer, who also happened to be the former owner of the Golden Arrow Hotel. "Sometimes it snows in August," he replied, without a hint of sarcasm. I was beginning to have second thoughts about our new purchase.

That was 22 years ago and, thankfully, it has not yet snowed in August, at least while I've been there. And, the woman behind the desk? I was not destined to meet Stefanie Holderied again until years later, when we both served on the Board of the Lake Placid Institute. Stefanie didn't remember that frozen woman, standing in front of her, shivering. But I remember her and I no longer wonder why she came to Placid Lake.

Stefanie Holderied and Annalie Randall were born in opposite corners of Germany. Stefanie is willing to tell how her experience of living in Germany during World War II defines her and freely articulates her feelings about the past. Annalie is more reluctant to talk about her early years; perhaps it is too painful, and the less said the better. Or perhaps Annalie is just more circumspect. Although the contrast between their two stories is striking, both women came to Placid Lake for the same reason.

From the very beginning, Stefanie and Annalie were attracted to the Adirondacks because its natural architecture reminded them of their homeland. Both instantly connected to the pristine landscape and the raw beauty of Placid Lake, with its pine forests and clear mountain water. Each now claims the lake as her own. There are likely other German women on Placid Lake who moved here for the same reason. This is the story of just two of them.

<p style="text-align:center">✧ ✧ ✧</p>

In 1957, Stefanie Holderied emigrated to the U.S. from Germany. She found work in New York City as a secretary for the finance officer of Associated Metals and Minerals Corporation, a Wall Street company owned by a German man named Lissauer who imported and exported steel. Stefanie was young and inexperienced. And, just learning to speak English. "No one could read my dictation except me," remembers Stefanie. "I'd listen in German and write it down in English the way it sounded."

The German community in the U.S. was especially cohesive after World War II, and most of Stefanie's life understandably centered on her employer, Associated Metals and Minerals. During the summer, the entire Lissauer family, along with assorted relatives and friends, went to a place called Placid Lake. In the summer of 1957, Stefanie, a single 19 year-old and new to the company, was invited to the lake as a guest of the Lissauer family. "The lake was so beautiful," said Stefanie. "I was very impressionable back then. I decided right then and there that Lake Placid was the place to go if I ever had the money."

Stefanie had grown up in a rural farming community in the Black Forest of Germany and had never even heard of the Adirondacks before she visited. But she knew instinctively, even at 19, if she could live on Placid Lake, she would've arrived. "Placid Lake represented the ultimate for me," said Stefanie.

Stefanie had arrived in the U.S. with a lot of painful memories. "I remember being shot at by planes flying low over the fields where my family was working," said Stefanie. "My mother would throw me in a ditch and my father would fall in on top of me. The planes used to shoot at anything that moved."

Towards the end of World War II, Stefanie's mother would put Stefanie and her sister and brother in a baby carriage, along with some possessions, and take them to a bunker dug out of the nearby mountain. They would stay in the bunker all day and go home at night. That was their life. Since they were only 40 miles from the Swiss border, Stefanie's family didn't have it as bad as others. "But neighbors of ours were bombed, a family of five," said Stefanie. "My father and mother raised the only son who survived."

Stefanie also remembers listening to the radio, in late 1944. "I must have been six-years old—it was just before the end of the war," she said. "The men were gone; it was only the women left at home. Hitler was telling everyone how Germany was about to beat the Allies. How Germany was going to win the war." Many people, like Stefanie's family, believed him.

"When I look back on it, my parents were naïve. In 1944, we were totally isolated from the whole world. There was no outside news. We had one radio station and it was controlled by the state. We didn't know much about a Jewish problem. We lived in a small town, like thousands of others."

At that time, 80 percent of Germany was rural and most Germans were not educated beyond grade school. Stefanie was the first in her family to go to a school of higher learning and that was only because she was sickly; the family couldn't use her on the farm. Forty percent of the German population was unemployed after the Treaty of Versailles in 1919. "People were starving, and then Hitler came along," remembers Stefanie "He created jobs."

When Stefanie got to New York, she tried to reconcile what her new friends in the U.S. said about Germany with the Germany she'd grown up in. She'd had no first-hand experience with the "Jewish" problem. And, truthfully, she was too young at the time to understand it, even if she had known.

"At first, I didn't believe what was said because it was not my experience at all," said Stefanie. "When I worked for Mr.Lissauer, a Jewish woman in her sixties worked next to me. The whole company was German-Jewish, except me. The woman told me she had lost half her family. They didn't leave Germany even when they were told to, because they felt it wasn't possible that the Jews would be exterminated. They felt German more than they felt Jewish, she said."

Up until then, Stefanie thought she knew everything there was to know about Germany and its people. Slowly, she began to comprehend what had really happened. "After the war I'd had a good education, but there was never any world history or geography—German history had been totally eliminated from the curriculum," said Stefanie. "It was in the U.S. when I was living in New York City that I learned what really happened in Germany during the war."

After she met that Jewish woman at Associated Metals and Minerals Corporation, Stefanie started asking questions about Germany and the war. She read *Mein Kampf* for the first time. "It basically outlined how Hitler was going to do what he did," said Stefanie. "But no one took him seriously and anyone who spoke up was gone, dead, until there was no more opposition. Germany had become isolated. There wasn't much help from anybody, especially the Allies. There had to be people who knew what Hitler was doing, but they closed their eyes. They didn't want to know. It was easier for them not to think about it, than to deal with the problem. Hitler was a dictator, like Saddam Hussein."

Little by little, Stefanie began to reassemble her personal history. Eventually, she came to terms with the past, at the same time building a new life for herself in her "new world." She had come to the U.S. at the age of 19, not meaning to stay longer than two years. After awhile, like many other immigrants before her, she got hooked on life in the U.S. In the end, Stefanie decided that America was where she wanted to live.

Specifically, Placid Lake, New York, was where Stefanie wanted to live. From the beginning, Placid Lake had made an indelible impression on Stefanie, though she'd only been there once. The mountains were the same height as the Black Forest, with the same dark pines. There wasn't as much water, but otherwise the scenery was similar, and there was hiking and skiing—the sports she loved. She couldn't get Placid Lake out of her mind. "Germans typically first immigrate to the city, but the minute they have the wherewithal, they move to the country," said Stefanie. "If you find Germans in an area, you find German-speaking Swiss and Austrians, too, because they look for the same thing. That's why Lake Placid appeals to them all. In the back of my mind I knew I would be happy living here." She just had to find a way to make it happen.

Stefanie subsequently got married and had three children. She tried to go back to work after the birth of her third child, but she was pregnant again and it was just too much. Her husband, Winfried, was a builder and an avid skier who had also been to Lake Placid once, as a tourist. One weekend, Stefanie and Winfried were vacationing in nearby Lake George with their young family and decided to drive up to Lake Placid. As they drove through town, they passed the Wildwood Motel on Saranac Avenue. There was a green "For Sale" sign outside the motel.

Instantaneously, both Stefanie and Winfried felt the same urge to buy the Wildwood Motel. "Believe it or not, we jumped in with both feet," said Stefanie. "We were totally green and bought the property that very day." Stefanie and Winfried had three children under the age of four and, justifiably, were scared

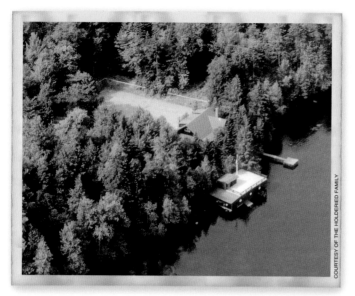

Sunny Cove from the air

Three views of Sunny Cove

out of their minds once they realized what they'd done. To mitigate their impulsive decision, they agreed that Winfried would keep his construction job and come up to Lake Placid on the weekends. Stefanie would stay in Lake Placid, and, if she were successful running the motel, her husband would give up his job in New York City and move to Lake Placid permanently.

Stefanie went to work managing the hotel while caring for her three children—and awaiting the birth of her fourth. Her efforts paid off. Ten years later, Winfried quit his job and they sold the motel and purchased the Golden Arrow Hotel from local attorney and realtor, Bob Urfirer, along with the land on either side of the property. At the time, the Golden Arrow had 36 rooms and a restaurant. The hotel now has 145 rooms, two restaurants, a swimming pool, a gym, a conference center—and a very high occupancy rate. All three of the Holderied children work for the hotel (sadly, the Holderied's fourth child died in 1997) after stints away from Lake Placid for college and work experience.

About 10 years ago, the Holderieds purchased Sunny Cove, the old Davis camp on Placid Lake's peninsula. "In the back of our minds, we knew we always wanted to be on the lake," said Stefanie. Stefanie and Winfried had made an offer on lakeside property three times, and each time the properties sold for more than the asking price. "Each time, my husband was furious to have lost the bid, so we forgot about it," said Stefanie.

Then one day, Robi Politi (a local realtor, now the mayor of the Village of Lake Placid) called to say he had a fantastic property that couldn't be seen from the lake—on a secluded inlet with eight acres. "We never got into the house, but once we saw the land we were hooked," said Stefanie. "One hour later we made an offer."

Stefanie and Winfried decided to build right away on a secluded section of Sunny Cove's ample acreage. Two years later, they sold the house that Winfried had built on Mirror Lake Drive, the house where they'd raised their children, and moved into their new all-weather home. Constructed in typical Swiss architecture, the house has carved gables and a white stucco façade; the interior is furnished in a bright European style, with paintings of the German countryside and a Swiss cuckoo clock that chimes every hour. Next door, on the same property, the original Davis camp, built in 1910, remains un-winterized and is rented to the same two people every summer.

In many ways, it is amazing that Stefanie was able to fulfill her dream. She was so young when she arrived in this country, so unsure of her past. In other ways it is not at all amazing. "In my young mind, I always knew I wanted to be here—on Placid Lake," said Stefanie. "And once I got here, this was always going to be home. There was no doubt in my mind. Now I go for a swim every morning during the summer. It's totally peaceful. No matter what season it is, the beauty overwhelms me when I drive out the driveway to go to work. I have a little of everything. Sports, culture, beauty, some quiet, some busyness."

Stefanie has worked hard to get where she is, to enjoy her slice of Placid Lake. "The fact that I can make a living here is a wonderful thing," said Stefanie. "All my children came back to Placid Lake and now work at the Golden Arrow. One way or another, they'll stay in the business. And the grandchildren are planning to come back; they needed to go away for school, but we want them to come back too."

For Stefanie Holderied, all the hard work has been worth it. "Now I take my time before I go to work in the morning," she said. "I have a little swim. The business has grown and the children are here taking care of it. I can come back to the lake in the early afternoon and sit on the deck of Sunny Cove. It's so peaceful. It's the ultimate luxury."

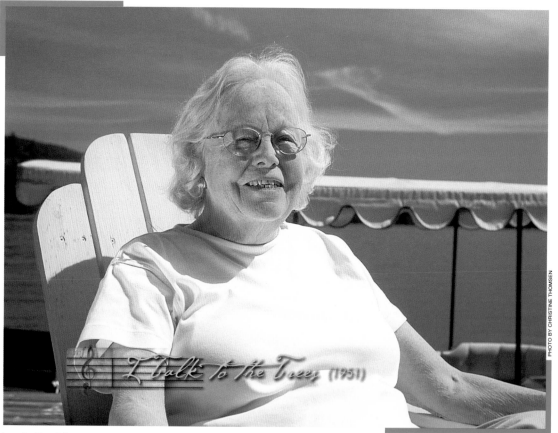

I talk to the Trees (1951)

Annalie Randall

Both my husband and I are originally from Minnesota, the land of 10,000 lakes and acres of undeveloped forests, liberally sprinkled with pine trees of all varieties. When we were living in Connecticut, Colt and I often mused about our "homeland," and one evening mentioned to neighbors of ours that we were looking for a place on water in the East, in the woods, one that would remind us of Minnesota. Something we could drive to from New Canaan for a long weekend.

We spent several years looking for the ideal spot, trampling through parts of northern Connecticut, Maine, Massachusetts, the Catskills, and Vermont. Nothing seemed right. Our neighbors mentioned the Adirondack Mountains and, in particular, Placid Lake. "The Adirondacks?" we asked. We had never heard of them. We had never heard of Placid Lake either and our neighbors explained that their old Long Island neighbors, Annalie and Jack Randall, had been going there for years, and loved it.

So Colt and I headed north to scout it out. We arrived in Lake Placid, checked into one of the small motels in town and spent two days driving around the lake, looking at the area. We went home, duly unimpressed. The next time we had dinner with our neighbors, we mentioned our disappointment. "It wasn't what we imagined," we complained. "The houses are out in the open. There aren't many tall pines. The lake is too small. We drove around it in ten minutes."

There was a long silence and finally our neighbor's wife said, "You can't drive around Placid Lake. You were on Mirror Lake, and never even got to the 'Big Lake.'"

Like many visitors, we had totally missed Placid Lake. Tucked away from tourists, Placid Lake is out of view and off the beaten path. The next time we visited, we found the "Big Lake" and several beautiful camps that were for sale, among them Camp Midwood. Colt and I stood on Midwood's dock and that very day made an offer.

The week we moved in, Annalie Randall called to welcome us to Placid Lake. We thanked her for being a good neighbor—and also, for loving pine trees.

*I*n her youth, Annalie Randall summered in the mountains of Bavaria in a town called Chieming, about half an hour from Salzburg, Austria. Chieming is on the Chiemsee Lake and is most famous as the place where King Ludwig II built the famous Castle of Herren on the Isle of Men, a copy of the castle at Versailles. A forest of tall, dark pine trees surrounds the lake, and the walking trails are cushioned with fallen pine needles. Annalie's most enjoyable times during her childhood and teenage years were on that lake, before World War II started. The memory of her summers in Bavaria has never left her—especially her memory of the forest and all the tall, dark pine trees.

Annalie met her husband, Jack, before the war in London, England, and they married in Munich in 1949. As a young bride living on Long Island, Annalie often was homesick for the mountains of Bavaria. One holiday, she and Jack drove north to visit the Adirondacks; Jack had been there before and hoped the mountain air would make Annalie feel better. They were staying overnight in a small town on Route 9, when Jack spilled catsup on her dress at dinner.

The next morning, they decided to drive north to Lake Placid, the nearest big town, to buy Annalie a new dress. As they approached the village, Annalie immediately commented on how similar it was to the one she had summered in as a child, especially noticing the tall, dark pine trees.

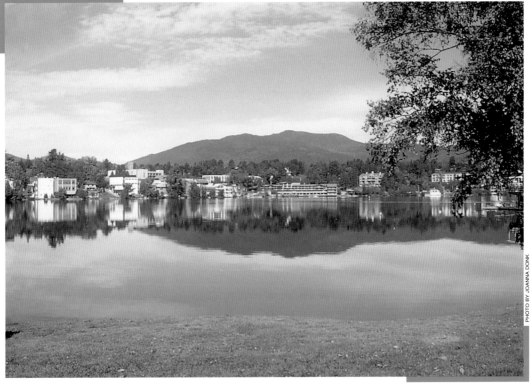

Mirror Lake

PHOTO BY JOANNA DONK

While Annalie and Jack were in Lake Placid, they met an old attorney friend of Jack's, Bob Isham, who suggested they join the Lake Placid Club. It didn't take much for them to agree, and for several years in the 1950s Jack and Annalie rented cottages on the Club property around Mirror Lake.

Lake Placid Club ladies Lee Scudder and Annalie Randall with Merrill Thomas

"It was a little St. Moritz," Annalie remembers. "Even though the mountains weren't as high, I felt so much better on the lake. There were all these beautiful white pine trees in the surrounding woods—balsam, spruce, maple, and birch trees too."

No motorboats were allowed on Mirror Lake, making it very quiet, especially in the winter. Annalie used to smuggle her miniature dachshund in her purse into the Agora auditorium through the side entrance of the Lake Placid Club—even though dogs weren't allowed. The Austrian elevator operator and Annalie spoke German together and they became good friends. "It was wonderful to be able to speak my language again," said Annalie. "Of course the dog was always very well-behaved."

In 1967, Jack and Annalie bought property on Mirror Lake, but decided in 1982 to move their family to Placid Lake. (Their three children were unhappy because no boats were allowed on Mirror Lake.) One day, their realtor, Merrill Thomas, took Annalie and Jack out to look at property. "Every camp we looked at, he said to me, 'Aren't the mountains beautiful?'" said Annalie. "And, I said, 'Merrill, those aren't mountains. Those are hills.' Obviously he had never been to Bavaria."

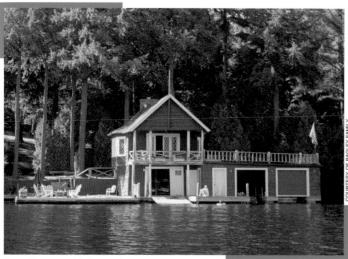

Camp Chenango and its famous pine trees

Jack and Annalie bought Camp Chenango on the west side of Placid Lake that same day—because of the view of those "hills" from its dock, because of the white pines that lined the water's edge, and mostly because when Annalie sat on the deck and looked out at Placid Lake, the setting reminded her of Lake Chiemsee.

Years later, Annalie arrived for the summer with a friend from her Munich boarding school days. All of a sudden, she noticed that all the lovely branches on the white pine trees were gone. "I was screaming bloody murder; I have never been so unhappy in my life," said Annalie. "Normally I'm a calm person, but this was too much." Her husband had hired a man to trim two trees; the worker had cut all the branches down.

"I screamed and said, 'what did you do? They look like palm trees now,'" remembers Annalie, years later. "All I could see were two trunks. The tree trimmer cut those branches—after ten years of discussing with Jack that these branches should not be cut. I've never been so upset in my life."

Annalie pauses to take a long breath. "You can mess with a lot of things, but don't mess with my pine trees."

I Still Get a Thrill (1930)

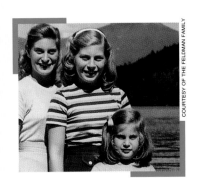

DIANA FELDMAN

Trading Places

The morning of that cold day in August when I went to close on our new property, I was instruct-ed by our lawyer to inspect the contents of Camp Midwood prior to the closing. Most of the camp's furnishings and fixtures were included in the sale, even the boats. It was standard oper-ating procedure for the buyer to verify their existence, but, even so, I felt a little sheepish. The owners were still in camp. I felt uncomfortable surveying the "goods" while they were still there.

Nevertheless, I made my way over to Midwood and introduced myself. Sol Kann, the owner of the camp, greeted me with a smile and graciously showed me around, opening closet doors, explaining how things worked. When we got to the top floor of the main house, I could hear someone sobbing.

A woman came out of one of the bedrooms to shake my hand. "This is my daughter, Diana Feldman," said Sol. I could still hear sobs in the background. They were too loud for any of us to ignore. "That's my son," explained Diana. "We told him the new owner was coming. He does-n't want us to sell the camp." There was absolutely nothing I could say. I felt guilty and sad— and speechless.

I went to the closing and bought Diana's son's camp. Only now, more than 20 years later, do I fully understand what all the tears and sobbing meant. Camp Midwood, like other camps on the lake and summer homes everywhere, is a metaphor for family. The camp is an intensely imme-diate place, implacable and unchanging, where loved ones gather to laugh, to talk, to fight and to cry. As you drive into camp, you leave the world behind. You join those you love and you live life together. That's all you do, under the same roof, summer after summer, year after year, in your own private little country. I understand it now. On that cold August day in 1982, Diana Feldman's son thought he'd lost his beloved family.

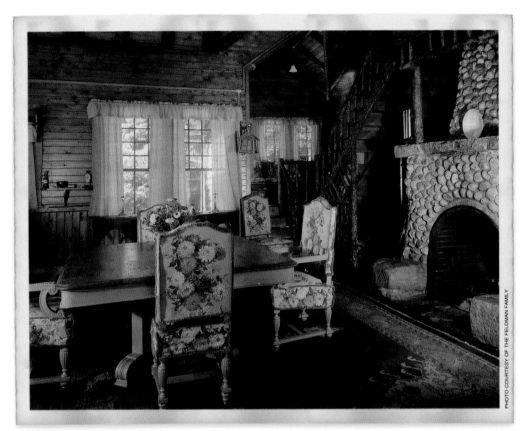

Camp Midwood dining room, circa late 1940's

The pictures are in black and white and they haven't faded much. Diana Feldman's leather photo album is crammed with the memories of growing up in Camp Midwood on the west shore of Placid Lake. Her father, Sol Kann, purchased the camp from John W. and Emily Brune Griffin in February 1942. The Kann family summered there for nearly 40 years.

Midwood is one of the oldest camps on Placid Lake; Edward H. Griffin, a Johns Hopkins University professor, purchased the land from Oliver and Mary Abel in 1886 and erected the first log building several years later. During the Depression, the Griffin family added a larger main house, and an outbuilding for the housekeeper, the cook and the butler. Shortly after buying Midwood, Sol Kann renovated and enlarged the existing boathouse. The names of Sol and Eleanor Kann and their three daughters—Eleanor, Barbara and Diana—are still engraved in 12-inch letters on the boathouse's green linoleum floor.

Judging from the old photographs, life at Midwood was, if anything, stylish and refined. There is a picture of the Kann family sitting together in formal pose on the dock, another of Diana and her two sisters in matching designer linen shorts and shirts. A photograph of the dining room shows a table set with delicate Limoge china and fine crystal. In the background, there is always a fire roaring in the fireplace. It must have been a full time job just splitting the firewood and maintaining the fires in all five of the camp's fireplaces. But life at Midwood was also filled with fun and laughter. "It wasn't at all serious or stuffy," said Diana. "We had many laughs with family and friends growing up at Midwood, tons of jokes, too."

Diana admits that the pace and style of life on Placid Lake was much different in those days. When she was a child, her parents used to hire Madden's Moving Service (still operating out of nearby Saranac Lake, New York) to truck the family heirlooms up from Merry Hill in Stevenson, Maryland—the silver-ware and the Wedgwood china, the monogrammed linens and tablecloths, the Vermeil plates and so many clothes. "You would think they were staying for a year," said Diana. Not to mention the fact that the chauffeur then would drive the help up, along with coolers and cartons of food, including frozen chickens and turkeys. "Those days are gone forever," Diana muses.

Diana's mother and the three girls would travel up by train for the months of July and August—never thinking about coming in June because there were too many black flies. Diana's father would commute from Washington D.C. to New York City every Friday morning, then take an overnight train to Lake Placid, arriving early Saturday morning. "We'd put him back on the train every Sunday night," remembers Diana. "That was a major commute. During August he was here longer. It was what a lot of the men did in those days."

While in camp, the Kann family and their guests were treated a little like royalty—although it was by no means palatial living. Each bedroom had a buzzer wired to a callboard in the kitchen to communicate with the maids. When you pushed the buzzer, a bell rang in the kitchen. A blinking light showed the location of the buzzer. Each guest was served breakfast in bed on a tray lined with freshly ironed linens, a folded newspaper in the side rack of the tray, and a soft-boiled egg in a Spode eggcup.

The day's activities were leisurely, revolving around the lake and water skiing. Late in the afternoon, family and guests might walk from the dam to Charlie McCutchen's camp (about a mile away, along the western shore) on a sawdust trail that went along the shore of the lake. "I will always remember that

Diana with her sisters Eleanor and Barbara, 1952

fresh sawdust smell," said Diana. "And, everything was so quiet and peaceful back then. There were only two houses between us and the dam—the Salmons and the Fishes."

At night, the family was expected to dress for drinks, then dinner. After dinner there were the inevitable gin, backgammon and bridge games—and usually a party or two to host. "My sisters and friends often put on shows for the family, making up words, singing and dancing to Broadway show tunes," said Diana.

Camp Midwood's two-story boathouse sits at the bottom of a hill and faces Whiteface Mountain. When you look out the huge glass windows of the boathouse, or stand on its wrap-around deck, you have a 180-degree view of the lake. With high ceilings and lots of square footage, the boathouse lends itself well to parties. There is an old upright maple piano in one corner; in the other, a built-in bar with tan leather barstools and two maple bridge tables. A 1950s turntable and a collection of 45-and 33-rpm records provide the music and there is plenty of space for dancing. Two enormous sofas frame a fieldstone fireplace that is roomy enough almost to stand in. And the chairs on the outside deck are perfect invitations to stargaze.

One of Diana's first memories is of a birthday party in the Midwood boathouse. "On my fifth birthday, we had a party there," said Diana. "My best friend was Wendy Lehman, whose grandfather was Governor Lehman—we were so close I called the governor 'Gramps' and his wife, 'Granny.' I remember Wendy coming to my party, falling in the boat slip, and Gramps saving her."

Sol, Eleanor, Barbara, Eleanor and Diana Kann
on Midwood's dock, 1952

COURTESY OF THE FELDMAN AMILY

That may have been Diana' first party in the boathouse, but it was definitely not the last. "That's another fantastic memory—another birthday party in Midwood's boathouse," said Diana. Diana shares the same birthday as her friend Jeannette Cone, who lived in Camp Carolina on the other side of the lake. On Diana and Jeannette's 21st birthdays, Diana's parents invited more than 100 people for a joint birthday celebration and they brought the *Doris* over to Midwood's dock. Guests enjoyed champagne on the dock, cocktails on the boat and a sit-down dinner for 100 at Jeanette's Camp Carolina on the east shore of Placid Lake. After dinner, everyone came back to Midwood for a discothèque in the boathouse. "That was the best part of the party," remembers Diana. "I remember it was the first disco on the lake. My parents brought Slim Hyatt up from Shepards, the first disco in New York City. It was something else."

Despite her friendship with Jeanette, who lived on the opposite shore, Diana remembers a real "East Lake versus West Lake" mentality back then, mostly because of the Lake Placid Club. The Clamato Regatta that was held every Labor Day weekend was created by camp owners on the east side of the

lake, all of them Lake Placid Club people. "The Club was very exclusive, and Jews were not invited—not until the early 1970s," remembers Diana. "Looking back on it now, I realize that a lot of our socializing was based on exclusion."

Diana became more aware of the anti-Semitic problem on Placid Lake during the late 1960s, when the Alfred Rose family, along with the Kann family, was invited to join the Lake Placid Club. They were the first Jews to be asked to join the Club. There were a lot of late-night discussions about anti-Semitism and Diana remembers her parents deciding that the invite had come too late, and for the wrong reasons. "It was so obvious why they were finally going to let in Jews," said Diana. "By this time, the Club was in financial trouble and looking for new members to avoid going broke. The Roses and my parents saw right through the invitation and politely declined."

Camp Midwood boathouse, 2003, now . . .

Since then, things have changed for the better. "Unfortunately, the change came after the demise of the Club," Diana reminds me.

Diana eventually married, had two children, divorced, and remarried. She continued to visit the camp every summer, whenever she could. In 1982, Diana's father decided to sell Camp Midwood. Diana's mother, Eleanor, had died and Diana's two sisters and their families were scattered all over the world. Sol had winterized the dining room house at the camp for the 1980 Winter Olympics in the

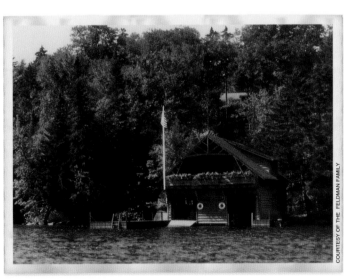

. . . and then, late 1940s

hopes his family would use it. But in the modern world of separation and distance, it was just too difficult for his daughters to travel. None of them came that year. The truth was, most of them could rarely manage to use the camp at all anymore.

Diana felt the loss more acutely than the others, probably because she was there more often. "It was very traumatic for me when my father sold Camp Midwood," said Diana. "All those summers, and all those memories; I'd been coming there for 40 years. The thought of not knowing whether I would ever be up here again was devastating. I thought, 'Oh no. My lake. All those summers.' It was terribly sad for my children, Jamie and Anthony. The day we left Midwood for the last time, we were all crying." (A fact the author can attest to.)

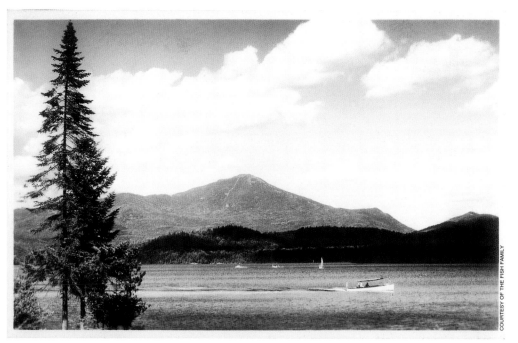

Landscape postcard of Placid Lake

Diana continued to visit the new owners of Camp Midwood (Colt and myself) whenever she came to Lake Placid, often bringing guests along, to show them where she had grown up. The sense of loss remained with her, and so did those magical memories of so many summer days on Placid Lake.

On Memorial Day in 1983, Diana and her husband, Richard, were visiting friends and staying at the Hilton Inn in Lake Placid. At breakfast, Richard announced he was walking down to Meyer's Drug Store in the village for a newspaper. Thirty minutes later he returned with a surprise.

"'Get your purse', he told me," said Diana. "'We're going to look at a camp on Placid Lake. This is the only one that has road access,' he said. Which was so cute of him."

When Diana and Richard drove down Camp Woodlea's driveway on the Peninsula Road, her heart sank. "It was so small, compared to Camp Midwood," said Diana. "I thought to myself, there has to be a happy medium."

Room by room, Diana slowly walked through Woodlea. It didn't take her that long since there were only two bedrooms, a bath and half a bath. "Richard told me I had to have vision and imagination," said Diana. "We could add another bedroom and eventually a proper dining room. We could convert the garage to a bedroom for the kids. I knew he was right. The important thing is, we would be back on the lake again. I burst into tears. I could not believe we were doing this. I was so happy."

Gradually Diana and Richard created their own space in their Peninsula Road camp, transforming Woodlea into a bright and airy lake home, retaining some of the flavor of Midwood by keeping the same caretaker that her father had employed for many years, Roland Sears. "Now I love my Camp Woodlea—even though I miss the views from the Midwood boathouse of Whiteface Mountain and Kate Smith's boathouse," said Diana. "I'm thrilled to be back on the lake."

 Growing up, Diana always felt her Placid Lake upbringing was a gift. "Life on the lake was so good to us," said Diana. "Now I want to give some of that happiness back to the local community. Not just to my children, though I hope they will have the enjoyment of Placid Lake too, in the years to come—and throughout their lives."

There is another reason for Diana's continuing love of the lake and her gratitude for being on it. "You know, my parents fell in love on Placid Lake," she said. "My parents were staying with good friends at Camp Taboo before they bought Camp Midwood. They fell in love at Camp Taboo, so they always adored the lake. I do too."

It's All I Ask (1963)

PHOTO BY CHRISTINE THOMSEN

M A R A J A Y N E M I L L E R

The Adopted One Adopts

On that second trip to Lake Placid in August of 1982, Colt and I saw several camps the day we bought Camp Midwood, including Camp Cavendish on the eastern shore of Placid Lake. We never went inside; the camp was under a "tentative" offer and the realtor didn't have a key. I forgot about Cavendish until the following summer when we were introduced to its new owners, Jeff and Mara Jayne Miller. A mutual friend, Jan Huwiler, who also ran our children's nursery school back in New Canaan, Connecticut, arranged a game of doubles tennis. It was there that Mara and I learned we were both newcomers to life on Placid Lake.

Thus a friendly rivalry of East Lake versus West Lake began. Over the next 20 years, Mara and I carried on an ongoing discussion about the merits of living on our respective sides of the lake. Our sparring was light-hearted. The east side had the sunset. The west had the sunrise. The east had more Lake Placid Club history. The west was more private. The east was more social. The west had a golf course. On and on our conversations went, neither of us ever giving in. It appeared the only thing we could agree on was that, surprisingly, our tax assessments and our annual tax bills were exactly the same, year after year.

This was always a mystery to us and still is, though someone once opined that the tax assessor often sees Mara and me walking around Mirror Lake together. Maybe the tax assessor knows about our East Lake versus West Lake discussions and doesn't want to add fuel to the fire?

*M*ara Jayne Miller had a tough start in life. Her mother died of cancer when she was only nine, seven years after her father and mother had divorced. An only child, Mara lived with relatives in New York City for a year until she was placed in an orphanage. Two years later she was placed for adoption.

New York state laws require that a child placed for adoption live with a family for a year, before the adoption becomes legal. Mara's first adopted parents were considerably older and golf fanatics; they played every day. "I think they were just looking for someone younger to play golf with," laughs Mara. Within three months, the adoption agency's consulting social worker and psychiatrist took Mara Jayne out of that home.

During the next year, Mara lived with an assortment of psychiatrists, going from one to the next, all of them in New York City where she had always lived. She refers to the interlude as "terrific" because she didn't have to go to school very much. When Mara was 12, her current parents adopted her and moved her to Morristown, New Jersey. Though she loved—and still loves—her adopted parents, Mara Jayne never took to the suburbs. "It didn't feel like home," she said. "I'm a visual person, and Morristown always seemed a little out of kilter to me. I know it's one of the prettier New Jersey towns, but I liked the landscape of New York City better. I missed the sounds of the city at night—the ambulances blaring and the horns honking. When I went to Morristown, all I heard in the morning were these noisy birds—no trees rustling, no cars even. To a born New Yorker, the only bird is a pigeon, and I thought, 'What kind of a place is this?' It was so weird."

Whiteface Mountain on the Ausable River

PHOTO BY JOANNA DONK

After graduating from high school in Morristown, Mara enrolled at Sarah Lawrence College in Bronxville, primarily because it was close to New York City. After college, she and several roommates moved to New York's Upper East Side; two years later, Mara married Jeff Miller.

Mara and Jeff's son, Rob, was raised in the city and attended The Day School of the Church of the Heavenly Rest, where Mara volunteered and organized annual benefit auctions. In 1980, Mara and Jeff and six friends bid on and won a long weekend in February at a Day School family's house in Keene Valley, a small village some 15 miles southeast of Lake Placid nestled in the High Peaks. It was Mara's first experience in the Adirondacks and one that would change the course of her life.

Up until that weekend, Mara and Jeff considered themselves "ocean people." They had always summered on "flat, small" Nantucket where they sailed, played tennis, rode bikes and "trampled nature." But this weekend in February, they headed north instead, hauling their downhill and cross-country skies to Keene Valley, expecting to hit the slopes. Mother Nature had other plans.

The night they arrived in Keene valley, there was a sudden thaw that caused the Ausable River near their rented house to back up and flood. Huge chunks of ice blocked the road between Keene Valley and Lake Placid, making it virtually impossible for them to go anywhere. Housebound, they scrounged through the barren cupboards and fixed themselves a pathetic meal.

Instead of being depressed by these events, Mara was excited. "There was something so cool about it, how we were stopped by nature—even though you have all these plans and all this money," she remembers. "We were used to Nantucket, where nature was constantly abused, where people arrived in droves in their own private airplanes. There was something wonderful about nature being in control for a change."

In typical Adirondack fashion, the next morning was glorious and sunny. The roads were open, so the group hiked up to Marcy Dam. It was Mara's first hiking experience in the Adirondacks. "It was wonderful," said Mara. "I was hooked and so was my husband."

Jeff was from the Mohawk Valley and had hiked as a teenager. Mara had hiked out West as a child, but nothing in their hiking experience compared to this. The following fall, Mara and Jeff stayed at the Lake Placid Club and climbed Noonmark Mountain. The next summer, when it came time to make their Nantucket plans, Mara suggested they rent a house in Lake Placid, instead. "I wanted to get out of Nantucket," said Mara.

Anita Varga, a Lake Placid realtor, showed them properties to rent on Mirror Lake and on the west shore of Placid Lake. None of them was acceptable. "Jeff refused to get out of the car most of the time," said Mara. "It was pretty simple. We just wanted a big old place on the water where we could watch the sun set."

Anita drove Mara and Jeff to Camp Cavendish on East Lake, just for a look at its grounds. Anita told them it had already been sold, but there were some "snags" in the deal. The minute they looked at Cavendish, Mara and Jeff decided to buy, rather than rent, and made the owners an offer. "We never even looked inside, just stood on the dock, watching the sunset, and knew it was what we wanted," said Mara. The negotiations took some time because the other would-be buyer was still "in play." But, by December 1982, Mara and Jeff had bought the camp, still without seeing the inside.

The main house of Camp Cavendish, with the great room below and the bedrooms above it, was built in 1884 by Redfield Proctor, who was governor of Vermont, then Secretary of War in President Benjamin Harrison's cabinet, and later, a U.S. senator from Vermont. Proctor himself never lived at the camp, but presented it to his daughter Emily, who lived in it until her death—seasonally, of course, as the camp was not winterized.

In 1939, the camp was divided in two. The guest cabins of Camp Cavendish became Camp Sutherland, now the camp next door to Cavendish (recently owned by Harry Voege). Emily Proctor built a boathouse of her own and a new guesthouse. Camp Cavendish stayed in the Proctor family until the 1950s (from time to time it was rented during the summers—the composer Maeterlink and the illustrator NC Wyeth reportedly stayed there) when Mr. and Mrs. Clifton Waller Barrett, longtime Lake Placid Club members, purchased it. Barrett was a notable collector of first edition American literature who gave his entire library to the University of Virginia and counted among his friends many famous writers, including the poet Robert Frost, who was once a guest at Cavendish—Frost apparently spoke at the Lake Placid Club that same weekend.

The Barrett's sold the camp in the 1960s to the Buchanan family from Chicago, another Lake Placid Club resident family. When the Buchanan's daughter, Barbara, married New York pediatrician, William

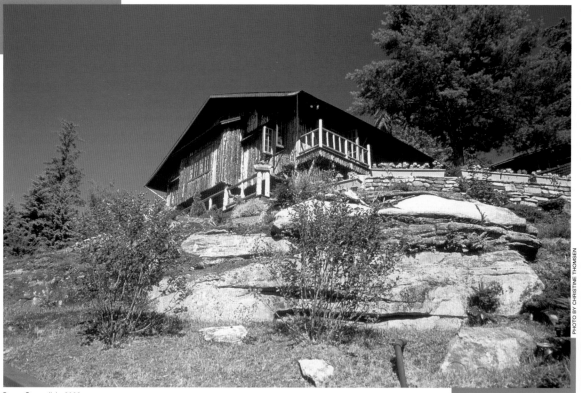

PHOTO BY CHRISTINE THOMSEN

Camp Cavendish, 2002

Seed, (who still visits the Matthews camp down the road from Cavendish), the Buchanan parents gave the camp to them as a wedding gift. The Seeds divorced in the early 1980s and the Buchanans took back the camp.

Mr. Buchanan died in 1981 and left the camp to the heirs of his estate, which consisted of his wife and daughter. In the winter of 1982, when Jeff and Mara bought Cavendish from the estate, the first thing they did was winterize the guesthouse.

COURTESY OF MARA JAYNE MILLER

46'ers hike (left to right: Michael Hannon, Jan Huwiler, Tom Powers, Mara Miller, Joyce McLean, Betsy Stewart)

Unfortunately, in 1984, the guesthouse burned down just after Columbus Day weekend; the cause of the fire is still unknown. No one was in residence at camp. The Lake Placid Fire Department arrived by boat, but didn't have enough water pressure to get the water up the front hill, so they had to go back and come in by road. By then, the guesthouse was already gone and sparks had begun to land on the wooden shingles of the main house roof. Luckily, the fire department was able to put out the fire before the main house went up in flames. In 1985, Mara and Jeff rebuilt the guesthouse, an exact replica of what it had once been.

When Mara and Jeff arrived the summer after buying Cavendish, neighbors on either side of the camp, the Geisler's and the Reiss's, introduced themselves within two days. Their sons, Peter Geilser and Peter Reiss, were Rob's age. The two Peter's swam over to the Miller's' dock and pulled Rob out of his room, took him out in the boat and taught him how to water ski. By the end of the week, the three boys were best friends, and have remained best friends ever since. That same week, Holly and Dan Donaldson, who also live on Mara and Jeff's road, walked over and introduced themselves. "They were exactly our age and their daughter Darcy was just one year younger than Rob," said Mara. "We became very good friends—it was Holly who introduced me to serious hiking."

Mara soon found others who loved to hike and joined them on their successful quest to hike all 46 of the High Peaks over 4,000 feet, to become what is known in upstate New York hiking circles as an "Adirondack 46er." Michael Hannan, a local teacher, hiking enthusiast and guide, suggested to Mara that she hike them all. Unfortunately, because Mara started hiking the most beautiful mountains first, she was left with a bunch of ugly and difficult peaks at the end.

Luckily, Mara met another local family, the Lussi's, who were also into hiking; Serge and Caroline and two of their children had already hiked the full 46, but their youngest, Katrina, still had a few more to do. "Any number of Lussi's could be counted on to hike with Jeff and me," said Mara.

According to Mara, the worst mountain was Allen. It was an all day trail-less hike and Mara and Jeff and the Lussi family got lost. They had to bushwhack to the top, and when they arrived there was no view. Of course it was raining— that's the Adirondacks. "It was awful," said Mara. "There is a canister at the top of the mountain where you sign in and register your climb. Inside were all these handwritten messages, like, 'I hate this mountain,' 'This is the worst day of my life,' 'This mountain sucks.' And it's true. It did."

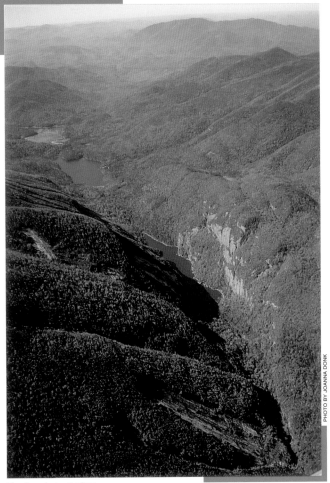

View from Avalanche Pass

July, 1986, Mara's first time out in her new guideboat, Santanoni (made by Ralph Morrow)

Mara Jayne eventually finished hiking all 46 High Peaks, in between running several marathons, and then moved on to rowing. She was delighted when her husband presented her with a beautifully crafted Adirondack guide boat on her birthday. The boat had taken local Adirondack craftsman Ralph Morrow three months to build, specifically for her size and weight. "It was beautiful, a whole new art form I was totally unaware of, with a design based on the branches of a tree," said Mara. "I started rowing and liked it a whole lot, so then I bought a scull, which was a real pleasure to row." But sports were not the only thing bringing Mara closer to Placid Lake.

Mara's friend, Holly, was affiliated with the Lake Placid Sinfonietta, a small resident summer orchestra, originally started by the Lake Placid Club. Through Holly, Mara became involved in its annual summer benefit, a silent auction. And then, in 1993, Mara helped found the Lake Placid Institute for the Arts and Humanities. "We wanted to bring back to Lake Placid the kind of creative art-making that had long ago made the area famous," said Mara. "I have a visual, literary and performing arts background, which seemed an apt fit."

That same year, Mara also joined the board of the National Sports Academy (NSA) in Lake Placid, again at the urging of friends. "NSA, to my mind, is a magnet school, using individual winter Olympic sports as the magnet to draw individuals into learning," said Mara. "NSA provides a truly unique environment for student athletes." Mara also became deeply involved in the Placid Lake Foundation, a conservation board organized just after the Lake Placid Shore Owners' Association Centennial celebration (for which Mara curated an exhibition, Scenes of Placid Lake, at the local arts center, the Lake Placid Center for the Arts).

"I came to see that preservation of this small lake—which has become my home, and I assume will one day become the home of my child, his children, and their children, as well as the homes of other shore owners, their children and their grandchildren—was something I, as an individual, could directly influence," said Mara.

Over time, Mara created a life for herself on Placid Lake, but, as fate would have it, she would have to struggle to keep it. In 1993, she split with Jeff and spent the next nine years negotiating with lawyers, trying to hold onto Camp Cavendish. "It took a long time to get divorced, so I certainly had plenty of time to think about what I really wanted in my life," said Mara.

Mara came to realize she had lived on Placid Lake longer than she had lived anywhere and it had become hard for her to separate the camp from who she was. She was convinced that Camp Cavendish was her place. "It's very odd," said Mara. "I was born and raised in New York City. I don't know why these mountains made such a difference. I had no problem giving up the apartment in New York, where Jeff and I had lived for 20 years. The apartment had no hold on me, not like Placid Lake does. My lawyer kept asking me, 'Are you sure?'"

After Mara and Jeff separated, Mara lived in Camp Cavendish for two years, all year round. During the winters, she spent long periods of time by herself. "I saw that it was going to be all right, that I could dig myself out of the snow banks, that I could be self-sufficient," remembers Mara.

Living on the lake alone gave her renewed confidence. As she began to do things for herself, like starting the boat and changing the oil, she felt even more wedded to the place. "Camp Cavendish became the site of a transforming experience for me," said Mara. "It's hard to separate gaining your self-esteem from the place where you gained it."

Ownership of Cavendish brought some regrets. "I realize that the Adirondacks meant something to Jeff as well, something important that had meaning and passion," continued Mara. "Jeff never loved the water like I do, or being on the lake, or rowing and sailing. But he liked to play golf. He had a life here too."

Two years after their divorce, now that there are no more hard feelings or fights, Mara understands this. Part of her feels sad that Jeff is missing what she now has. "Our grandchildren—we have three—will grow up with this heritage, but they won't be able to share it with both of us and that gives me pause," said Mara. "Maybe some day, Jeff and his new family will join me and my partner James' and Rob's families in Camp Cavendish."

Mara's greatest joy is her grandchildren. She loves that Rob's children love the camp. Rob and his wife, Lisa, and their three children come up from Westchester and leave their swimming lessons and carpools and televisions behind. Within two hours, the children are taking walks, picking up worms and checking out the snake population. "The camp is an intrinsic part of them; maybe underneath it will feel like their real home too," said Mara. "I know I would be a poorer person if I weren't part of Camp Cavendish. I would be missing a part of my heart and soul. Sometimes I imagine that this might be true of Jeff, too."

Visual things are important to Mara and contribute to her sense of home. Her personal landscape has always been important to her. Not surprisingly, all of this seems to have been magnified by her experiences on Placid Lake.

"I love the landscape on the lake," said Mara. "That landscape inspired me to think and write and curate shows about landscape art." Pretty soon dealers were calling Mara because she could distinguish one mountain from another in a painting. That gift led Mara to attend graduate school at Bard's Center for the Curatorial Studies. Mara eventually opened a contemporary art gallery in New York City in partnership with Peter Geisler, Jr., who grew up at Camp Taboo up the road from Cavendish—the same young boy who rounded up Mara's son, Rob, that first summer and taught him to water ski.

All of this happened to Mara because of Placid Lake—and she is grateful. "In the winter I stay in the guest cottage; I love the sounds," said Mara. "When the ice is forming, it sounds like a giant bear walking up the front steps to get me. I remember the first time it happened. I've never heard anything like it before. By the end of the week I found it very comforting—as if everything was evolving the way it should."

Mara works best in her boathouse. "It's my space on the water," she said. "I'm always able to write at my best there, listening to the sounds, watching the weather. I used to take my books in the bathtub with me as a kid; I guess I've always worked well with water under me. When I'm in Camp Cavendish's boathouse, I know I'm where I should be. I'm home."

'Til The End of Time (1948)

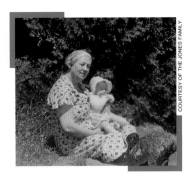

COURTESY OF THE JONES FAMILY

GEORGIA JONES

The Matriarchal Line

At the top end of Whiteface Inn Road, on the western edge of Lake Placid, sits a parcel of land—about 17 acres in total—with a spectacular view of Whiteface Mountain. When Colt and I first moved to Placid Lake, the entire parcel was for sale. The parcel remained on the market for many years, until one day, an article appeared in the local newspaper, The Lake Placid News, announcing that the owner of the land, Vernon Lamb, was about to sell all 17 acres—to Wal-Mart. I fired off a short letter to the editor, questioning the wisdom of sacrificing one of Lake Placid's finest scenic spots for a gigantic, cement eyesore.

A barrage of opinion letters, pro and con, deluged the local editor. One of the most vociferous opponents to the Wal-Mart sale was a Lake Placid resident, Georgia Jones. An active member of the community, Georgia already served on several local boards and was a member of the town's planning commission. I knew of Georgia's reputation and had seen her in action at local meetings and hearings. She was a fierce defendant of Placid Lake and a passionate, articulate advocate of many local causes. Personally, I was very pleased that Georgia had taken on Wal-Mart.

And take them on, Georgia did. For the next several years, Georgia fought the possible development of a Wal-Mart store almost single-handedly. In the end, she—and the Village of Lake Placid—won the fight. Hats off to the matriarch! Georgia Jones is probably the main reason there is no huge, cement Wal-Mart at the top end of Whiteface Inn Road today.

The gentlemen at Aller Camp have come and gone, but the ladies live on. Georgia Jones's granddaughters, Taylor Grace and Savannah Mary, are the seventh generation of Aller Camp inhabitants. "Our lineage is mostly carried through the female side of the family," said Georgia. "It was matriarchal by design."

In 1893, Georgia's great-great grandfather, George Washington Platt, purchased two acres and 100 feet of frontage on Buck Island from a woman named Noble. (Before that time, the land was part of some-

COURTESY OF THE JONES FAMILY

Placid

Georgia's maternal great grandmother, Penelope Bathsheba Potter, on the left and her maternal grandmother, Dr. Georgetta Platt Aller Potter.

COURTESY OF THE JONES FAMILY

Great grandmother Mary Eliza Platt Aller in 1936

COURTESY OF THE JONES FAMILY

1948

Georgia's mother with Georgia's maternal grandmother in 1948

thing called the Adirondack Land Company in New York.) George Platt bought the land for Georgia's great-grandmother, Mary Eliza Platt Aller, known as "Marty" to her family. The following year Marty and her husband built Camp Our Ideal, later changing the name to the Aller Camp.

When Marty died, she left the camp to her daughter, Dr. Georgetta Platt Aller Potter, a general practitioner from Brooklyn, whose husband was also a doctor. When Georgetta died, the camp was left to Georgia's mother, Mary Potter Jones, bypassing Mary Potter Jones' husband, Binion. When Mary Potter Jones died, Camp Aller was left to Georgia and her sister, Roxanne. Georgia's daughter, Katherine, now summers there, and so does Georgia's son, Jeffrey, his wife, Fiona, and their daughters, Taylor Grace and Savannah Mary.

If Georgia Jones ever has a great-granddaughter, it is a pretty safe bet she will summer at Camp Aller too.

The Aller Camp is tucked behind a grove of cedar trees on the south side of Buck Island, at the eastern entrance to Sunset Strait. The camp was once large and roomy, with a separate barn for the "rent-a-cow" leased from the Lake Placid Club farms for the summer, so that Harris Aller, who was born in 1896, could be provided with fresh milk. There was a "mad room" for anyone not behaving or not getting along—a place to pound a piano, read a book, or work it off. Georgia still has the plans and deed for the original house. The old house wasn't pretentious; the old camps never were.

"There was no such thing back then as a trophy house—I find them unsettling, disturbing and objectionable, anyway," said Georgia. Georgia's idea of a castle is Highwall, a large camp near Aller on the east side of Buck Island once owned by Bessie Benson Emerson. It has a sense of scale and is not pretentious—inside or out.

"I think Highwall is outrageously beautiful with all that native stone," said Georgia. "Even if we had the wealth that some people have today, it would never occur to us to show it. We might shore things up, straighten them out, or be less primitive. But that's about it. That's the way we were raised. It's part of our life style and heritage—a New England-type concept of life. We like our walls leaning, our floors uneven. That's just the way our family is."

Georgia's grandmother's brother, T. Gustin Aller, was a dental surgeon who served in World War I. When T. Gustin Aller died of the Spanish flu, the family was devastated and went into a long mourning. The Aller Camp was unattended

throughout the 1920s, and consequently fell into a state of disrepair. Georgia's mother and her mother's brother came to Placid Lake in 1929 when they were both in college, looked everything over and fell in love with the place all over again. Neither of them wanted to let the camp go, so they negotiated a deal with Georgia's great-grandmother, Mary Eliza Platt Aller, who was still alive.

In 1936, the original Aller Camp was torn down, and a new camp was reconstructed. "My great-grandmother, Mary Aller, was the only one during those Depression years who had enough money to fix it up," remembers Georgia. As in many of these stories, the matriarch to the rescue.

The diamond-paned windows, nail-ridden doors and local stonework in the original house were removed and incorporated into the new cabin. Years later, a cabin for extra guests was constructed on the hill. "The overflow cabin is woefully small and there are not enough bedrooms—but how many rooms do you really need?" asks Georgia. "We should be outside anyway." Both cabins are now brimming with family memorabilia and artefacts, some of them over 100 years old.

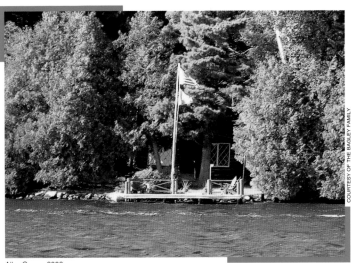

Aller Camp, 2003

Because it is located on an island, there is a romantic and distant quality to everyday life at the Aller Camp. Time slows down. The nights are quiet. Georgia Jones has always loved the ambiance of island life. She first came to Aller when she was five months old. "My earliest memory is falling off the dock," said Georgia. "I was maybe three. My sister grabbed me and yanked me back up. It never put me off the water, though."

Georgia's early years on Placid Lake took place during turbulent times. The U.S. had just entered World War II and was coming out of the Great Depression. Camp Aller was an escape from all that. Even though gasoline was rationed, Georgia and her sister, Roxanne, would make the eight-hour drive from Syracuse with their grandmother, Dr. Georgetta Platt Aller Potter, and, sometimes, with their parents who both worked full time. It was very quiet on the lake; there were very few boats. Various friends, mostly women and children, came and went. But, because they were on an island, people couldn't just arrive out of thin air on their front doorstep.

They still can't. "You need a boat to get here, so we're set apart," said Georgia. "Some people don't like the isolation, or the confinement. I've seen families move onto the island, stay six or seven years, then vacate. It's too distant for them, and they always have to get in a boat to go anywhere." All of this isolation and confinement may have put others off, but it only served to deepen Georgia's understanding and appreciation for the lake as her pristine refuge.

Because both of Georgia's parents worked—her mother was a social worker and her father was in the steel business—her grandmother used to bring Georgia and her sister, Roxanne, to Aller Camp for the entire summer. There was another reason they stayed so long. Tuberculosis was prevalent in those days, and polio, too. Her grandmother, Dr. Georgetta Potter, would take the girls out of school early and keep them on the island until after the New York State Fair was over, when the weather broke.

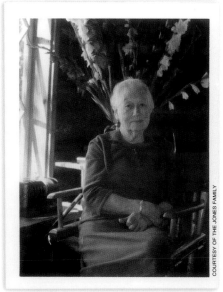

COURTESY OF THE JONES FAMILY

Dr. Georgetta Platt Aller Potter in Aller Camp's living room

RULES

ALLER CAMP needs your help because she is old and wise.
Let's keep her happy for the next 100 years!

NO YELLING (Only if you're in trouble)

ALL CLOTHES HUNG UP
(Chairs are for sitting, not hanging)

ALL TOWELS GET HUNG UP AND ONLY ONE
PER PERSON PER DAY

BEDS ARE TO BE MADE IN THE MORNING
WHEN YOU GET UP

ALL PADDLES AND LIFT VESTS AND WATER THINGS
RETURNED
AND HUNG IN PLACE IN THE BOATHOUSE
AT THE END OF THE DAY

ALL BOATS PROPERLY TIED UP AND RETURNED
TO THEIR PLACES

ALL BOATS BAILED AND CHECKED
RIGHT AFTER A RAIN STORM

ALL DISHES WIPED AND PUT AWAY AFTER DINNER

NO GARBAGE LEFT OUT ANYWHERE
(Raccoons and bears are hungry)

NO FOOD ON BEDS

PLEASE READ THE SHORE OWNERS' RULES
FOR THE LAKE

KINDNESS IS ESSENTIAL AND SO IS SWEEPING
AND PICKING UP

BE RESPECTFUL OF OTHERS. BE HAPPY,
ENJOY AND LOVE

Because of the threat of contracting TB or polio, Georgia's grandmother wouldn't let Georgia or Roxanne go into crowds. Placid Lake was considered by both "doctor" grandparents to be an antidote, though getting there could sometimes be considered hazardous. "My sister and I were told to hold our breath when we drove through Saranac Lake, so we wouldn't inhale any germs," remembers Georgia. "We weren't allowed to stop, never ate a meal there and didn't go to the markets or the circus. We weren't allowed to swim in any lake, other than Placid. All these things were considered too infectious."

Once Georgia and her sister arrived on Buck Island, her grandmother relaxed and stopped worrying about the germs. "My grandmother was big on fitness," Georgia said. "She made us swim in the lake every day. But other than our obligatory daily swim, nobody paid a lot of attention to us. There were kids our age all over the place. We were allowed to play everywhere. It was like living in a giant tree house in the woods."

When Georgia was only six years old, her grandmother gave her a homemade kayak and allowed her to paddle along the shore to Eleanor Lamb's camp nearby—because Georgia already knew how to swim. "We used to bushwack to Highwall to play with Gael Smith Arnold and her brother Tony Smith; the Rosenwald kids lived on the other side in the Jacobs camp," said Georgia. "We'd all get hammers and nails and build our own rafts out of scrap lumber."

Each day after lunch, Georgia and Roxanne had "down" time. They would lay around in hammocks, sipping coke out of glass bottles and singing songs. Life was unstructured and pretty wonderful. Yet there were things one was expected to do as a matter of course. Civility was at the top of the list. Everyone was expected to participate in the running of the camp. Georgia's grandmother ran a tight little ship. Her list of rules that still hangs in Camp Aller's kitchen today says it all. Notice the gender of the camp in the list.

Many of Georgia's friends employed big staffs at their camps. Georgia's friends' parents used to make their children come home at mealtime, so the help wouldn't quit. Her friends hated being on that kind of a schedule and used to love spending time at the Aller Camp because Georgia's grandmother's rules weren't so restrictive. "As long as we were reasonably responsible, Grandma let us do what we wanted to do," remembers Georgia.

And, because she was a doctor, Georgia's grandmother could handle most things that came along. Dr. Georgetta Potter was an enlightened woman, especially for her era, and capable of doing just about everything—a great role model for Georgia. "She kept us busy," said Georgia. "We didn't have hot water or electricity, so at night we lit kerosene lamps and heated our bath water on the stove. After dinner we'd play board games or solitaire. At 9:30 p.m. when the train whistle blew, it was lights out. When we went to bed, we were exhausted."

In the mid 1950s, Georgia would motor over to town and dock at the George & Bliss landing. She'd park at the marina, and her date would meet her there. If Georgia wanted to leave in a hurry, she could just jump in her boat and go. "I loved it. Sometimes I would get lost in the fog driving home, but I was never afraid."

As she grew older, Georgia went to the Grandview Hotel or Whiteface Inn with the Rosenwald boys who are still her oldest and closet friends; or she partied in the woods. "I couldn't go to the Lake Placid Club with my Jewish friends, so therefore I wouldn't go," said Georgia. "I learned to play tennis on beautiful well-groomed courts all around the lake, not at the Club. I knew this set me apart, but I didn't care."

Georgia's grandmother had been raised in a liberal family, and this rubbed off on Georgia and her sister. When Dr. Georgetta Potter first came to Lake Placid, she stayed at Bonnie Blink cottage—part of the Lake Placid Club. But sometime in the 1930s, Georgetta decided she didn't care too much for the Club—a lot of her acquaintances and connections were Jewish, and the Club was just too anti-Semitic for her. "We never went there when we were growing up," said Georgia. "Grandma said it was off-limits and that was the end of that."

By the age of five, Georgia was already trying to figure out a way to stay in Lake Placid permanently. "I never really wanted to live anywhere else," she said. "I would have married the first guy who asked me—if he lived here. But nobody ever did. I would have married him just to stay here."

Georgia Jones on Whiteface Landing circa 1944

Georgia and her sister, Roxanne, with Tom and Peter Rosenwald on Camp Oom Soo Wee's dock, 1941

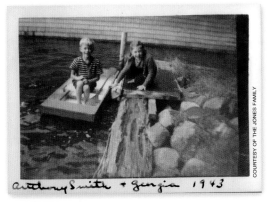
Georgia with Tony Smith at Camp Highwall, 1943

Georgia did eventually marry Arthur Volmrich—who was not from Lake Placid. When she and Arthur were divorced in 1974, Georgia moved permanently to Lake Placid and is now partnered with Don Jones, the owner and manager of Jones' Outfitters in the Village of Lake Placid.

"I lived in Chicago, went to college at Alfred University and moved three times before I finally ended up here," said Georgia. "I always came back to Placid Lake, every summer. I always knew this was where I wanted to be."

Georgia is very much a part of the Lake Placid community and serves on the Town of North Elba Planning Commission, the boards of the National Sports Academy Board, the Olympic and Winter Sports Museum, and the Placid Lake Foundation. She is the current president of the Lake Placid Shore Owners' Association and works daily at Jones' Outfitters. Living in town and growing up on the island, she has one foot in each world.

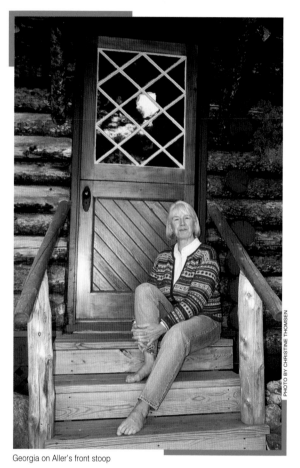

Georgia on Aller's front stoop

PHOTO BY CHRISTINE THOMSEN

Like the matriarchs who came before her, Georgia Jones is not afraid of controversy. She is a fierce defendant of Placid Lake and more than willing to "go to bat" when she thinks something destructive is happening to its waters, its shoreline or its view shed—a contractor dumping into the lake, a shore owner building an illegal boathouse, or a leaky septic system. Georgia fought the possible development of a Wal-Mart store at the edge of town almost single-handedly. She has attended umpteen board meetings and hearings, speaking with a passion and vigor that is sometimes blunt, but nevertheless honest and articulate. Like the line of matriarchs she comes from, Georgia is intensely loyal to her lake.

Although she moves comfortably in both worlds, Georgia often finds herself embroiled in issues that pit the town people against the summer people. "I have a different perspective," said Georgia. "Sometimes I wear too many hats. It's an odd position to be in, representing the lake people when you're also appointed to the town board. When I'm in town speaking about lake matters, I represent the lake and its owners. I have to be a little careful."

It is not surprising to find Georgia smack in the middle of contentious issues—like the banning of jet skis, the relocation of a local school or the enforcement of building codes. Outspoken and forthright, Georgia has made a few enemies along the way. "But now, older and I hope wiser, I'm trying to mend the fences," said Georgia.

Georgia wasn't always such a devoted advocate. "Of course I loved the lake and the woods, but I didn't have the enlightened concern I do now," said Georgia. "Back when I was a girl, there weren't that many of us on the lake. We didn't have a village dump. There was a pit in the ground behind each camp. We'd recycle out the back door—by burying our cans and bottles in holes in the woods. I don't think we were deliberately polluting; there just wasn't any other option. Sometimes, we took stuff out to the middle of the lake and dumped it overboard. I remember as soon as we got electricity, we hauled these old Victorian kerosene lamps out in a wooden boat and threw them all overboard. We watched them plunk, then disappear and go down. There must be a treasure trove at the bottom of this lake, because I know we weren't the only ones dumping things."

Indeed, many others on the lake probably did the same thing, as a matter of practice. "There's a huge garbage abyss down there, at the bottom of the lake, and I hope it never comes back to haunt us," said Georgia.

Five years ago, the Shore Owners' Association of Lake Placid hired a barge that took 22 tons of accumulated junk out of the woods on the lake—railroad tracks, old metal bedsprings, oil tanks, a jeep, corroded pipes—an incredible amount of garbage. "Now, there is a more heightened awareness of environmental issues," says Georgia. "Thank God, much greater care is given to the lake."

Like other Ladies of the Lake, Georgia Jones continues to be concerned about development and growth in the Lake Placid area. "I guess we're lucky we have such a lousy, long winter," said Georgia. "Living in Lake Placid on those 20 below zero days doesn't appeal to a lot of people. That—and the fact that Lake Placid doesn't have an airport runway suitable for corporate jets—is our built-in safeguard. The truth is, we do have a lot to be grateful for. The lake is still clear. The air is still clean. The woods are still wild. And I, for one, am going to do everything in my power to keep it that way."

So that unborn, unknown great-granddaughter of Georgia Jones will be able to say the same thing. Seven generations of strong Aller Camp matriarchs would, at the very least, expect as much from the eighth.

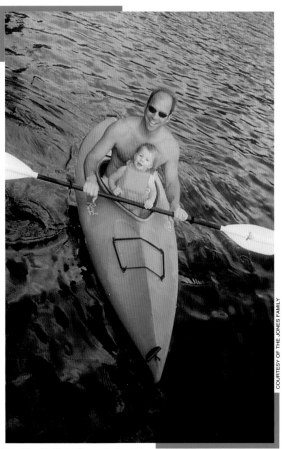

Granddaughter Taylor Grace with Georgia's son, Jeff, 2002

When Day Is Done (1941)

K R I S H A N S E N

A Real Camp for Kids

Our children learned to drive a boat at a very early age while sitting on their father's lap. Born fifteen months apart, Forth and Sarah could each start the engine on the Tin Kan, our aluminum rowboat, by the time they were seven—they used to circle our floating dock until they ran out of gas. By the time they turned 11 years old, both could dock the Kan Kan, our 1955 Century speedboat, without tearing off its wooden siding (something it took me longer to master). In their early teens, Forth and Sarah learned to take each other water skiing. By the time they were 12 and 13 years old, all they were missing was a legitimate boating license.

The lack of this licensure became even more of an issue when Colt and I learned that Camp Midwood's boathouse was located right next to Camp Whoda Thunkit, the residence of Placid Lake's constable, Johnny Rickard. New York state law stipulates that children over 16 may drive a boat on Placid Lake without a license. But neither Forth nor Sarah could wait that long; they wanted their freedom now (at the same time Colt and I wanted to avoid prison). As parents, surely the conscientious, neighborly and law-abiding thing for us to do was to get them a boating license. But how?

Many phone calls later, our prayers were answered by a woman named Kris Hansen, the owner and operator of Camp Woodsmoke on Placid Lake's western shore. Kris Hansen not only ran an overnight camp for boys and girls at Woodsmoke, she also provided services for children who summered on the lake, like the issuance of proper boating licenses.

I telephoned Kris and arranged to bring both Forth and Sarah around for their written exam, expecting to be grilled about their illegitimate boating skills. Kris Hansen couldn't have been more gracious and I was spared the lecture. But Kris was no nonsense. Kris made sure Forth and Sarah knew every single rule of the "boating" road—night or day—before she passed them.

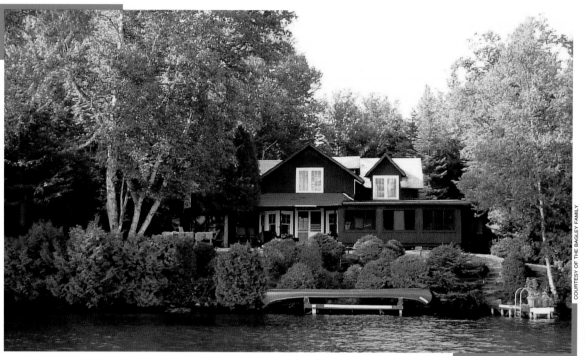
Camp Woodsmoke, 2003

When most people think of a camp on Placid Lake, they think of children. In actual fact, there is only one real children's camp still in existence on the lake: that is Camp Woodsmoke, nestled in a quiet cove called Echo Bay at the foot of Whiteface Mountain on the upper end of West Lake.

Camp Woodsmoke was originally the caretaker's cabin for Echo Lodge, one of the early hostels for summer guests, built by Addie Mallory in 1880. Since 1895, there have been five intervening owners; Echo Lodge was once part of the Calvin Pardee family estate, which included 2,000 acres that ran up the Placid Lake side of Whiteface, and over the top of the mountain. After World War II, Echo Lodge lay idle until 1964 when it became a camp for kids, thanks to its down-to-earth owner and director, Kris Hansen.

Camp Woodsmoke is now an institution on Placid Lake and so is Kris Hansen. Together with her partner, Jane Bacon, and a loyal and committed staff, Kris has devoted the last 40 years of her life to offering children between seven and 15 a total camping experience. Woodsmoke campers, limited to 50 per session, stay in Adirondack log cabins or tents with hot showers and flush toilets. The food is plentiful and wholesome. There are limited day camp facilities for children who summer on the lake.

A Woodsmoke day starts with reveille every morning at 7:00 a.m. On offer are a host of summer sports and experiences: water skiing, orienteering, cooking, wind surfing, woodcraft and crafts, hiking and climbing, fishing, wilderness survival, skin diving, wilderness appreciation, guitar and harmonica, kayaking and war canoeing. The list is long and wonderful, and makes you want to be a kid again. "By 9:00 p.m.," said Kris, "the campers are half-asleep and begging to go to bed. Let's just say they have a busy day."

Kris Hansen must be doing something right. Camp Woodsmoke boasts a 90% return rate, even though Kris spends no money on promotion and the camp's lone television set stays locked in a closet. Parents like it as much as the kids do. They often ask Kris, "When are you going to open a camp for adults?"

Kris Hansen was enticed to Placid Lake by various events in her life. In 1953, she brought her students from Briarcliff Manor School to Whiteface Mountain for a ski weekend. "Coming originally from Michigan, I wasn't exactly attuned to the mountains," said Kris. "But I fell in love with the mountains and the area and from that point on never really left."

After a teaching stint in Michigan, Kris became the Lake Placid Club Program Director in 1956, organizing its summer day camp programs as well as winter sports like skiing and skating. Her family joined the Club as members at approximately the same time.

Later still, after seven years of owning and operating a camp in Maine, Kris had a fortuitous conversation with Dr. Herbert Bergamini, a local Lake Placid physician. (Kris always had her annual physical with Dr. Bergamini whenever she came back to town and they were friends. She called him "Hub.") Dr. Bergamini was into airplane gliding and had just spent the morning flying over "beautiful land" at the far end of Placid Lake. Owned by the Pardee estate, the land was part of acreage the Pardee family had recently deeded to the state of New York. (Today, the area comprises Whiteface State Park and the lookout complex on the peak of the mountain where an elevator, dug deep into rock, takes visitors to the very summit.) The state had recently taken over the unoccupied buildings on the Echo Lodge property and was in the process of removing them.

"It's such a shame," Dr. Bergamini told Kris. "The state is towing the buildings out onto the lake and burning them." (Kris would later spend 10 years pulling metal debris and burnt lumber out of Camp Woodsmoke's swimming area.) Dr. Bergamini posed the obvious question: Shouldn't Kris come back to Placid Lake permanently, rescue the caretaker's cabin and start her own children's camp at Echo Lodge?

Kris returned to Maine. That weekend an ex-camper and her husband arrived in Maine out of the blue. "They followed me down to my cabin to talk to me," said Kris. "The wife told me she was still in love with the camp I was running in Maine—as ex-campers usually are. She confessed she had always dreamed of buying my camp and directing it. Without hesitating I asked her, 'Well, would you like to?' I didn't have to think about it; my response was pure instinct. Minutes later, we shook hands. It was all very fortuitous. That night I called Hub (Dr. Bergamini) to ask him if the Pardee property was still available."

Luckily for Kris, it was. That spring, Kris purchased the 16 acres, the caretaker's camp and a small log cabin built in 1881 that, according to Mrs. Mary MacKenzie, the historian of the Village of Lake Placid and the Town of North Elba, is the oldest original structure still in existence on Placid Lake.

Addie Mallory's sister, Sarah Molloy, was a landscape painter who had used the cabin as a teaching studio for a tented colony of fellow artists in the late 1800s. The artists came down from Canada and up from New York City, pitched their tents out on the Echo Bay peninsula and painted Whiteface Mountain. *The Essex County Republican*, in its August 4, 1881 issue, reported: "Mrs. Molloy's pictures are soft and fine in tone and quite accurate in their essential features. Persons wishing to learn to sketch and paint from nature will find a good teacher and good practice by coming here to receive instruction." Later, the caretaker of the Calvin Pardee estate lived in that same log cabin in the wintertime.

With the help of her father, an architectural contractor, Kris went to work. The biggest challenge—lack of road access—was also Camp Woodsmoke's best feature. The lack of easy access allowed Kris to create a world where children could first of all be safe. The camp's location was remote, some five miles down a shoreline, away from human contact. It made for a pioneer-like environment where the campers could learn about nature and life and themselves.

Oldest structure on Placid Lake (1881)

"I've always been overly protective," said Kris. "I know most of my campers are here to escape the noise of the city. I want them to have a camping experience in a safe, peaceful environment. Because of our remote and woodsy location, not many people can get to us. We've never had the security issues other camps have."

Without road access, the problems of construction seemed, in the beginning, insurmountable. Kris faced an exhausting and financially risky summer. There were no big barges on the lake back then, so every-thing had to be dragged in or out by boat, or delivered by a lumber company the following winter on a truck that traveled over the frozen lake.

The water for the camp was pumped from the lake, and the system needed repair. The original septic system consisted of a big hole in the ground at the crest of the hill above the main cabin. Kris had to supplement this with a new system some 600 feet from the lake, acceptable to code at the time. This was in the era before functioning machinery could be brought across the lake, so the septic system was for the most part dug by hand. After laboring to build log cabins, tents, hot showers, flush toilets, a swim-ming dock, and a water filtration system, Kris welcomed her first 10 campers—all of them girls—into her eight-week program in July of 1964.

By Kris's standards, the first season was an immediate success. One night that first August, Kris and her campers were sitting down for dinner. Out of the clear blue there was a clap of thunder and a flash of light. "We smelled something funny, so we rushed outside," said Kris. "It turned out that a bolt of light-ning had blown the water pump some 30 feet below the surface of the water and had traveled along the pipe into the woods. The damaged tree above the end of the pipe was steaming and its bark was smok-ing. The girls stood there, looking at it, in tears. The lightning had attacked 'their' tree—their love of nature." Kris knew then that buying Echo Lodge had been the right decision. "We were getting our mes-sage through at Woodsmoke," she remembers thinking.

Gradually, Kris adapted her program by going coed in 1973 and by offering two-, four-, six-and eight week sessions. Woodsmoke was one of the first camps to recognize that the era of sending a child away for the whole summer was over. If Kris offered her sessions in shorter sessions, took in both boys and girls, and introduced day campers, Woodsmoke would always be full.

Kris believes in individual attention and concern. She now has a staff to camper ratio of 30 to 65, more than exceeding the industry standard. "I really don't care for those camps with 600-700 children," said Kris. "You can't possibly know where they all are, or what's going on."

Woodsmoke campsite

The camp may be small, but Camp Woodsmoke is not homogeneous. The staff is from all over the world and provides language exposure—just in the act of doing. The sailing counselors are from England, the head of Arts and Crafts is from Egypt. There are counselors from France, China, Slovakia and Germany. And the composition of campers is just as diverse. "We've had every kind of child here imaginable—from Jane Fonda as a youngster, to Norman Vincent Peale's daughter, to children from the local area who are provided with scholarships," said Kris.

Campers at Camp Woodsmoke

And the programs keep expanding. Kris' partner of 30 years, Jane Bacon, leads a five-day oceanography trip on her nephew's schooner out of Booth Bay, Maine. Campers can qualify for certification in American National Red Cross Swimming and Community Water Safety. They are eligible for American Red Cross Certification in canoeing and sailing, for American National Red Cross First Aid and CPR, and for certification in the National Camp Archery Association.

When Camp Woodsmoke first began in 1964, there were seven other children's camps on Placid Lake. Not one of them exists today. Most had transportation problems; all of them were unable to make the numbers work. "A lot of sad things happened," said Kris. "When the Boy Scouts abandoned their camp on Moose Island, they loaded rocks on their sailboats and sent them down a marine railroad straight to the bottom of the lake. God knows what else is down there."

After surviving the early "building" years and a year or two of test programming, Camp Woodsmoke has been profitable. Financial issues continue to threaten all camps. The Federal Clean Water Act and the New York State Health Department required Kris to install a new chlorination and filtration system to

comply with code, "costly for our beautifully clear H_2O in Placid Lake." After September 11, 2001, Kris's insurance company for some reason insisted she spend $20,000 on a huge protective shield over the kitchen stove. Other costs of supporting a camp in such a remote location continue to rise—transportation, food and staffing.

Each spring, Kris and her staff spend a full two months assembling the camp. There are no shortcuts and everything depends on the weather—and the black flies. After the campers leave at the end of the season, tents need to be dried out, docks dismantled, the fleet of Sunfish sailboats brought up on land, and pipes drained for the winter months.

Kris, still smiling

Kris continues to live her dream of keeping the camp "forever wild." Now that she has bought the remaining two acres of Pardee property, Camp Woodsmoke is bordered on all sides by state land, with the exception of Dr. Evans' property next door, to the south.

When she first purchased Woodsmoke in 1964, Kris decided she wanted to keep the original buildings as they were. With the exception of several wood-floored tents, she has made only temporary additions to the property, so the camp can always be returned to its original state. Kris's campers enjoy a truly historical and rustic experience in the woods. "It was such a dream to begin with, we wanted to keep it the way it was," said Kris.

Kris is legislative chair of the American Camping Association's Upstate Board and chairperson of the Camp Safety Advisory Council for the State of New York. In 1966, Kris received the Bernice Scott Award for Excellence in the Field of Camping. A former president of the Lake Placid Shore Owners' Association, Kris continues to care about the lake in the most uncompromising terms.

"The tubers are riling the water up, racing in circles," said Kris. "The jet skis have been banned on 95% of the lake, but we continue to have incidents. This summer, one person dragged a jet ski all the way down to Echo Bay, where we were holding a sailing regatta. He raced back and forth next to the sailing course—we had four safety boats and 11 sailboats out there—just to make an impression. How stupid, how much fun was that?"

Kris also feels too many boathouses are being built on the lake, some of them illegally. She worries that shore owners have waited too long to make changes to assure the quality of the water. And, she is concerned about sewage issues. "At first, I didn't like the fact that the state was buying up land, but now I see what a good thing that was," said Kris. "Believe me, we are on the most peaceful part of the lake because of it."

Kris turned 72 this summer. She is still spry, and her quick blue eyes miss nothing. "But who wants an old wheelchair camp director around here?" she asks. Kris has tried to retire, to back off slowly by eliminating the day camp portion of her program. There was a huge outcry from the lake people and Kris had to reinstate it.

"The phone didn't stop ringing," remembers Kris. "One caller said, 'If it's a financial issue, call me immediately.' I told him it wasn't a financial issue, it was an age issue!" She has received many high-priced offers for the camp. "Every moment I ask myself, 'Have I had enough? Have my campers had enough of me?'"

Lady of the Lake picking up at Camp Woodsmoke's dock

Kris knows she could sell Camp Woodsmoke for a tidy sum and travel for the rest her life. "I might see other parts of the world, but I don't know I'd find more beauty than what I have right here. I just can't walk out the door. I have no plans to leave. They are going to have to carry me out of here." Kris hands me an email that reads:

"While my son is only nine months old, I understand it would be wise to get a rate quote and possibly book a reservation for him as soon as possible since there is a waiting list. Can you give me an idea what it would cost to send him when he's seven years old, for a two-week stay? I realize these figures may be approximate. Or could you tell me what it will be for the year 2003, and I can add a percentage for every year between now and 2008."

In the year 2008, Kris Hansen will be 79 years old. Chances are good that Kris will be on Camp Woodsmoke's dock greeting that seven-year-old camper when he jumps off the tour boat, the *Lady of the Lake.*

"She'll Always Remember" (1942)

COURTESY OF JANE ACKERMAN

JANE BENSON ACKERMAN

Connections

Colt and I learned we had a relative on the lake when his "Aunt Mimi," otherwise known as Margaret Emerson Noyes Banks, came to visit us at Camp Midwood one summer. It turns out that Aunt Mimi had summered at Highwall on Buck Island as a child, with her mother, Helen Benson Emerson, her grandfather, Charles Francis Emerson and her maternal grandmother, Bessie Benson Emerson. Bessie Benson Emerson was the owner of Highwall and the sister of William Sumner Benson (who is also the grandfather of Placid Lake resident David H. Ackerman). Hence, we family-loving Bagley's thought we were, through distant relations, part of the Ackerman clan.

David Ackerman is a well-known historian in the Placid Lake area. A one time president of the Shore Owners Association of Lake Placid, the founder of the Placid Lake Foundation and the author of two books on Lake Placid history and culture, David is a passionate, if not effusive, spokesman for the environment and for Placid Lake itself. If there were such a book, David would certainly be included in one entitled, Gentlemen of the Lake.

We Bagley's were honored to be in such good company. Unfortunately, after much research, it turns out that Colt's "Aunt Mimi" is but a third cousin of David Ackerman's, which makes Colt, in the exact words of his Aunt Mimi, "nothing," no relation at all.

That news didn't stop me from wanting David's wife, Liz Ackerman, included in my book. When I called Liz, she refused to be interviewed as a Lady of the Lake. Well, refused isn't exactly the word. She insisted I interview her daughter, Jane Benson Ackerman, instead. Like her father, Jane has an abiding passion and a keen interest in family history and the history of Placid Lake. And, with a middle name like Benson, maybe, just maybe, we are related after all?

*T*here is an old Ackerman family anecdote that describes how Jane's father, David Ackerman, came to Camp Majano on Buck Island in the summer of 1925 as a newborn, tucked inside a laundry basket in the back of his grandfather's mahogany Fay and Bowen speedboat, the *Majano*.

The story then continues to describe how his daughter, Jane Benson Ackerman, came to Placid Lake in exactly the same way, as a newborn in a similar boat, a generation later. "There's a version of that story, less often told, that intimates I was conceived on the shores of the lake," Jane says with a smile. "It certainly makes sense. How else can you explain my intense feelings of connection? Placid Lake is more essential to me than any place on earth. It's in my blood."

Jane's great-grandfather, William Sumner Benson, built Camp Majano (the vaguely Native American-sounding name came from an amalgamation of his children's names) in 1915 on a point of land on Buck Island called Cape Marie. In the 1890s, Cape Marie was a popular camping and picnicking site for locals and visitors alike; it had a campfire ring and grassy picnic area, and plenty of land for setting up tents with a direct and breathtaking view of Whiteface Mountain.

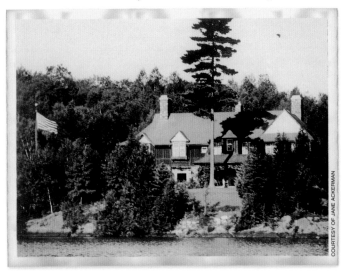

Camp Majano, circa early 1930's

William Sumner Benson knew that Placid Lake was a genial location for a family fond of the outdoors; he had tramped around the Adirondacks as a young man and knew the northern woods well. William's brother, Rob, had acquired in 1911 an existing camp next door to Cape Marie and named it Schonoe (pronounced Shawn-away). Shortly thereafter, Rob also purchased the Cape Marie site itself. W.S. Benson bought the rocky point from his brother in 1915.

About the same time that William built Majano, his sister, Bessie Benson Emerson, and her husband, Charles, built their own camp, Highwall, on the other side of Schonoe, on property also once owned by her brother, Rob. William Benson, together with his two siblings, then owned nearly a mile of shoreline stretching around the tip of Cape Marie.

In 1922, with his grandchildren getting older and noisier and coming to camp more often, William Benson bought the camp on the other side of Majano, Unterwalden (later changed to Canadohta), for his daughter, Sarah Jane Benson Ackerman (David Ackerman's mother) and her growing family. So, for a very long time there were four Benson camps next door to each other.

In those early days, getting to the camp was a logistical challenge. Sometimes the journey could take three days. Jane's grandmother, Sarah Jane Benson Ackerman, once reported a total of 11 tire changes on the way up from New Jersey. Sometimes the family would put the car on a night boat in New York City, which arrived the next day in Albany. Other times, they would take a steam train all the way from New York City to Lake Placid. Once in Lake Placid, the family was taxied to the landing, where they made their way to Buck Island by boat.

"They came up from New Jersey with their families and nannies and cooks—the whole kit and caboodle—and stayed for the whole summer, every summer," remembers Jane. "They had elaborate, beautiful gardens, the bones of which were still there when I was a child—perennial beds, a stone Koi pool, and a rock garden. Probably a vegetable garden, too. My father could tell you."

Jane relies on her father, David H. Ackerman, to provide the details of the family's long association with Placid Lake. David is an historian and author of two books about the area, *Lake Placid Centennial 1893-1993* and *Lake Placid Club 1895-1980*. Jane and her father have always shared an intense interest in family history and in the history of the Placid Lake community. "My father can be totally relied on for accuracy in that department," said Jane. "I'm always after him to tell me more. As I get older, my appreciation for the lake, and Majano, and its history, deepens. I will never even come close to knowing everything he knows."

Jane remembers listening to "crazy boy" stories of her father's adventures while growing up at Camp Majano. "My dad and his sisters and cousins ran wild all summer long on Buck Island," said Jane. They did the usual outdoor things, like building forts and tree houses, fishing and canoeing.

Jane's father David Ackerman, and his sisters and cousins playing on Majano's beach, 1930

Jane on the same beach in 1961

"But they did crazy stuff too, like converting the top half of a solid brass fire extinguisher into a diving helmet, or pretending to be loggers by rolling logs across the lake while wearing fishing waders," said Jane. "It's a miracle they didn't kill themselves. If they'd fallen off those logs in the middle of the lake, the waders would have instantly filled with water, and they'd have gone straight to the bottom."

Camp Majano was—and is—an enormous house. When Jane and her brother, David Greenlie Ackerman II (he is named after Jane's paternal grandfather), were kids, they used to count the rooms for fun. They could get to 100 if they counted all the walk-in closets and the laundry room. The house was suspended in time. In many ways, living at the camp was like living in an antique. There were old crank telephones, vintage china and silverware, antique toys, monogrammed linens.

As a child, Jane was forever rummaging around in the attic. No one in her family ever threw anything out, so there were old steamer trunks full of woolen bathing suits—the very ones her grandmother and

her grandmother's sister wore—and exotic things, like beautiful parasols and kimonos from Japan. There were bottles and jars of old medicines in the cupboards, and the books her grandmother read when she was a child. "My great-grandparents were avid travelers and liked to bring back interesting things," said Jane. "I still have some of the photos from the 1880s and 1900s—one of my great-grandmother being hefted into a boat on the Nile, another of her on a camel in Tunisia."

In addition to the old photographs, Majano also was filled with souvenirs from Jane's great-grandparents' journeys—wooden boat models, musical instruments, baskets and carvings from Asia and Africa. Jane and her brother, David, used to scare the stuffing out of each other by chasing each other around the house waving a witch doctor's totem pole—a long ebony staff, inlaid and elaborately carved, with a hunk of human scalp and hair attached to one end. "I was a typical little kid and sometimes imagined that my ancestors would creep out of the attic at night," said Jane. "Even though there were a zillion bedrooms, I'd insist on sleeping in the second twin bed in my little brother's room, with my back to David, so my ancestors couldn't watch me."

It is not difficult to understand why growing up in the actual setting of Jane's family history, with its artefacts and its stories, made the details of her forbearer's lives very real to Jane. "In handling these things, I felt instantly connected to my father and my aunts, my grandparents and great-grandparents, and to a time that seemed so impossibly gone. It was at once thrilling, and a little unnerving. I wanted to be close to them, and because their stuff was still there, it was as if they were still there."

Jane adored the steady pace of life at Camp Majano. As a small child, Jane used to sit on the wide front lawn that stretched down to the water's edge and wave at the *Doris* when it went around the lake, trying to get the captain and all his passengers to wave back. (They always did!) As a teenager, Jane would sit on the front dock for entire days, reading through novel after novel rummaged from the bookshelves at camp or from the public library in the village, while waiting for the mail boat (hopefully, the postman would switch the empty leather mail bag, stenciled MAJANO on the front, for a nice, full one). "It's funny," Jane remembers. "Nothing extraordinary happened. We'd do simple things, like noodle around in an old canvas and wood canoe, or dive for round-bottomed bottles off the point. But, it was heaven."

When Bomma (Jane's great-grandmother) died in 1941, Camp Majano was passed first to Jane's grandmother and her grandmother's sister, and then to Jane's father and his three sisters, Juliette, Margaret and Sarah Jane. Candohtoa, also known as Unterwalden, had been sold in the 1950s after Jane's father's grandparents passed away. The other camps in the family, Schonoe and Highwall, had been sold off long ago, too. Jane's father's sisters had families of their own and other places they all wanted to be, so they rarely used the camp. The David Ackerman family was the only one still spending time there.

Camp Majano is a huge place, ark-like and expensive to maintain. The house sits on an island in the middle of a big lake and isn't winterized, so it can only be used part of the year—six months at the very most, and then only if you are very hardy. "My immediate family spent more time there than the rest of the family, and I know it ended up being a lot of work for my dad," said Jane. "He'd spend his vacation time there, trying to keep the place from falling apart. Basically, it became impractical for us to keep it and in 1974 the decision was made to sell it."

Jane was a sophomore in high school when the camp was sold. It was extremely traumatic for her father, and also for Jane. "I'm quite sure it was one of, if not the hardest decisions of his life," said Jane. "I know that Camp Majano meant the world to him. It was full of memories and life-long attachments to his grandparents, parents and cousins, to the island, the woods, and the lake. I felt that way and I only had 16 years of memories, while my father had close to 50 years."

Jane will always remember leaving Camp Majano for the last time. "I remember looking back at it," said Jane. "My father was in tears. It was a very hard good-bye for him. I understand. I still ache for Majano."

It is not surprising that Jane still mourns the loss of the house itself, not just the memories, given the impressionable childhood years she spent there and her close identification with its history. Jane knows her Ackerman grandparents and her Benson great-grandparents much more intimately than the other family branches—because of Camp Majano. Jane can identify all of them in the old photos. "I've slept in their linens. I've used their combs and read their books. Through their everyday objects, they are very present and real to me—even though I know they were dead long before I was born. But I still feel like I know them in a way I might not have otherwise."

Jane pays natural—in a sense subconscious—homage to those who instilled in her a love of Placid Lake through their own intimate absorption of its details. "It has to come from the fact that I love my father so much," said Jane. "He loves the lake; I love the lake. It was always a way for me to get to know him as a person—not just as my dad."

At Majano, Jane's dad taught her to paddle a canoe, to sail their little sailboat called the Carrot, to build a fire and find her way up a mountain. Jane's comfort level for all these things started with her father, at Majano.

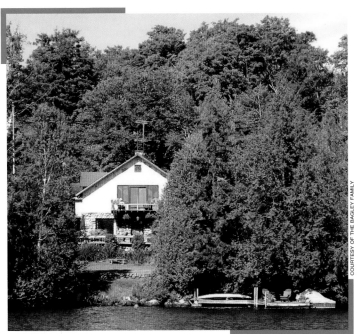
White Birches, 2003

COURTESY OF THE BAGLEY FAMILY

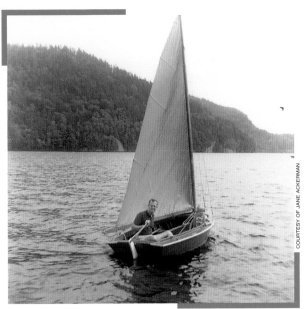
Jane Ackerman and her father, David Ackerman, in the "Carrot," circa 1962

COURTESY OF JANE ACKERMAN

There are also other visceral reactions to the camp for Jane. These feelings probably came from initially watching and absorbing what other family members were moved by as well. "I like the way it smells here, the bracken in the air," said Jane. "I like the color of the sand on the beach—grainy, with flecks of iron. And the particular way the water tastes and the particular way your skin smells after you swim in the lake."

In 1979, Jane's parents bought White Birches on the west shore of Placid Lake, and she visits them there as often as she can. But it is Camp Majano that defines her. Even though she no longer summers at

Majano, she knows how privileged her memories are. "I see now how fortunate I've been, how rarified those early days were," said Jane. "I'm conscious of the fact that my family had the resources to come up to Placid Lake at the most beautiful times of the year, in the summer and during the snowy parts of the winter. We could come and go as we pleased. We weren't trying to make a living, and weren't subject to the ebb and flow of the tourist season—and the changes in the economy that go along with that."

These are factors often overlooked by less sensitive summer residents. The people who stock the groceries and pump the gasoline, maintain the boats and close the camps for the winter, do not usually have the option of coming and going at will.

"When I was very young, I didn't really understand we were part of a moneyed class—though I was fascinated by the displays at the Lake Placid Club depicting its history, and vaguely aware that Placid Lake was a very glamorous place to be in the 1930s and 1940s," said Jane. "I remember references to Lake Placid in some of the Cary Grant-Katherine Hepburn movies I watched on television. But for me, as a youngster, it was all about the mountains, woods and water. It was about the particular taste of the air, and the smell of the tamarack and pine, how the light looked reflecting off the lake, and the mist rising at dawn."

COURTESY OF JANE ACKERMAN

Jane's great grandmother, Juliet Harton Benson, picnicking in her fur coat during the summer of 1916 with Jane's great grandfather, William Sumner Benson

It never felt elitist to Jane. "Now, much later on, I understand it was a world that can never be fully replicated," she said. "I see how lucky I was to be born into such an interesting slice of history—into this amazing world where I could spend my days hunting for blueberries and clambering over rocks, and my evenings watching the sunset from a wooden boat, listening to the echo of my voice bouncing off the mountains. It was a rare, rare privilege."

Older now, Jane can accept the eccentricities and the paradoxes of that former era—like her grandmother "roughing it" in front of a campfire on Moose Island in her fur coat. It was part of what people did in the early 20th century. "Our camp wasn't as elaborate or as remarkable as some," said Jane. "The Great Camps were truly ostentatious. It is utterly fascinating to me that people in the 1880s would lug all that stuff up here by wagon—on roads that were barely roads—and set up these fancy places in the woods. Enormous, ornate complexes built of branches and trees, complete with bowling alleys and formal dining rooms for exotic dress parties. They thought it was good, healthy fun. Fresh air was good for you! And if you happened be also cold and wet—well, you didn't whine about it."

No part of the Benson camp was winterized, so the Ackerman family used to visit the Lake Placid Club in the winter. "I had a faint understanding that it was a place not everyone went to, but it never occurred to me it was founded by people who were unapologetically anti-Semitic," said Jane "As a child, I wouldn't have understood what that meant, even if you told me."

Gradually, however, Jane became aware of the Club's dubious rules. "I learned from my father, for example, about signs, once prominent on the front lawn of the Club, that read 'No Dogs. No Tuberculars. No Hebrews,'" Jane recalls. "Those signs were long gone by the time I was born, but there was an awful real-

ization that for all its gentility and strict code of Christian ethics, the Lake Placid Club had a terrible legacy of discrimination."

It was a tough topic for Jane's father when he was gathering material for his book, *Lake Placid Club 1895-1980*. "My father was aware of the restrictions, and very much wanted to write a complete and accurate account," said Jane. "That meant confronting a part of his heritage about which he is not at all proud. I've actually spent a lot of time thinking about it, trying to come to terms with the unspoken, unacknowledged realities of the Lake Placid Club. As an adult, I'm finally understanding all the implications."

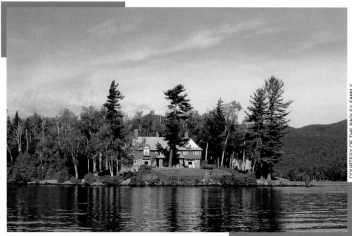

Camp Majano, 2003

And, writing about them, too. Recently Jane, who is a published poet, freelance editor and writer, wrote a screenplay about Placid Lake that she submitted for a masters' thesis at Dartmouth College. Jane is revising the novel into a screenplay.

The story takes place on Placid Lake in 1918-19, and is about a young woman who falls for a Jewish intellectual from Chicago, whose family visits a camp nearby. There are traces of World War I and the impact of the Spanish influenza epidemic features heavily. Many details woven into the story come directly from Jane's family history. The main character, for example, summers on an island. "Many of the stories my dad told me over the years make appearances and have been adapted into the adventures of my characters—albeit totally fictionalized," said Jane.

Jane Benson Ackerman is telling her own history, in a way, through her writing. "I can't let go of the topic," she said. "It's integrated into my sub consciousness; I just can't separate it anymore. Camp Majano is the wallpaper of my childhood. It's who I am."

There is a giant white pine tree on the front lawn of Camp Majano that's been there forever. Jane gets sentimental about that tree. It appears in family photographs over the years, growing old along with everyone else. She loves the fact that all the important family pictures are in front of that tree—like her father's christening, and that of her younger brother, David.

"I know I spend too much time thinking about this," said Jane. "I'm too nostalgic and completely emotionally involved in the lake. My passion for the place is sometimes hard to explain. I can't separate my feelings for Camp Majano and the lake from who I am. But how can you not be moved by the views? Those mountains are staggeringly beautiful, and every summer, that was the view from my bedroom window. I can't imagine anything in the world more amazing."

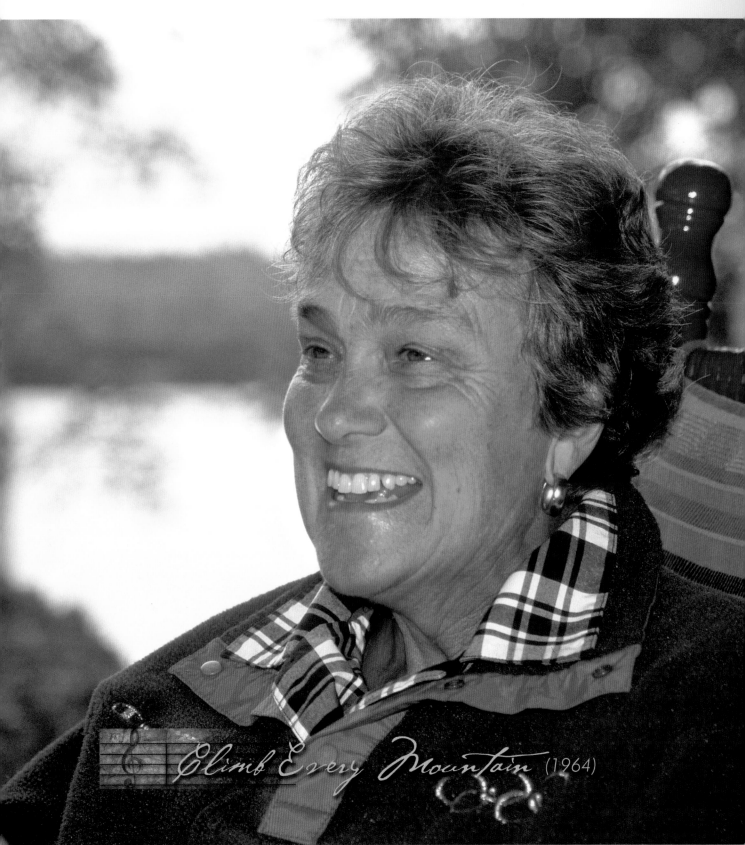

Climb Every Mountain (1964)

PHOTO BY CHRISTINE THOMSEN

C A R O L I N E L U S S I

The Olympian Spirit

Caroline Lussi's reputation preceded her. Years before we were introduced, I knew of Caroline as a former downhill skier, an accomplished "46er" and the owner of the Holiday Inn on Mirror Lake. What I didn't know, and what became evident to me within five minutes of talking to her, was that Caroline processed life differently. As I learned more about her, it became clear to me that, for Caroline, challenge is everything. It is the struggle that counts, the contest—and not necessarily the outcome. Caroline is a true competitor.

After I got to know Caroline better, I thought maybe it was Serge, Caroline's husband, who sparked her spirit and spurred her on. Although they are both in their sixties, the two of them still water and snow ski, wind surf and cross-country ski together, in addition to running their own business. There is no doubt that together, Caroline and Serge are a formidable pair. And clearly, each motivates the other. But, no offense to Serge, I've changed my mind about his influence. It is Caroline who drives Caroline.

Caroline Lussi is lucky to have two spectacular vantage points of Placid Lake. Her Camp Majano is on the north side of Buck Island, resting on a promontory, with a spectacular view of Whiteface Mountain from one side, and the High Peaks range from the other. Caroline can't see her Camp Majano from her winter house on the mainland, at the southernmost end of Placid Lake. But Caroline always knows it's there.

"It's such a contrast," said Caroline. "So different from what other women have. I see life all year round from two places. In the winter I have a huge picture window that overlooks the frozen lake. From there, I can see all the way up East Lake to Whiteface Mountain. In the summer, I can stand on a knoll at Majano and look out over water and the mountains to the north and to the south. It's the biggest treat in the world."

Camp Majano, 2002

In 1975, Caroline and her husband, Serge, bought Camp Majano on Buck Island from the David Ackerman family. In partnership with Martin Stone, a seasonal resident and businessman, Caroline and Serge also bought the Lake Placid Marina and Harbor, the primary terminal for boats on the mainland. Caroline and Serge converted the boathouse at the terminal to an all-season home and moved there from the Holiday Inn, a hotel in the Village of Lake Placid that they own and manage. Both of them wanted to live on Placid Lake.

When Caroline and Serge bought Camp Majano, the grounds were overgrown. The main house had been sporadically occupied for the past 20 years by David Ackerman, a long time Placid Lake seasonal resident, and his three sisters. It had become impractical for David to keep the camp, because none of his sisters wanted to maintain it, and David Ackerman was forced to sell Majano, basically against his will. "It's still a tender subject," said Caroline. "I wish there were more items I could pass on to David to make him feel better. I think I have shared some things he has appreciated."

Built in 1915, Camp Majano is, in a word, huge. The camp still sleeps 32. When Caroline and Serge bought the camp, it needed airing and a cleaning. "Majano was unoccupied for a long time," said Caroline. "I'm trying to go through each room, one at a time. We don't want to change very much. We're trying to retain the flavor of the camp and keep it as it was, a family place."

Caroline and Serge use the camp for water skiing and picnics, for graduation parties and entertaining. "It forces us to live in the present," says Caroline. "I dream of getting older there, watching my grandchildren grow, slowing down, and hanging out. At some point, I just want to go to Majano to read a book and not worry about the business, or my golf score—or opening a new business."

If you stand in the middle of the main room at Camp Majano, your eyes are immediately drawn to the trophies and plaques that line the walls. The rest of the room is sparsely furnished and has an air of disuse about it. Dusty and tarnished, the trophies are not displayed in glittering glass cases, nor brightly lit. Not surprisingly, there is a family rivalry involved here. For, not until each family member earned an equal number were the trophies removed from boxes and drawers and ultimately displayed. The trophies are now part of the woodwork.

The trophies are also a testimony to excellence and a not-so-subtle reminder of hard work and discipline. Some are awards for alpine skiing or slalom, some are for tennis or aerial free style; others are for

academics or golf or sportsmanship. All of them exist because of hard work, but also because of the determination of one woman.

Caroline Draper Lussi was born south of Lake Placid in a small town called Glens Falls. Her father developed Whiteface Mountain's ski resort, the greatest vertical drop east of the Rockies, an extreme skiers paradise. Caroline grew up on the slopes. By the time she was three, Caroline was skiing at North Creek. By the time she was six, she was racing on downhill skis. When she turned 10, Caroline was the gutsy downhill skier who could beat all the boys.

As a member of the Junior USA National team, Caroline competed in Wyoming at the age of 14. As the two-time Junior Eastern Combined Champion, she competed in the Pre-Olympics in Squaw Valley. She was competing for a place on the U.S. Ski Team to compete in the World Championships and the 1960 Olympics when she was injured in Aspen, Colorado. By then, she had not only accumulated boxes of trophies, but also an indomitable, competitive spirit.

Over the next several decades, Caroline would dig deep into this reservoir of purpose and resolve, in sports and in real life. In 1960, she married Serge Lussi, a Lake Placid native whose Swiss father, Gus Lussi, coached world champion Olympic skaters, and whose mother was "Miss Saranac Lake" in the 1932 Olympics. Serge, himself, was a gifted athlete who gave water-skiing lessons on the lake. When Caroline and Serge met, Caroline had never been on water skis. But, in a very short time, all that changed. "Serge introduced me to the water and the lake," said Caroline. "Now, I think I'm the one who treasures it the most."

In addition to challenging each other athletically, Caroline and Serge combined forces in business and operated a motel-restaurant together in Wilmington, New York, until 1969 when they purchased the Holiday Inn in Lake Placid. Caroline and Serge closed on the sale of the Wilmington motel the same day they opened the Holiday Inn. Besides being completely mortgaged to the hilt, they admit to having no experienced staff the day they took over the business.

"We couldn't afford to pay well, so we did several jobs ourselves to get by," said Caroline. "Serge did reservations and I did accounting. The night audit from 11:00 p.m. to 7:00 a.m. was the biggest challenge for me. Sometimes we were short housekeepers, and I cleaned rooms."

Serge and Caroline were fortunate that as their three children (Arthur, Cristy and Katrina) grew older they were able to help out at the Holiday Inn as bellhops and bus-girls. At 14, daughter Cristy was supposed to be a breakfast cook one summer, but ended up being a dishwasher. "It wasn't fair, but she didn't complain," remembers Caroline. "It was so real a necessity that no one ever questioned the need to work."

Over the years, Caroline's children continued to help out during their vacations, filling whatever job needed filling, never staying in the same "department." "I suppose it was good experience for them," said Caroline.

In 1996, Caroline and Serge purchased the defunct Lake Placid Club on the shores of Mirror Lake. Serge had worked at the Club as a caddie when he was a youngster and, when he saw the Club folding, became intrigued with the idea of buying it.

"It wasn't until 1996 that we fulfilled his vision," remembers Caroline. "It's a separate story—our failure to purchase the Club earlier, at auction. Even though we were the highest bidder and had several moneyed partners, the sellers turned us down. We should have been able to buy it then. But Serge and I waited and eventually made another bid. As it turned out, our family ended up purchasing the Club without

any other partners. Time will tell if someone was looking out for our future."

Over the years, the Lussi children have become more and more involved in the business. "We never encouraged them to come back into the business after their education," said Caroline. "Lake Placid brought them back. We never had a game plan for involving them. Life just evolved."

Caroline and Serge are now embarking on another adventure and will continue to need the help of their children. A management company is helping their Lake Placid Resort (the Holiday Inn and the former Lake Placid Club) gain certification as a "Destination Resort."

"We hope it works," said Caroline. "Becoming a Destination Resort will give our family a new dimension and a better hope for the future of the Club property." And, add more dollars and jobs in the local community. Last year, the Lussi's were the largest taxpayers in the Village of Lake Placid and the Town of North Elba.

Caroline's firstborn, Arthur, now a lawyer, handles the family's legal business and manages the Lake Placid Resort operations and the Lake Placid Club real estate sales. His wife, Martina, oversees interior design in the Holiday Inn and the golf and boathouse restaurants and shops. Daughter Cristy is head of Group Sales (conventions and conferences), the mainstay of Lake Placid Resort's business. Daughter Katrina's husband, Rich, used to be Caroline and Serge's financial officer; now that Katrina's family has moved to Massachusetts, she continues to work on Lake Placid Resort business from her home there.

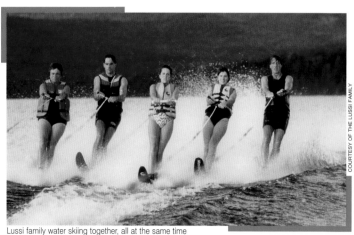

Lussi family water skiing together, all at the same time
(left to right: Caroline, Arthur, Katrina, Cristy and Serge)

It is not surprising that all three Lussi children are gifted athletes and highly competitive. Sports were an important part of their upbringing and Lake Placid was—and is—a great place to do them. With Whiteface Mountain in their backyard, the single most important family event was hiking. (A somewhat harrowing drive to the top of Whiteface, which can be done on a paved road constructed during Roosevelt's New Deal era, is thrilling enough for most people.) All five Lussi's have climbed all 46 of the High Peaks.

"The kids used to cry and hyperventilate, jump in the mud, then enjoy the rest of the hike," said Caroline. "There's something about getting very dirty that makes you forget how tired you are. We hiked Gothics—my favorite— from every direction possible."

But that was not all the Lussi family did together. They water-skied in human pyramids. They cross-country skied to the top of Mount Jo. They snow-skied up Mount Marcy. They climbed Whiteface Mountain several times on its snow-covered highway. They took cross-country trips to Lake Colden and Avalanche Lake, and completed various treks up Mount Seymour. "The kids learned to set realistic goals," said Caroline. "It was a preparation for life. They didn't have to be great, they just had to do great things."

And, great things they each did. Arthur was an alpine skier who competed in the World University Games and was 50th in the world in slalom racing. ("Who can count that high?" his grandfather asked when hearing of Arthur's ranking, and they all laughed.) Arthur also skied and played varsity tennis for

Dartmouth. Cristy was an All-American Collegiate skier for St. Lawrence University, undefeated in tennis for an entire season on the college circuit. Katrina traveled the World Cup Tour as a member of the USA ski team and was 11th in the world in free-style twists, jumps and flips.

During the 1980 Winter Olympics in Lake Placid, Caroline volunteered with her husband, who also served on the Winter Olympics Executive Committee. Between the business and their involvement in the Olympics, Caroline and Serge entertained—and still entertain—a lot. But they try not to lose sight of the environment around them.

"We've had people from all over the world visit us at Camp Majano—some famous, some not—and they're always awed by the beauty of Placid Lake," said Caroline. "They're impressed that we haven't any algae and that the water is clear and clean. The lake hasn't been ruined, despite development and the jet skis. We just need to take care of what we have. Serge and I are doing some developing, but we're not subdividing and selling willy-nilly. We want to be very careful about what makes sense. We're trying to cluster our homes in one spot, so we don't ruin the sense of space."

Caroline is clear about the reason for her concerns. She wants the same kind of lifestyle to continue for her grandchildren. "Memories are an important thread in their lives, even if it's remembering eating off the chipped china with mismatched silverware," said Caroline. "I've watched our own children learn to ski and swim on Placid Lake, and now I watch my grandchildren. They say the same things, like 'I'm scared' or 'this is fun.'" Caroline wants them to remember the simple things.

"At six o'clock this morning, I could hear my grandchildren on the dock," said Caroline. "There was a mist on the lake, which was absolutely flat. I stood on the porch and watched my son-in-law and his two children. He was in the middle of the canoe. With their small paddles in hand, the two-year-old was in the bow and the three-year-old was in the stern. They were rowing their father around and around in circles. It was wonderful: no one else in sight—so pure and safe."

In 2001 and 2002, when Caroline was recovering from breast cancer, she swam twice a day, trying to regain her arm motion. As soon as she didn't have to worry about infection, she got in Placid Lake. It was early summer. There was a loon who would wait for her to get into the lake, and then he would swim along with Caroline, every single morning.

"He was like a guardian angel on my shoulder," remembers Caroline. "When I was bed-ridden in New York City and undergoing treatment, I used to dream of being able to see the wonder of life every day, in front of me like that. My doctor in New York told me to have my chemo at home in Lake Placid, that nothing would be better for me. He was right. No matter how awful I felt, I could look out over Placid Lake and feel wonderful. I know I was blessed. I know I was very privileged and fortunate to have it."

Caroline has a full life, but she always comes back to her lake. "It's my escape from stress," she said. "I don't have to pretend to be anything here. When I'm on the lake, I'm just plain old me. Just a basic person. Someone who is who she is, way underneath it all."

Caroline loves putting on her sweatshirt and jeans. She loves going out on the water. "I'm comfortable here, safe, at peace with myself," said Caroline. "Just me and my lake and the friendly old mountains."

And, her indomitable spirit.

My Buddy (1940)

PHOTO BY CHRISTINE THOMSEN

PEGGY BEEBE AND PAT EDGERTON

Best of Friends

The Village of Lake Placid recently constructed a three-mile brick path along the shores of Mirror Lake. My daughter, Sarah, and I sometimes walk the path in the morning, along with many other Lake Placid residents and visitors. One day last summer, Sarah and I noticed two elderly women walking ahead of us, one of them holding a notebook and pen. Every 20 yards or so, the two women would stop, look down at the brick path, then one of them would scribble something in the notebook. The two women seemed to be on some kind of a mission.

I was less curious about the mission than I was about their body language. The two of them seemed so close, like they were sisters, or mother and daughter. Whatever they were doing, they were obviously enjoying it, and enjoying each other's company. Every so often, the women would sit down on one of the benches along the path, just to chat, before resuming their mission.

I found out later that Peggy Beebe and Pat Edgerton were best friends. And yes, they were on a mission. Laid into the new brick path along Mirror Lake are stone plaques commemorating all of the region's 46 High Peaks. Peggy and Pat were curious about the random order of the plaques, so they went around the lake, counting the names and writing them down to make sure the village hadn't omitted any of the mountains.

Sure enough, it turns out there are only 40 plaques, not 46, and they are in no particular order. Missing are Mount Marcy (#1 highest peak at 5,344 feet), Skylight Mountain (#4 at 4,926 feet), Dix Mountain (#6 at 4,857 feet), Basin Mountain (#9 at 4,827 feet), Rocky Peak (#20 at 4,420 feet) and Cascade Mountain (#36 at 4,098 feet).

Curious stuff, indeed. But more curious, is the story of the two women.

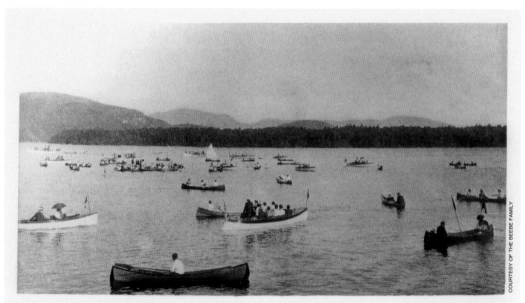

A regatta on Lake Placid

Lake Placid Club handbook photo of the 1920 Regatta

*N*o wonder the body language was close. Peggy Beebe and Pat Edgerton have been good friends for some 52 years. When the two women first met at the Lake Placid Club back in 1951, Pat Edgerton had already been in Lake Placid for 25 years. Pat had summered at the Club and remained a member after her parents bought a camp on the west shore; Pat's children attended the Club's day camp.

1951 was Peggy Beebe's first summer at the Club; her children were attending the Club's day camp too, along with Pat Edgerton's. "The minute Pat and I met, I felt like I'd known her forever," said Peggy. "I still feel like I've known Pat forever."

Pat Edgerton came to the Placid Lake area "before I had memories." Her first scrap of history is a postcard of the Lake Placid Club postmarked 1927 addressed to Mr. and Mrs. Alton Jones, her grandparents. The postcard came from Pat's parents who were visiting the Adirondacks while her grandparents on Long Island, the Jones's, took care of her. Scribbled on the back of the card was a one-line message: "Lake Placid is the most beautiful place."

The next year, the entire Jones family came to Lake Placid and stayed at the Lake Placid Club. "I was only four years old, but I remember a governess who escorted me to the playgroups and ate with me and my sister, Betty Marie, in the children's dining room," Pat remembers.

For the next eight years, the Jones family summered at the Lake Placid Club. They took the train up at first, until Pat's mother learned to drive. It was 300 miles, door to door, from Long Island to Lake Placid and Pat's mother drove it in eight hours. "We came up Route 9," said Pat. "Most people didn't go very fast back then, even though there weren't many cars on the road, because they were afraid of getting a flat tire. Not my mother. She had a heavy foot."

The Lake Placid Club was a never-ending reservoir of fun for children back then. Pat remembers climbing Mount Marcy, the tallest of the High Peaks at 5,344 feet, when she was just six years old. Her par-

ents let her go because a trusted 18-year old family friend was leading a group from the Lake Placid Club, including Pat's eight-year old sister.

"I remember we ran into a family with a goat," said Pat. "Mount Marcy isn't hard, but it's a long climb, five hours up, and I got tired. Halfway up, the family let me ride on the back of their goat. And that's how I arrived at the top of Mount Marcy my very first time, on the back of a goat."

In the last part of the 19th century and all the way through the 1920s and 30s, it was not uncommon to find ponies and packhorses too, on the High Peak Region's mountain trails. In Seneca Ray Stoddard's 1874 book, *The Adirondacks Illustrated*, he relates how a doctor from Buffalo made it to the top of Whiteface Mountain with a four-horse team and then proclaimed, "We rode down again without getting a scratch." Stoddard illustrated those same horses resting on the summit in an accompanying engraving.

There was a stable near the Lake Placid Club where Pat took lessons from a Mr. Fortune. She recalls that Mr. Fortune was a superb teacher who made riding fun for her. "When I was very little, I used to get up at 6:00 a.m. every single morning and ride the big horses until I dropped at night," said Pat. "I'm still addicted to horses."

And Pat still gets up early in the morning. "I don't like to sleep much when I'm on the lake," said Pat. "I don't want to miss anything. The first thing I do now every morning is get into the water. Even though I have a thermometer, I never look at it. I know how cold it is."

In 1934, the Jones family bought Camp Littlebrook on the west shore of Placid Lake. The camp was located between the Hall camp, Camp Shawnee, and Camp Minnowbrook, owned by the Bahnsons. "When my father heard that Littlebrook was for sale, he immediately bought it, because Littlebrook was right next door to the Halls," said Pat. "To live near dear friends like Bess and Lou Hall was, in my parents eyes, just about perfect."

There was no road to Littlebrook, so they family came in by boat, "which was great fun," said Pat. Every morning supplies of fresh eggs and fresh milk were delivered

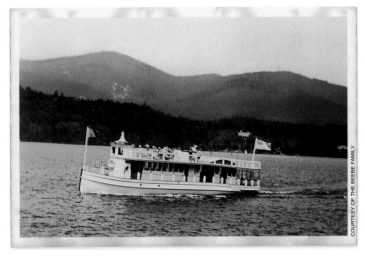

Doris I on Placid Lake

to their dock. "There were always lots of guests; it was like being in a small hotel," remembers Pat. "As a kid, I knew the names of all the camps on the lake, which camps had kids my own age, and who was the most fun. You wouldn't believe the hours I spent in rowboats on the lake, waving at passengers on the *Doris* tour boat."

A guide named Loren Risley took care of all the camp's buildings year round. He lived in one of the houses at Camp Littlebrook with his wife and three children. Two of those children, Donny and Ray, were the same age as Pat and her older sister, Betty Marie. "I got to know them well, and we're still friends," said Pat.

Loren, the father of Donny and Ray, was one of the best ski craftsmen in the area. For Pat's 15th birthday, Loren gave her a pair of skis he'd made, in an effort to lure the whole family up during the winter.

Pat's father's reaction was: "Pay money to get cold?" So Pat's grandmother brought her to Lake Placid in the winters and Pat learned to ski at the Club's ski facility on Mount Whitney.

"Donny and Ray used to carry their skis up McIntyre Mountain—now renamed Algonquin—or Mount Marcy, and then ski down," remembers Pat. "I never skied those trails, they were way too expert—but a lot of the local kids did."

In 1955, the family's friend and next-door neighbor, Lou Hall, died. Pat was in her early thirties and remembers coming in the door from horseback riding with her father that day. "My mother told us that Lou Hall just had a heart attack," said Pat. "Mother was devastated. Bess, Lou's wife and mother's best friend, had died the year before. Mother said she wasn't going to spend another summer on the lake without the Halls as neighbors. It was never the same after they both died." Littlebrook was sold several years later.

In 1966, Pat and her husband Milton bought their own camp, Camp Lakewood, on Victor Herbert Road. "Coming up to Lake Placid got to be more of an effort after I married Milt," said Pat. Milt, a physician and surgeon from Georgia, was more used to life in the South. Little by little, Milt and Pat began to spend more time at Lakewood.

"It took a lot of adapting, but Milt has grown to love the lake as much as I do," said Pat. "Some years when I get busy, he starts to get antsy to get here—he's the one doing the pushing. I used to come all summer when I was a child. Sometimes I'm sad because I'm only here in August most seasons. Peggy is here more often, and longer. She's lucky. We both are. We're lucky to have each other. I always look forward to coming up, because I know Peggy will be here."

The friendship Pat's mother had with Bess Hall in many ways mirrors the friendship Pat Edgerton has with her good friend, Peggy Beebe. Like her mother, Pat cannot imagine life on Placid Lake without her dearest friend.

<p style="text-align:center">◇ ◇ ◇</p>

*P*eggy Beebe arrived on the Placid Lake scene in 1949. When Peggy's husband, John, returned from World War II, he was stationed in the reserves in Watertown, New York, just two hours from Placid Lake. The Beebe's knew a lot of people from Garden City who stayed on the lake—the Barrett's, the Salmon's, and the McNealy's. "In 1949 our friends persuaded the whole family to come up and we rented Camp Owaissa, the Higgins camp on the east shore," said Peggy. "We took one look and fell in love with the lake."

The following summer, the Beebe's rented Owaissa again, and then, for the next several years, stayed at the Lake Placid Club. After that, they rented Camp Sunnyside, also on East Lake. "With two kids and a dog, it was perfect," said Peggy. "We loved being able to walk out the door and jump in the lake." In 1956, John Beebe's mother, Ga, and her sister, AA, managed to buy Sunnyside from the Eels family. The Beebe family no longer had to rent. "And, we've been here ever since," said Peggy.

As a child, Peggy summered on Squam Lake in New Hampshire, which was also a beautiful place. "The water was warm—much warmer than Placid Lake—and it had the same sort of family feeling," said Peggy. "But it didn't have the elevation and the cool nights and the wonderful air. Or the Lake Placid Club."

When the Club disbanded in the early 1980s, Peggy Beebe was heartbroken. "I have so many good memories of the Club," said Peggy. "We were friends with many of the summer staff and the golf cad-

dies, mostly college kids working to pay for school. I was sorry it didn't keep going. My cousin worked there several summers; he even met his wife there. Dan Donaldson, who built the camp next door to us, was a bellhop; Ralph Schneider, who we knew from Garden City, was a lifeguard."

Although the family no longer stayed at the Club, Peggy continued to have some good times there. "But then, the Club got cliquish and snobby. You can't have a governor come for a conference and then not let him come back the next week as a guest. That's the way it was back then. In one way, the Lake Placid Club was very family-oriented and comforting. But there were all these rules about who could or could not be a member."

For Peggy's friend, Pat Edgerton, the moment of truth about the Lake Placid Club occurred earlier, when Pat was a teenager. "As a child, I didn't know," said Pat. "I wasn't aware of what was going on. I liked everyone. I had no idea there was anything wrong with the picture. Then, in my teens, I had friends who were not welcome. I would take some of my houseguests to the Club, where they would get a cool reception. I started to understand that something wasn't right. I guess I was sorry when it folded, but I had deep enough roots on the lake not to care too much. It's the lake that really matters, and the friendships."

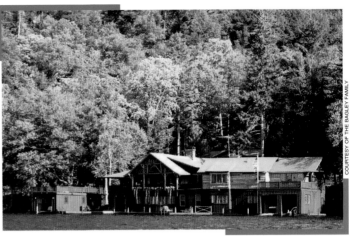

Camp Sunnyside, 2003

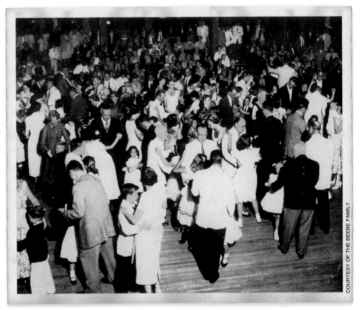

A Saturday evening dance in the Agora auditorium at the Lake Placid Club

Peggy agrees. "It was probably a good thing when the Lake Placid Club disbanded," she said. "It brought us all back to the lake—where we belong. I work hard to keep Camp Sunnyside maintained for my family and friends. If I didn't love my family and my friends so much, I wouldn't spend so much time painting, scrubbing, raking and scraping—to keep it going." Luckily Peggy has a little time leftover to enjoy her favorite pastime, painting with watercolors, on the deck of Camp Sunnyside.

Because of the Lake Placid Club, Pat and Peggy's children are close. Nowadays they keep in touch by e-mail. The children went to day camp together for years, and they make an effort to be here at the same time each summer. "They used to get in all sorts of trouble when they were kids, so they have a bond that'll last forever," said Peggy.

Peggy and John built a house in the back of Sunnyside, so their daughter, Martha (Marf), and her fami-

Two friends on Sunnyside's porch

ly can have their own space. Pat has a daughter who lives in Lake Placid and a son who's addicted to the area. "It's hard to believe, but our grandchildren are now friends," said Peggy. "They've all inherited their love of the lake from us."

"John and I stay here about four months a year now," said Peggy. "Pat's still trying to figure out a way to live here too, though I doubt it will ever work because of Milt's schedule. But she'll keep trying."

"Every summer, I can't wait to get onto 'my' lake," Pat adds. "I always feel like I've come home."

"Pat and I identify mostly with the lake," said Peggy. "Neither of us is very social. The highlight of my day is a boat ride around the lake every night."

"I can set my clock by when Peggy's boat passes our dock," said Pat. "Lake Placid wouldn't be nearly as much fun without Peggy Beebe."

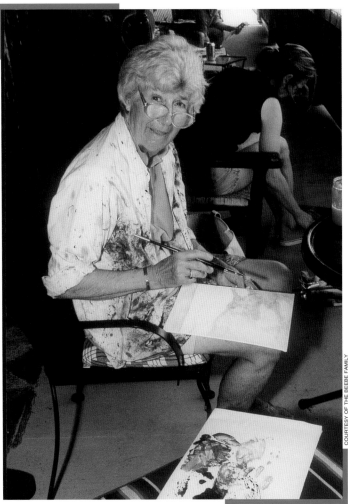

Peggy Beebe in an art class on Camp Sunnyside's deck

Marching Along Together (1933)

MARTHA BEEBE KNOWLES

Lake Versus Club

For a long time, Colt and I had little to do with the east side residents of Placid Lake, other than to cruise by their camps every evening in our wooden boat. This was not by design; it just never dawned on us to venture out of our own private world to meet the folks on the "other" side of the lake. We were content to wonder who they were as we passed in our wooden boat.

For a long time, we didn't know much about the Lake Placid Club either, except that it was in trouble and its buildings were crumbling. Not until much later did I begin to understand the deep and lasting connection between the east side of Placid Lake and the Lake Placid Club.

Martha Beebe Knowles is the last generation of women to come out of the Lake Placid Club. For Martha, the Club experience was intimate and personal. Even after she stopped going there for day camp, the Lake Placid Club remained a huge part of her life. Many of her friends are former Lake Placid Club friends. Most of her memories on the lake are directly related in some way to the Club. Yet, oddly enough, in the last analysis, for Martha, it is only Placid Lake that matters.

Martha Beebe Knowles, better known as "Marf," was two years old when she first went to the Lake Placid Club. Her memories are sketchy at best. "I remember the big dining room," said Marf. "But that's about it. I know my parents didn't like the formality of the Club that much. We didn't have a nanny or a governess like a lot of the other Club members, so Mom had to sit with my brother and me in the children's dining room."

Even after Marf's grandmother, Ga, and her aunt, AA, bought Camp Sunnyside in 1956, Marf's young life remained centered around the Lake Placid Club. It was the Club that mattered.

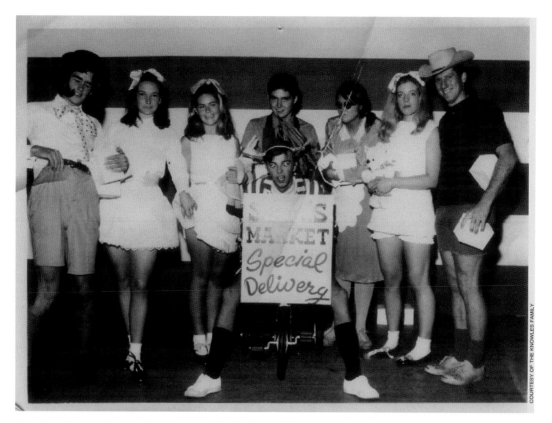

Lake Placid Club Community Chest Night party, 1968 (left to right: Win Lockwood, Susu Schneider, Susan Wemyss, Jack Beebe, Martha Beebe, Gail Scudder, unknown, Ned Scudder on tricycle).

The Lake Placid Club was where Marf met people her own age, where most of her activities were organized, where she would see the same kids, summer after summer because of its day camp which was a veritable playground. Marf went to the Club's day camp for ten years, from pixies at the age of four to junior sports club as a teenager, and did most of her "kid" things there— climbed Cobble Mountain, sang songs, played tennis, built lean-to's, had overnights. "Every year there was a costume party, and we'd dream up some gimmicky costume to try to win the prize," said Marf.

Because of the Lake Placid Club, Marf has friendships that have lasted her whole life. She was maid of honor in Sue Schneider's wedding. Marf is still friends with Parmalee Wells, Bill Edgerton, the Salmons and Win Lockwood. Ned Scudder has been a friend since they were both very young. Ned even proposed to his wife, Cree, at the Lake Placid Club in 1977.

"It wasn't a surprise to any of us," said Marf. "The minute we met Cree, we knew—all of Ned's friends did. We knew Cree was the one—we were just waiting for her." Cree and Marf are now best of friends, and tennis chums; the last three years they've either won or were runners-up in the Whiteface Club Doubles Tennis Championship. Marf and her husband, Kek, have spent practically every New Years' Eve with Cree and Ned.

Marf remembers that, at first, Cree wasn't so sure about the lake. It always rained every time she came, and it was cold. "It's never nice in Lake Placid," Cree used to say and she spent a lot of time in front of a fireplace, mostly at Camp Sunnyside. Every Memorial Day, the four of them—Marf, Kek, Cree and

Ned— would jump in the lake, no matter what the temperature was. "We shamed Cree into doing it too—the Polar Bear Dip," laughs Marf.

Marf also remembers that Cree's mother-in-law, Lee Scudder, was always fond of the lake—and it pleases her that Cree now is, too. "It helped when Ned bought Cree her own camp—Camp Bullwinkle," said Marf. "It's a little camp, but always full of people. And, Cree made sure there is no television. To her, the whole point of living on Placid Lake is that there shouldn't be any distractions."

Marf's Placid Lake friends—the Salmons, Parmalee Wells, Bill Edgerton and Win Lockwood—were Lake Placid Club members, but not as involved with the Club as Marf was. "I was probably the cruise director," said Marf, "because I could coordinate the activities of the lake kids and the Club kids. It was easier because I had an older brother. As kids we had the Lake Placid Club connection. When we were older, the lake was a big thing."

The lake was also where they dreamed up things to do when they were bored—like the "Indian" raid on the *Doris* and the Clamato Regatta (both adventures are summarized by Sue Riggins, another Lady of the Lake).

Ned and Cree Scudder with their children, Ford and Shelby

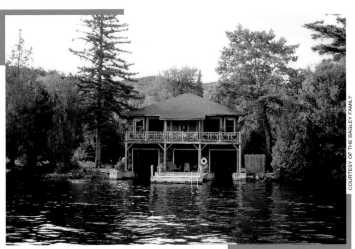

Camp Bullwinkle, 2003

For Marf, Placid Lake was—and still is—like a 1950s neighborhood: safe and slowly paced, where friends stop by in their boats any hour of the day. Life is unstructured. There is a relaxed atmosphere that transcends generations. Marf's friend, Cree, is a good friend of Marf's mother, Peggy Beebe; they take watercolor classes together. Marf, herself, is friends with several of her own friends' parents.

Two summers ago, Marf and Cree, along with Sue Riggins and Susan Lockwood, hosted a Lake Placid Club Revisited party. They invited all generations of old Lake Placid Club people to Ned Scudder's father's home on East Lake for a reunion. For Marf, the greatest thing about the Club was the interaction between the generations, and she wanted to honor that. "I was always friendly with everyone's parents and grandparents," said Marf. "Our kids are friends with our generation. And we will be friends with their children's generation. That much won't ever change. At least, I hope it won't ever change."

Besides the many friendships she has made, Marf has other reasons for believing that Placid Lake is special. She remembers spending time with her grandparents, doing jigsaw puzzles and playing cards. Marf's family would gather every night for dinner in Sunnyside's dining room—the grandparents, Poppy

Lake Placid Club Party

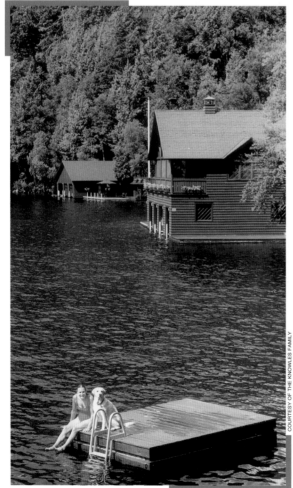

Martha on Sunnyside's dock

and Ga, and her Aunt AA and Uncle Raymond. Back then the Beebe family employed a cook at Sunnyside—most families did. The cook's name was George Chang and he was part of the family. "I spent hours in the kitchen with George," said Marf. "I always felt like I was part Chinese because of George Chang."

Marf's grandfather, Poppy, used to love to drive the old Chris Craft around the lake. Her grandmother, Ga, and her aunt, AA, were both afraid of the water and didn't know how to swim, so they only dipped their feet in the lake. Marf remembers sitting on the porch swing with Poppy, swinging back and forth, watching the sunset.

"We used to plan our dinner around the sunset—we still do," said Marf. "Poppy died in 1959, and Ga and AA both died in 1964. My father was an only child, so the camp was left to him. Luckily my mother's relationship with my grandmother was fabulous. Ga allowed my mother to love Camp Sunnyside as much as she did. So my mother already had an emotional investment when she and my father took the camp over. That was key."

When Marf's grandmother died, George Chang "came with the camp." Marf's mother, Peggy Beebe, didn't know what to do with George. Peggy wasn't used to having help and was accustomed to cooking herself. So the solution was that breakfast became the major event at the Beebe house—for some folks anyway.

"Every morning my parents were the first up, and the first on the golf course," said Marf. "We kids would sleep as long as we could. By the time our friends pulled up to the dock, my brother and I were at the kitchen table, digging into George's breakfast. The word got out that there was always French toast for a late breakfast at the Beebe's, as long as you wore a shirt and shoes. George was like a third grandparent and kept us teenagers in line during the 60s."

Marf's parents worked hard to keep the camp together after Marf's grandmother, Ga, died. The original camp had a four bedroom servants' wing with a laundry, icehouse and tool shed below. When the live-in help disappeared, Marf's parents replaced the servants' wing with

a garden. They had to sell off part of the property to do the necessary maintenance on the underpinnings. "I'm sorry they had to sell, but I understand why," said Marf. "Camp Sunnyside is really a large boathouse with water underneath the main building, and, as such, needs constant maintenance. It's just a fact of life up here."

When Marf's husband, Kek, came to Placid Lake in 1972 for the first time, Kek immediately saw how special Placid Lake was to Marf. Later on, they both wanted to have more time on the lake to do their own thing. "My mother is very particular about her house," said Marf. "We weren't allowed to do this and that. Plus we had these two rambunctious kids. I explained that we had to have our own place and it had to happen right away, not 20 years from now, because our biggest use is now—while our kids are around. We like both Bill and Liza to be here, with their friends, whenever they can come. Kek and I are hoping we can help my parents out with some of the costs, now that we've built our own house on the property, Sunnyside Up."

Liza Knowles as a child

Ever since she was a little girl, Marf has liked climbing the hill behind Camp Sunnyside and Sunnyside Up on the backside of Mount Whitney. It's a 20-minute hike up and back; sometimes she treks up twice a day. There is a fabulous view over West Lake, the ski jump and the open sand pit where Marf used to slide as a kid. The hike is good for Marf's sore Achilles tendon. And, the mountaintop is a great place to meditate and think.

"When my children were little, we came to Placid Lake as guests of my mother and father, who helped take care of them," said Marf. "The family lived under one roof—three generations spending time together. When our children were really young, Mom and Dad used to baby-sit so we could stay out late, just like my grandparents did with us. My grandmother and grandfather came to Placid Lake in the first place in order spend time with us."

Marf has the same wish for her own children. "When our two kids are married, there will be space here for them, and time for us to spend with their families, too," she said. "A place where their kids can do the same things we did as kids—sit in a stream or drive a little boat. Most likely, Kek and I will be babysitting them, just like my parents and grandparents did."

Marf's daugher, Liza, loves the sunsets on Placid Lake. As a youngster, Liza called them paintings in the sky. When Liza was 10 years old, she wrote about how she felt about Placid Lake. It pretty much sums up how her mother, Marf, feels too:

"'When I die, I hope heaven is just like Lake Placid.' That's what my grandmother says as she gazes into the mountain. I put my arm around her and look up at her and nod. I know what she means. Lake Placid is a special place where dreams and memories are born. It's a place where my family and friends surround me. It is MY perfect world."

So Many Memories (1937)

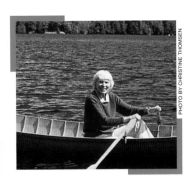

PHOTO BY CHRISTINE THOMSEN

L A U R A N A F I S H

Drowning in Lakes

Since the day 20 years ago when I met Laurana, walking the Jack Rabbit Trail behind our two camps, I have considered her a contemporary—even though her grandchildren, Lindsay and Jayson, are the same age as my children, Forth and Sarah. Laurana seems ageless to me, one of those women who will be "forever young," probably because she is constantly doing "forever-young" things—like climbing mountains, bike cycling, or riding her thoroughbred horse.

Laurana has an outlook on life that is always positive, no matter what. She has a twinkle in her eye and a smile on her face almost every time you see her. She sees the funny side of life and lives it. Laurana is not afraid of hard work and is wholeheartedly in love with her family. I unabashedly proclaim Laurana a role model for future Ladies of the Lake and one of the reasons that "cross-generational" friendships on Placid Lake should be encouraged.

*L*aurana Fish has lived her entire life on one lake or another. "It's no understatement," said Laurana. "I'm practically drowning in lakes." Laurana grew up on Conneaut Lake in Meadville, 40 miles south of Erie, Pennsylvania. She and her husband, Henry, had their wedding reception on September 9, 1950, at a country club on Conneaut Lake.

When Laurana was a child, she spent seven summers at a camp in Maine on Clary Lake. "I took the camp train from New York City all by myself, at the age of 11," said Laurana. On Clary Lake, Laurana learned to swim, sail and paddle on long canoe trips.

After she married, Laurana moved with her husband, Henry Fish, to Lake Erie in Pennsylvania. "I love that lake," Laurana said. "As a teenager, I used to skip Sunday school to travel 40 miles from Meadville to hang out on its peninsula."

For 20 years, Laurana and Henry also had another lake home on Lake Chapala in Mexico. "We've always gravitated toward the water," explains Laurana. "That's just the way it is."

During most of the year, Laurana now lives near the lovely peninsula, Presque Isle, on the south shore of Lake Erie. Presque Isle has its own sandy beach and little inlets where Laurana can canoe and kayak. In the summer, there are markets bursting with fresh homegrown corn and ripe tomatoes. During July and August, Laurana can sit on her front porch and watch the sunrise. The wind picks up in the afternoon and a symphony of sailboats appears on the horizon. At night, the moonlight dances on the water.

Camp Red Wing's boathouse

But Laurana is rarely there to enjoy all that. Friends ask why she chooses to come to yet another lake to summer. The answer is simple. "The other lakes were just there," said Laurana. "They just happened. But this lake is special. This lake among the mountains I chose. Placid Lake is mine."

Every morning during the summer, Laurana takes a dip in Placid Lake. She has been doing so since 1950 when Henry Fish, her soon-to-be husband, invited her to Camp Red Wing. "Henry wanted me to see his parents' camp," she said. "Dorothy and Howard Fish, Henry's parents, spent four summers on the lake as guests of Helen Murray's aunt, Nora Platt, at Camp Ostenola, (Helen Murray is the owner of Camp Menawa and another Lady of the Lake). In 1944, just as World War II was approaching, Dorothy and Howard purchased Camp Red Wing on the west shore of Placid Lake from Mrs. Lyman, whose husband had died recently.

The camp was originally built in 1902-03, by a Mr. Arrowsmith. The Lyman family, who bought Red Wing in the 1920s, was from Philadelphia, but one of the previous owners was from Red Wing, Minnesota (hence the name). In intervening years, Camp Red Wing may or may not have been owned by several others. By the time Laurana got there in the summer of 1950, it seemed like it had been in the Fish family forever.

There was no road back then, so Henry brought Laurana to camp that first summer by boat, from George & Bliss Marina. Being a "Pennsylvania-type" person, Laurana thought Red Wing would be a hunting camp, like the ones in Maine. "When I came through the strait and saw this little boathouse with Camp Red Wing written across it, I thought to myself, 'Well, that's kinda cute,'" said Laurana.

Laurana had no idea that Red Wing was a bona fide camp, with a main house that slept a dozen or more, as well as the "little boathouse." To her surprise, life at Red Wing was very formal and structured, with fancy dinners that began promptly at seven every evening, and loads of staff. Laurana also was surprised to find she wasn't on an island, even though she had arrived at camp by boat, that she could walk on trails to town. "It was probably why the focus was the dock and the lake—it still is," said Laurana.

At that time, just four camps dotted the west shore from the dam to Whiteface Inn (oddly enough, they belonged to the Fishes, the Salmon's, the Eel's, and the Kann's). Life was simple and very contained.

Red Wing's double diving board, circa 1950

The Fishes might walk to the post office at Whiteface Inn on a boggy path that followed the shore; the Inn had Western Union Telegraph and long distance telephone facilities too. But mostly the family stayed at home, in camp.

"Back then we made our own fun," Laurana reminisces. The whole family found water skiing great sport and fashioned a water ski jump from planks of wood. Someone dreamed up a double diving board with a high board and a lower springboard that everyone loved to narrowly miss on one ski. They hauled each other around the lake behind a beautiful old 1935 Chris Craft runabout for hours at a time. "It's a miracle the boat still runs," said Laurana. "No one dares use it as a ski boat any longer."

Laurana remembers how clear the water was. "It was so clear, you could read the date off a penny when you stood on the dock and looked down," she said. "Now you can see the penny, but you can't read the date."

There were always people around—Henry's brothers and their wives, Dorothy's bridge partners, family friends, kids galore. Occasionally, they would visit Camp Comfort on the island or Camp Midwood up the lake (the four Fish boys were friends with the three Kann girls), and sometimes they would go to the Saturday night dances at the Lake Placid Club.

"The Fish group was always huge, so they would send the *Lady of the Lake*, the tour boat, over to pick us up and we would all pile in—the vagabonds from West Lake!" said Laurana. "The ragamuffins. It was a formal thing, and we were all gussied up—even the kids. The Lake Placid Club was very elegant back then. But Dewey had all sorts of strict rules and regulations at the Club. Liquor was forbidden. Pretty soon that wore thin, and the Fish clan voted to forget it. We went back to making our own fun again, in our own camp."

When Henry's parents divorced, the camp was awarded to his mother, Dorothy. "In my mind Henry's mother was the grande dame," said Laurana. "I was so lucky to be able to connect with her. I still value the relationship we had—it wouldn't have happened without Red Wing."

Those early times with Dorothy were some of Laurana's best. Laurana was in camp with her young family and always a little nervous, because she wanted to please her mother-in-law. "She was a wonderful woman and a good friend," said Laurana. "I admired her greatly." Dorothy loved people, so the camp was always full. It was always a family gathering. "Our social life was strictly Red Wing," said Laurana. "That's just the way it was—and the way it is now, too."

As Henry's mother, Dororthy, got older, it became more and more difficult for her to negotiate back and forth by boat—groceries had to be picked up at the marina and guests delivered to their cars. So Dorothy arranged to have an old logging road between Camp Midwood and Red Wing opened up and made passable. Unfortunately, it opened a Pandora's box, because gradually the lots between the two camps were sold, and a lot of the privacy of the camp disappeared.

Dorothy Hall Fish ("Mother Fish")

With access to a road, Camp Red Wing started to burst at the seams. People came more often and stayed longer. Henry's brother, Mac, decided it was logical to move his family of six to a camp next to the dam, Tapawingo. The Tapawingo that Mac and his wife, Margo (another Lady of the Lake), created was very basic, and had the merits of being close to family at Red Wing.

At first Red Wing was just a vacation place for Laurana, a place to entertain and be entertained. "We hung around the lake during the day," remembers Laurana. "In the evening, everyone used to dress for dinner. We were expected to be there on time. And we were expected to dress when we went to the Lake Placid Club on Saturday evenings. Life was pretty structured back then."

When Henry's mother died in 1978, Henry, as executor of the estate, sent a letter to his brothers explaining the costs involved in maintaining Red Wing. Brother John already had a place in Lake Geneva, Wisconsin; brother Mac had moved next door to Tapawingo; and brother Doug didn't use the camp much. So Henry and Laurana became the sole owners of Red Wing and began in earnest to carry on its traditions. The first thing they did was semi-winterize the camp, so they could spend two weeks there during the 1980 Winter Olympics.

Laurana remembers her focus shifting around that time. "After the Olympics, everything changed again," she said. "After being depressed for a while, the town started to attract athletes. People were jogging and riding bikes and climbing mountains. I was swept along with that and became a jock, too. So

were our children. And, so were our grandchildren. Placid Lake wasn't just a vacation place anymore. It grew into something else for me. Life became more casual, less structured. Our summers still revolved around family, we still went for nightly cruises in Red Wing's Chris Craft, but there was less formality. I remember thinking at the time, where are all the Lake Placid Club people, what happened to them?"

There is barely a day all summer when Red Wing is not humming with family and friends. "It's funny because we see each other all the time in Erie, but here it's different," said Laurana. "We can connect without any distractions. We have time to think about things, to exchange ideas. It's all very low key—

a lot of laughs. We make fun out of nothing and appreciate it more than we do at home. And mostly, we can be together."

Life at Red Wing is not always rosy. For one thing, it is usually crowded. Crowds mean food, food means shopping and chopping and baking and grilling and washing dishes. Crowds also mean messes, and messes mean cleaning floors, changing sheets and lots of laundry. In the olden days, hired help was always at hand. By the time Henry and Laurana took over, the golden era was over, and each member of the family was expected to pitch in. The caretaker, Bill Umber, was the camp's only holdover from that golden era.

Red Wing's Chris Craft, now (2003)

Bill Umber was the son of John Umber, the original caretaker of Red Wing. Bill was supposed to chop the wood, drain the pipes, paint the dock, fix the leaky ceiling—in short, keep the camp going. He claimed to be fluent in French, but Laurana never believed a word of it. "Bill loved to tell stories," said Laurana. Bill was also a former Canadian fishing guide with two cocker spaniel puppies and a drinking problem. He used to make passes at all the guests and feed the raccoons and squirrels (he called them his animal kingdom) in Red Wing's kitchen, so Dorothy, Henry's mother, sent him to Alcoholics Anonymous and Bill eventually straightened himself out. But Bill still loved to tell stories.

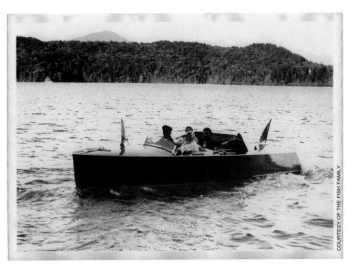
. . . and then (1939)

When Dorothy died, Henry and Laurana inherited Bill. "As we like to say, 'Bill came with the camp,'" said Laurana. Bill had an apartment in town, but the Fish family had an arrangement. When they were gone, Bill could live in the basement room under the kitchen. When they were in residence at the camp, Bill was supposed to live in his apartment in town.

Bill paid no attention to the arrangement. Instead, he permanently parked himself in the furnace room where he collected stacks of telephone books and lined the walls with old newspapers. His refrigerator held unrecognizable food that was covered with a slimy, yellow film. The Fish family couldn't bear to go down there.

Sometimes Bill would make the family a special stew on their arrival. "He considered himself quite the cook," said Laurana. "God knows what was in it. I'm still alive, but I don't know how. I'm sure the bacteria count was through the roof."

Bill smoked constantly and used to cook his meals in the basement on a wooden stove. "We were terrified he would fall asleep and leave something on the stove, or a cigarette lit," said Laurana. One day, Laurana was out on the lake and saw smoke coming from the bottom of Red Wing. She was panicked. Apparently, Bill had fallen asleep on his cot and left some concoction on the burner. Laurana arrived home just in time, before the fire could spread.

It was just a matter of time before Bill began considering that Camp Red Wing belonged to him, not the Fish family. "One Christmas when we arrived, Bill was holed up in the basement," said Laurana. "The kids were with us, and we were having a gay old time in the kitchen, making a lot of noise. We didn't realize Bill was still down in his hovel until we heard this loud thumping—Bill banging the end of a shovel against the ceiling. 'Shut up, up there. You're making too much noise,' he shouted at us. When I opened the basement door, Bill emerged in a flying rage, but then took one look at the incredulous look on my face and retreated. Temporarily, at least."

Still, the Fish family let Bill stay in the basement. They put up with his procrastinations and his idiosyncrasies. None of the Fish family felt comfortable kicking him out—"the poor man was not well," said Laurana. By this time, Bill had become in some strange way "Fish family."

Bill stayed in the basement until he was hospitalized with cancer. After he died, Laurana tackled the mess in the basement. "It was in dire straights. I've never seen anything like it in my life," said Laurana. "I couldn't believe it was actually part of my own house. There were dozens of garbage bags filled with dirty clothes. Ten years worth of junk. Everything was covered with a layer of black smoke."

Just before Bill died, the Fish family engaged Jim Beatty as caretaker. The camp, built in 1902, needed more help than Bill could manage. "Jim could fix and do anything, so we put his expertise to good use," said Laurana. "By the new millennium in 2000, Camp Red Wing was good for another 100 years."

Henry and Laurana now have six grandchildren and remain focused on the lake. Their greatest joy is being in camp with their grown children and grandchildren. Soon there will be great-grandchildren and yet another generation who will certainly love Red Wing. Inherent in transferring the camp to future generations are problems about maintenance, decision-making and equalization of age differences.

"When we inherited this place, just the two of us, we said 'great,' because having multiple owners tends to complicate things," said Laurana. "Camp Red Wing is a marvelous heritage, and we want to keep it intact. It means so much to all of us."

When there are multi-generations involved in the disposition of a camp, it makes for interesting conversations about the future. "You have to be extremely careful and smart about how you divvy it up," said Laurana. "There are lots of different ways to do it. Fortunately, we've devised a plan, a trust mechanism that will be very fair and worthwhile when it's implemented."

Laurana in her guideboat

That is, at least, Laurana's fervent hope. "The next generations?" asked Laurana. "I'm not too sure. They all love this place—that much I know. The rest? Well, it's very complicated."

There is no question that each and every descendent in the Fish family wants to preserve Camp Red Wing. The question is, as it is for many other families around Placid Lake: How they will manage to do it?

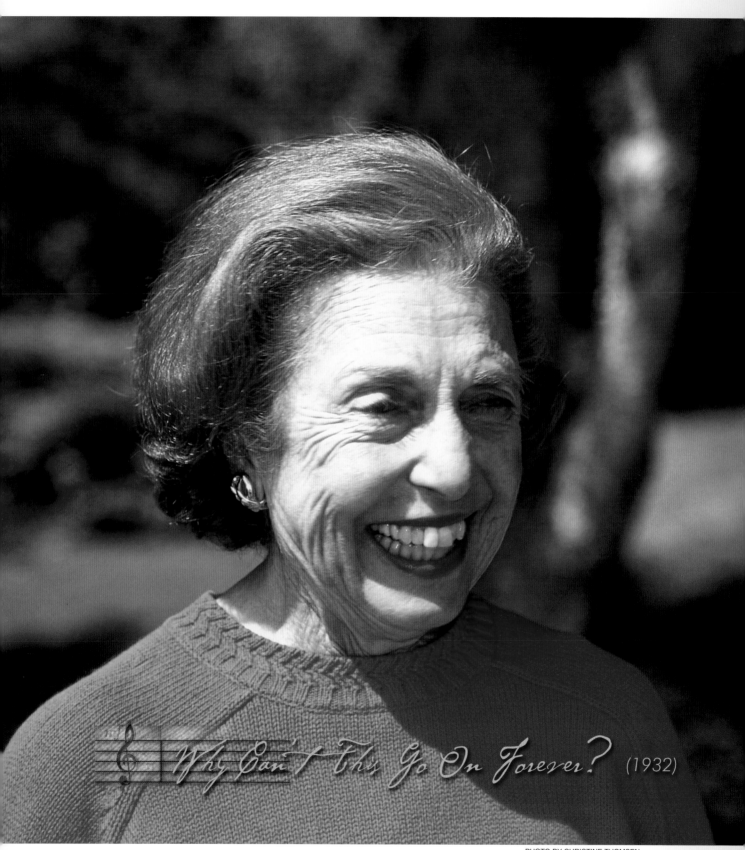

Why Can't This Go On Forever? (1932)

COURTESY OF THE BAGLEY FAMILY

TWO SISTERS: CLAUDIA RAZOOK AND CAROLE HUNT

Sharing a Camp

Some of the finest discussions around Camp Midwood's dining room table have centered on possible ways of sharing a camp and the best way to pass one on to the next generation. The ultimate disposition of camps on Placid Lake is on every owner's mind. All camps have escalated in value and in many cases there is a declining income capability for supporting the maintenance costs. Many offspring are artists, teachers, writers, architects, or travelers of the world who may lack the financial means and resources to support such a valuable family asset.

There are probably as many alternatives to succession as there are camps. Every time the question arises in our household, my husband, Colt, who is lucky enough to have been born into a family that owns property on the Brule River in the northwest part of Wisconsin, always talks about his ownership in the Noyes Camp.

Like many camps on Placid Lake, the Noyes Camp in Wisconsin was built in the late 1800s. It is a huge log lodge, still capable of sleeping 26, and gets lots of use. The original owners of the Noyes Camp, George Henry Noyes and Agnes Allis Haskell (better known to her descendents as Grandmother Noyes) had five children, all of who had children, all of whose children had children. For decades, the descendents of George and Agnes fought about costs (friendly fights, of course) and divided up time in camp among themselves (friendly dividing, of course) until 1937, when the third generation came up with a plan.

There are currently four families (a fifth family, the McLennans, felt they didn't get enough time, sold their interest and bought their own camp) who share ownership and use of the Noyes Camp via a corporation established called Noyes-Brule, Inc. Each family has an equal shareholding. Since 1937, there have been nine presidents, rotated by family. Each family is represented by

two trustees and is entitled to one month of occupancy that is rotated each season between June and September. There are 50 family members who own 300 shares of stock.

Every May, there is a family meeting with reports from the corporation's treasurer, the house committee, and the building and maintenance committee. There are insurance, canoe and camp historian reports and discussions about the per diem and the annual stockholder assessment. In short, the Noyes Camp is a non-profit corporation that functions well, given the large numbers of family members it has to accommodate each summer, usually 250 to 300. The camp is well into its seventh generation. As an "outlaw" (which, unrelated by blood, I am therefore considered to be), I have to admit I am impressed that Agnes and George's descendents remain a strong family unit, and also such good friends.

Claudia Razook and Carole Hunt's arrangement at Camp Colburn is not nearly as complicated and cumbersome as that of Noyes-Brule, Inc. Claudia and Carole are two sisters who have been sharing time at Camp Colburn on Placid Lake since 1977. By comparison, their arrangement is almost primitive in approach and evolution. Neither professes any jealousy when the other is in residence. Neither complains about the wear and tear, nor the necessity to rent in the off-year. Their arrangement is interesting and unique, because Claudia and Carole have made it so. It works because both Claudia and Carole have an abiding love for the lake and for each other.

But, Camp Colburn is only into its third generation, so the question has to go begging. What will happen to the arrangement by the seventh generation?

Claudia Razook first came to Placid Lake almost 50 years ago, as a newlywed. For several years she stayed at her husband George's family home on Signal Hill. "That was a beautiful house where you could see both Mirror Lake and Placid Lake from the front porch," said Claudia. Even though she remembers it raining for 40 straight days on her first visit, Claudia loved the area and its beauty straight away.

That first summer she was there, a lone gunman who'd escaped from one of the local prisons murdered the entire Lake Placid police force. Although the police force at the time was small, it was a dark and gloomy time—everyone was scared to death. Young boys were patrolling people's homes and searching for the murderer in the woods. "If we drove down Main Street to the movies, the trunk of our car was searched," remembers Claudia.

Eventually, the murderer was arrested out west somewhere. He'd escaped by walking along the railroad tracks and was in a bar in Colorado or Wyoming, where he pulled out a *Lake Placid News* article about the murders and started showing it to people. They got suspicious and were smart enough to report him. "It was a terrible thing for Lake Placid," said Claudia. "Nothing bad ever happens here. And, it was a very strange way for me to be introduced to the lake."

After living on Signal Hill that first summer, Claudia and her husband, George, rented a cottage at the Lake Placid Club for many years. Claudia's summer life centered on the Club, although she and her husband always knew they wanted to be on Placid Lake. "A lot of people left the area when the Lake Placid Club folded," said Claudia. "But people like us, who felt the pull of the lake, stayed on."

Because her husband owned Razook's, an exclusive women's clothing shop with locations on Main Street, the Saranac Inn and the Lake Placid Club (plus stores at the Plaza Hotel on Fifth Avenue in New York City and in Greenwich, Connecticut), Claudia and George began spending more and more time in the area. "George has been here forever," said Claudia. "He knows people's mothers because of those

stores—they'd be 100 years old right now if they were still alive."

Claudia's sister, Carole Hunt, first came to Placid Lake to visit Rene` Dunne, George's sister. It was a short visit and several years passed before Carole returned in 1960, at the tail end of her honeymoon. She and her new husband, Jim, were on their way to visit friends in Canada and they stopped at the Lake Placid Club on their way. Jim Hunt had grown up on a lake with a mountain. As youngsters, Carole and her sister had summered on a lake in the Pocono Mountains.

Jim and Carole concluded, looking out at Mirror Lake from their bedroom window at the Lake Placid Club, that the area was for them. "Jim said, 'I really love this,'" remembers Carole. "I said, 'So do I.'"

Carole and Jim came back to Placid Lake again when their children were nine, seven and five, renting Dr. Seed's cottage at Camp Cavendish on the east side of Placid Lake. For the next ten years they summered in the area, first at the Lake Placid Club, then at other camps on the lake. "It was a great meeting ground—for Claudia's family and for mine," remembers Carole. In 1977, Carole and Jim rented Camp Colburn on Placid Lake for the first time. That afternoon, after arriving, they stood on Colburn's dock and looked out at Whiteface Mountain.

"I had a visceral, emotional reaction," said Carole. "In exactly five minutes I knew I wanted to buy it. It was everything I could possibly have dreamt about." But when Carole and Jim talked it over that night, they came to terms with the fact that they had three children in private schools. "Plus, we wanted to take them to Europe," said Carole. Both Carole and Jim wondered how practical it was to commit to something like Colburn.

So, Carole and her husband called her sister, Claudia, and Claudia's husband, George. Maybe they would consider sharing the cost and the use of Camp

Carole Hunt

At Lake Placid Club's golf house (from left: Ted and Ruth Prime, Jim and Jeany McGraw, Carole and Jim Hunt, Nancy Bumsted, Claudia Razook, Bill Bumsted and George Razook) and at the Club's tennis tournament

Camp Colburn's Rube Goldberg furnace

Colburn? "Claudia and George turned us down," said Carole.

Claudia remembers the conversation, too. By this time, Claudia and George had a home in the village of Lake Placid, because they spent so much time there managing the Razook's shops. They also had a shop in town and real estate they didn't know what to do with. Both Claudia and George thought that another house would be too much.

After that phone call, Carole invited Claudia and George to Camp Colburn for dinner the next night. "It was very murky that evening," remembers Claudia. "The weather was changeable and dynamic. George and I stood on the dock, just as Carole and Jim had, took one look at the mountain in all that fog, and said we would do it."

Neither sister has ever looked back. They are surprisingly non-proprietary about their joint ownership. Claudia explains it. "We used to stay together all the time. In the winter, one of us would open the camp and invite the other family."

As their children got older, life got more complicated. "We had more and more children—three of mine and three of Carole's," said Claudia. "Then they started having children, and there were way too many kids. Carole just had her fifth grandchild and I have eight."

It was then that Claudia and Carole came up with the solution of sharing the camp, year by year. "And, it works out fine," said both.

As things at Colburn have to be repaired, which is frequent with these old camps, Carole and Claudia just discuss it, do it and share the expenses evenly. Carole takes the camp from December to December, the next year Claudia does the same.

"Starting this Christmas, the camp is Carole's again," said Claudia. "We've never had a bad word about it. Never a word. Ever. Except for the Rube Goldberg furnace that no one can ever figure out, Carole and I have worked it out nicely, basically on trust, and I think the children will, too. All our kids are darling and the cousins are very close."

Carole is also upbeat about the arrangement. Like Claudia, she quickly realized that each sister had to have full interest in the camp for the whole summer and Christmas, then hands off. In the off year, the family not occupying the camp simply rents something else on the lake.

"For many years, we rented the Matthews camp," said Carole. "It was like being on a boat—you hung over the water. We loved that little camp. You plugged the dishwasher into the sink—very campy. This is our first summer in a condo. I think we'll go back to renting a camp again—there are just too many children and grandchildren now. They are so in love with Placid Lake; they'll drop everything to come here."

Carole considers herself lucky to have been invited to that place in Canada so many years ago, to have stopped in Lake Placid again and re-discovered it with her husband. "Lord knows where Jim and I would've ended up," said Carole. "We wouldn't have been on Placid Lake, I know that."

Perhaps because the arrangement with her sister has worked out so well, Claudia is curious about how other families deal with the same issues and problems. The other day she and George were having lunch at Whiteface Inn on Placid Lake. Another couple near them was deep in thought and talking, talking, talking.

"George calls me Charlie Rose because I'm so curious, but I started asking them questions," said Claudia. "I really wanted to know what was intriguing them so much. They were from Upper Saranac Lake and getting away from their camp for the day, because it was multi-owned and multi-family. They told me how they had worked it out. One person was in charge for two years and did everything—all the repairs and the finances. 'Our two years are up,' they told me. 'They're having a conference back at our camp to decide who will be the next director. After lunch, we'll go back to see whom it is this time. God only knows.'" Claudia loved hearing their story.

Carole Hunt's children hike one of the High Peaks

Claudia Razook and her grandchildren on Colburn's dock at the Millenium

Claudia celebrated the Millennium at Camp Colburn. Luckily for her, 2000 was her year to use the camp. She stood on the dock to watch the fireworks with her children and grandchildren. The lake was covered with ice. There was snow on the ground. Claudia remembers every minute of it. "The night sparkled," said Claudia. "A moonbeam of light made its path right to our dock. I realized this is the place."

Placid Lake brings tears to Claudia's eyes. "Sometimes I just walk down to the dock and look at it," she said. "The lake has so many moods. It changes all the time. You can watch the mist rise in the morning, then the sun comes out. It's so beautiful. Placid Lake is a character in our family, just like everyone else. You know, I'm not very interesting. I don't think I'm terribly interesting. But I know the lake is."

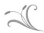

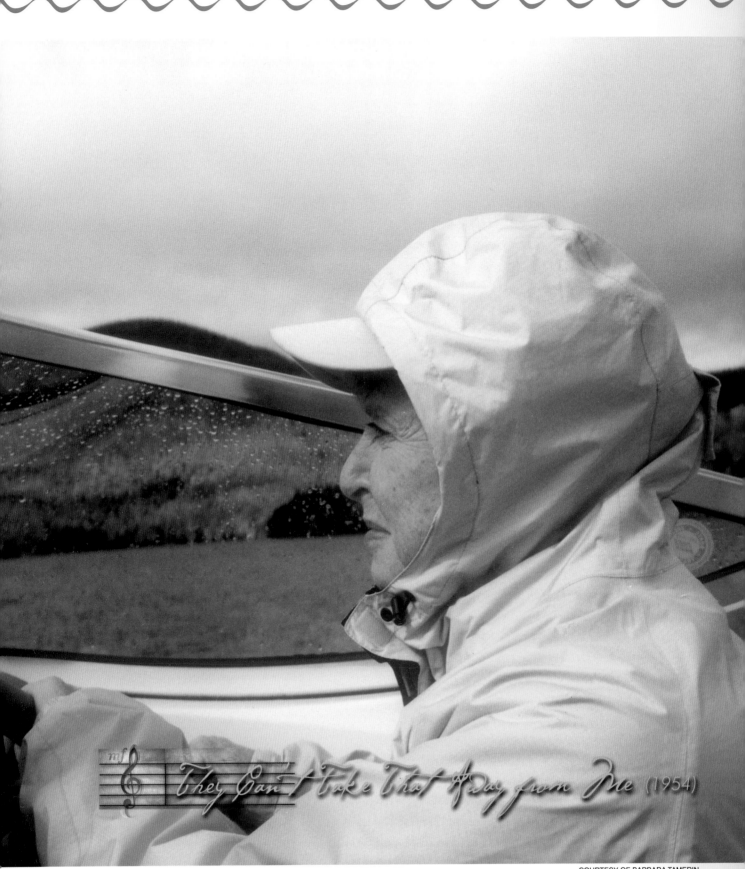

They Can't Take That Away from Me (1954)

COURTESY OF BARBARA TAMERIN

BARBARA TAMERIN

In the Company of Men

For some women on Placid Lake, the biggest challenge is not climbing Whiteface Mountain, or swimming around Buck Island, or sailing in the Clamato Regatta. For some women, the test of their backbone and fortitude takes place behind the scenes. It involves mettle, mental toughness, along with a spirit of compromise. And, always, a sense of humor.

For these women, time on Placid Lake is priceless—and only exists because they have managed to carve out an arrangement of ownership, a way to share time at their camp that is unique to them. Surgeons of a sort, their biggest challenge is keeping the patients—themselves—alive and well, once they have operated.

In the case of Barbara Tamerin, the surgery is even more delicate because Barbara is a complicated woman in the company of complicated men.

*I*f you visit Barbara Tamerin in New York City, you won't wonder what's important in her life. In Barbara's kitchen is a six-foot panoramic view of Placid Lake taken from the balcony at her Camp Oom Soo Wee. On the walls of her office hang Adirondack scenes by Placid Lake photographers, Gary Randorf and Nathan Farb. "It's just engrained in my brain," said Barbara. "Placid Lake is the most special place in the world."

Barbara's grandfather, Harry Alan Jacobs, bought Oom Soo Wee in 1910. Harry Alan Jacobs was a well-known architect in New York City who loved the mountains, especially the unusual view of the High Peaks Region from the balcony of his camp. Barbara's grandfather and grandmother, Elsie, used to trek up on the train from the city with her umpteen trunks and her entourage of help. "The camp has a special spirit because of her," said Barbara. "We called her Saint Grandma Elsie because she was so generous and always thinking of others. Grandma Elsie set the tone for love and family."

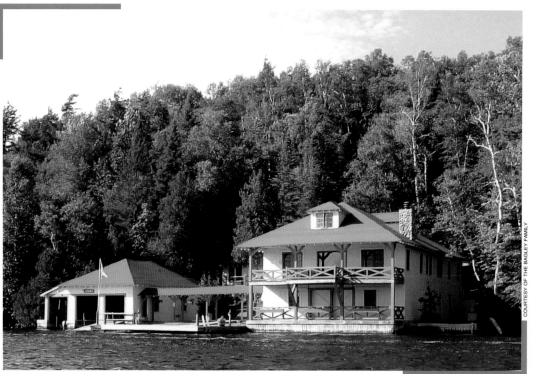

Camp Oom Soo Wee

Barbara's grandfather, Harry Alan Jacobs, died at a young age and his family continued to use Oom Soo Wee under the watchful eye of Grandma Elsie. (The name Oom Soo Wee was coined from an aberration of the words Oh So Sweet). When Barbara's grandmother died 30 years ago, a letter was sent out to all the relatives. Everyone wanted the camp so badly that the family called on a lawyer friend of her grandmother's, John Friedman, to put together a corporation. In the end, the only family members who signed up to be part of this new corporation were Barbara and her three Rosenwald cousins—Tommy, Johnny and Peter. Her uncle, Harry Jacobs Jr., decided he wanted his own house and bought one across from Oom Soo Wee on Placid Lake's peninsula.

Barbara's father, Robert Alan Jacobs, also opted not to take an ownership, but used to come up to Oom Soo Wee as Barbara's guest. "My father was an architect too, a famous one," said Barbara. "He designed the American Airlines terminal at JFK airport and the Rose camp on Moose Island. But he didn't have anything to do with the colors. My father was pretty upset about those colors." Barbara is referring to the camp that is painted an Adirondack brown, with its door and window trim painted bright red and yellow, not unlike the McDonald's® fast-food restaurants.

Every family member who opted to join the new corporation back in 1972 was reasonably young at the time, in his or her 20s and 30s. Barbara was—and is—the only woman in a consortium of men. "It's the three male cousins, and me," said Barbara. "Sometimes, as the only woman, I have to speak up to be heard among my male cousins. But it works because we want to make it work, and we all share a love for the camp."

With the growing number of children and grandchildren who want to come to Oom Soo Wee every summer, it's not easy satisfying everyone's calendar. "Each spring we divide up the time by filling out a sheet, indicating our preferred dates," said Barbara. "This year I was lucky and got three weeks."

The money issue is pretty straightforward. Barbara and her company of men manage it by adding up all the camp's yearly expenses and dividing by four. It is expensive, the maintenance of a 100-year-old wooden house. And then there are the surprises.

"This year we had an earthquake, of all things," said Barbara. Barbara and her cousins had to repair the foundation and rebuild the guest cottage. It was an extra expense that no one had budgeted for. But the cottage got rebuilt.

"All in all, the corporation is a pretty loose organization," said Barbara. "There are a lot of male powerhouses, pretty powerful personalities—even though they try to keep a low profile. You can imagine what I'm dealing with."

Sometimes, Barbara dreams of having her own little house on Placid Lake. "My partner, Hans, has already designed it for me," said Barbara. "But I haven't found the land. I confess I haven't really looked that hard because I still love Oom Soo Wee. Even with all its ownership problems, I love it here."

Barbara first arrived in Placid Lake with her grandmother when she was six years old. She used to come to Oom Soo Wee every summer for a week at a time. There was a lot of family life. Her brother Bob Junior, her sister Fran, and Tommy and Peter Rosenwald, her cousins, were always there. They did a lot of hiking, and expeditions of every sort. There was not much time for hanging around doing nothing.

Barbara and her father, Robert Alan Jacobs

COURTESY OF BARBARA TAMERIN

"I'm not the best hiker, but we always went up Whiteface from the lakeside," said Barbara. "I'd go with my cousin Terry. I'm not the hiker he is, though I've been introduced to some of the 46's."

Barbara's father taught her to water-ski. The family took overnight camping trips, canoe trips to Bolton Landing and nature hikes together, where they identified all the trees. They swam a lot. "Up until the age of 86, my dad used to swim over to the Jones' next door and back every day—even when he had Parkinsons' disease," said Barbara. "He was a good role model." Today, the rule is, you can't stay at Oom Soo Wee as a guest unless you swim before breakfast.

Before her grandmother died, Oom Soo Wee was a magnet for the family; there was always a full house. "We played a lot of practical jokes on one another," said Barbara. "Fourteen of us at the dinner table, and my dad would pour a bucket of water on my grandmother's head in the middle of dinner. That was his idea of a joke."

Back then, the family also did a lot of entertaining, because they had so much help. When Barbara first got a share in the corporation, she would load up the camp with a lot of people, like her grandmother used to do, but without all the help. Then she figured it out. "Now I have fewer guests," said Barbara.

Barbara's grandson, Simcha

"One family at a time. One or two friends at a time. When I have someone in camp, I slow down and spend time with them."

Barbara says she is meeting more interesting people on the lake, because she is now making time to do that, which she didn't used to do. "I think Placid Lake is a tightly knit community," said Barbara. "It's a very supportive place, especially among the women. When love of nature is the common denominator, all the other things about you become less important. You don't pay attention to glitz or the size of any-one's bank account. There's a true interest in finding out who you really are."

Barbara would like to be on Placid Lake for longer periods of time in the summer. This year she is rent-ing a condominium for a month at Whiteface Inn, in addition to her allotted time at Oom Soo Wee. Barbara would like to become more involved in the local community and recently joined the Board of the National Sports Academy.

Last year, Barbara was in Lake Placid during the winter for the first time in her life. "It was terrific," said Barbara. "I went cross-country skiing and then to a Celtic reading, things I've never done before. The more I do here, the more rooted I feel. I'm emotionally healthier here than I am in New York City. I was pretty frenetic before. Now I'm more centered—I've learned all that up here."

For Barbara, the family events and reunions at Oom Soo Wee are what she likes best. Her son, John Tamerin, Jr., fishes on the Ausable River and plays scratch golf. Her daughter, Elizabeth, has been com-ing here since she was a child. Elizabeths's son, Simcha Zissel Grieve, kayaks on the lake and rides horses at the Barkeater, a local riding stable in Keene.

Barbara's grandson, Simcha, does the same things Barbara used to do as a kid. He and his grandmother plan some activity every day—riding or hiking or kayaking. Simcha loves to catch fish off Oom Soo Wee's dock.

"That's a whole other generation doing the same things we did," said Barbara. "At some point I will pass the torch. I don't know how that's going to work. But I have my one share—out of four. That's something. And my grandson says he wants to live here forever and ever."

Barbara and the author on Oom Soo Wee's deck

Now That It's All Over

PHOTO BY THAYER ALLYSON GOWDY

KATHRYN KINCANNON

Managing the Masses

In the year 1992, I discovered yoga. Or rather, because of a disintegrated disc, yoga discovered me. Practicing yoga was never problematic when I was in London; there were and are plenty of yoga centers within walking distance. But finding a challenging yoga class in the Lake Placid area was more difficult, especially back then. Yoga postures, or asanas as they are called, exercise every part of the body, stretching the muscles and joints, the spine and the entire skeletal system; the asanas also work on the internal organs, glands and nerves. The aim is to keep everything healthy, to reduce the process of cell deterioration in older age—and maybe even regenerate a new disc?

One morning, as I was sitting on the dock of Camp Midwood's boathouse, I noticed that several women on the dock of Lake Placid Lodge next door appeared to be practicing Surya Namaskar, otherwise known as the Sun Salutation. I looked again. Maybe it wasn't yoga, but it was intriguing, whatever it was they were doing. I telephoned the lodge. "It's Kathryn Kincannon's T'ai Chi Ch'uan class," said the receptionist. I knew that Kathryn Kincannon was the manager of the Lake Placid Lodge. But what were they doing? I asked. "Those are yang sets," was the answer. Hmmmm. Yang sets looked a lot like asanas to me.

The next morning Kathryn's class met on the dock as usual. I decided to join them. Like yoga, T'ai Chi employs a constant flow of energy. Like yoga, it also appears to be deceptively simple. In reality, T'ai Chi is a form of Chinese martial art that combines mental concentration, slow respiration and graceful movements, similar to those of a dance. I found it as challenging as yoga, maybe more so because I was so unfamiliar with its movements. I stuck with Kathryn's class for a few weeks, and then went back to practicing my yoga. But every morning, when I looked over at Kathryn and her class doing their yang sets on the dock of Lake Placid Lodge, I still had a yearning to join in.

When it comes to mountains, Kathryn Kincannon admits she was a West Coast snob, having lived a lot of her adult life in the Sierras, the Cascades, the Rockies and the Tetons. The last place on earth Kathryn intended to spend eight years of her life was in the Adirondacks.

In 1994, after five years of managing a five-star *Relais and Chateaux* hotel near Yosemite National Park, Katherine was doing some consulting work in Eureka, California when David Garrett telephoned. David and his wife, Christie, had just purchased the Lake Placid Lodge on Placid Lake and were looking for someone to manage their rustic upscale resort in the Adirondacks, "a rugged mountain range with the most beautiful ski area."

Kathryn just laughed. "I told David he must be kidding," she said. "An East Coast ski resort was an oxymoron. Compared to our West Coast ranges, David's mountains were bunny hills. I listened politely while he tried to wow me, but I didn't take David seriously. I didn't need the job."

Kathryn Kincannon is a Los Angeles native who has lived most of her life in California and the Pacific Northwest. She pictured upstate New York as an extension of pastoral Vermont with cows, covered bridges, rolling hills and white clapboard houses. "The Adirondacks—isn't that where they filmed *Deliverance*?" Kathryn asked David. He laughed and said no, that was Appalachia. "Appalachia, Adirondacks, what's the difference?" asked Kathryn. "Sounds like a place where they speak in double negatives." David told her she might be surprised. But Kathryn was still doubtful.

Actually, David's timing couldn't have been more perfect. The small Victorian hotel in Eureka where Kathryn was doing some management consulting was headquarters for the filming of the movie, *Outbreak*. Literally overnight, the town had become manic and was swamped with movie executives, producers and actors. "It was an unforgettable experience," said Kathryn. "They were hiring and firing screenwriters, five in the span of one month. They wanted fax machines in rooms that weren't capable of having fax machines—high tech stuff in a town that prided itself on being back-to-the-basics. It was like trying to mix oil with water."

In the end, Kathryn agreed to come to Placid Lake to meet with David—just for the time off, for the chance to rest and sleep. "David called in the morning, after I'd been up since 4:00 a.m. doing an on-location breakfast," said Kathryn. "I figured a nap on the plane wasn't such a bad idea. And a few days of serenity in the woods might renew my energy, then I could come back and deal with these guys—these directors and actors."

Kathryn's first impression surprised her. David picked her up at the Burlington airport and drove her to the ferry. "When I stepped on the ferry in Vermont to cross over to New York state, it hit me hard," said Kathryn. "The expansive beauty of the place was overwhelming."

"Not quite your picture of Appalachia, huh?" David asked, grinning at Kathryn.

Kathryn just looked out over the water, speechless. "It was breathtaking—the combination of endless mountains and lakes, and so much breathing room," she said. "You can't fathom six million acres unless you're in the middle of it. I was amazed that the Adirondack State Park was bigger than Yellowstone, Yosemite and the Grand Canyon combined."

But then Kathryn's cynicism kicked in. After all, she came from California, where no land was sacred, where people with money could do anything. She asked David how long it would take for this beautiful landscape to be paved over, how long before the developers moved in. "David told me that New York

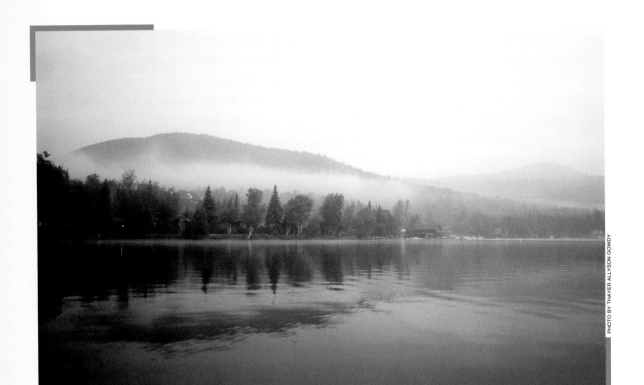

View of Placid Lake from Lake Placid Lodge

state land in the so-called 'Blue Line' was 'Forever Wild,' that it always would be so," said Kathryn. "I listened, but I wondered if it was for real."

Kathryn soon had her chance to discern the truth. When she got to the Lake Placid Lodge, the first thing she did was walk down to the dock that jutted out over Placid Lake, and gaze over the water at Whiteface Mountain.

Kathryn said to herself, "This is amazing. This is very cool." Kathryn was a long time practitioner of T'ai Chi Ch'uan and wanted to do a yang set, right then and there. Instead, to get rid of her jet lag, Kathryn went for a long run in the woods. "The smell of balsam was intoxicating," remembers Kathryn. "Afterwards, I went to the front desk to ask what that heady cinnamon scent was—I'd never smelled balsam before."

That night there was a sudden dramatic summer storm with fantastic lightning. Kathryn sat out in one of the big Adirondack chairs on the waterfront and watched. "I felt like I was in a drive-in movie," said Kathryn. "Nobody else around—just me and this big, huge weather. The sky was electrifying, alive and intense. The wind was whipping through the trees in a frenzy." Kathryn was starting to understand what David meant about "Forever Wild." Before she went to bed that same night, she read Harvey Kaiser's *Great Camps of the Adirondacks*, cover to cover.

"I was moved by what I read, and impressed with the foresight of those who a century ago recognized the need to protect the land," said Kathryn. "The whole area was virtually clear-cut back then and very barren—because of all the logging. I was amazed at the clever way it was now preserved." Kathryn's observations are true. No developer or lobbying power can ever overturn the "Forever Wild" statute.

By the second day, Kathryn was so in love with the environment, she figured loving the job would be easy. "If I love where I live, I can put up with the work," she said. Quality of life has always been a primary requirement of Kathryn's. It's why she has lived in off-the-beaten-track mountain resorts all her adult life, gravitating to places the world doesn't know too much about.

"Unless you come to the Adirondacks, you don't know how beautiful these ancient mountains are," said Kathryn. "I've always been captivated by Mother Nature. So I told myself I could live on Placid Lake for a while—maybe three years. And David was very persistent. He was not going to take 'no' for an answer."

But there were conditions that prohibited Kathryn from considering his offer. In 30 days time, Kathryn was due to take a job with Butterfield & Robinson leading bicycle trips in the Loire Valley of France. She already had her plane ticket and was studying up on her French.

A quick phone call to B & R's head office solved that dilemma. To her complete surprise, B & R agreed that Kathryn's opportunity at the Lodge was tailor-made for her qualifications. B & R also made it very clear that Kathryn would be welcome to work for B & R whenever she wanted.

"I was floored and amazed," said Kathryn. "I couldn't believe they would release me from such a contract, only weeks away. It was quite a sign. David's reaction was pure and simple. 'Good,' he said. 'That's settled.' He had no intention of letting me go to California, France, or any other place."

And, for good reason. After six months of intensive renovations, the Lake Placid Lodge had just opened without a general manager. Not surprising for a project of this magnitude, construction was behind schedule. To put it mildly, operations were chaotic. "Guests were arriving for rooms that had not yet been completed," said Kathryn. "Those who were lucky enough to have rooms were waking to the buzz saw of carpenters instead of the tranquil trill of the loons. It was bedlam."

That was the situation David wanted Kathryn to walk into. Kathryn exhaled deeply. She knew it would be a challenge.

The Lake Placid Lodge property has a colorful history. In 1885, Oliver and Mary Abel sold a parcel of land to Robert Schroeder, who built a humble hunting and fishing camp on the property for his family. The camp was renovated in 1896 and again in 1916. Under the ownership of Ted and Mae Frankel, Austrian Jews who fled their war-torn homeland, it opened to the public as a hotel, Placid Manor, in 1946.

Placid Manor remained a seasonal resort during the ensuing years. By the time the Garrett's purchased it in 1993, the Manor had changed hands several times and was worn to a skeleton. David and his wife, Christie, bought the 48-room, seven-acre property for $950,000 and initially invested $2.5 million in the first stage of renovation—plus plenty of sweat equity. Over the next eight years, they would invest another $5 million.

Contrary to the speculation of the locals, the Garrett's weren't crazy. David and Christie had a proven vision and the creative know-how as owners of The Point, a former 1930s "Great Camp" on Upper Saranac Lake that began its life as a private retreat for William Avery Rockefeller (the father of John D.Rockefeller, founder of Standard Oil).

The Garrett's had managed The Point for seven years, turning it into one of the most prestigious and luxurious resorts in the world. Room rates range from $1,500-$2,300 per day. Guests are assured of

exclusive privacy and the finest service. The Garrett's were convinced they could transform "this fixer-upper" on Placid Lake into something equally great. They just needed Kathryn to come on board.

The Garrett's were very persuasive that weekend and Kathryn took the plunge. A moving company packed and moved all her belongings east. A young Australian drove her car across the country. In August of 1994, Kathryn started working—12 hours a day, six days a week, for the next eight years.

For the first three years, she never left the property. "It must have seemed a little crazy and impulsive to my family and friends at the time," said Kathryn. "But the Garrett's and I related to each other immediately. I understood intuitively what they wanted to accomplish. I had the tools and was ready to prove myself. I'd worked in every facet of the hospitality industry in the most scenic spots in the West. I knew I was the woman for the job. The Garrett's did too. For me, the messages were clear, plus it felt right. And I knew one thing for sure. Nature had to take center stage. I had to make sure every guest who came to Lake Placid Lodge felt what I did."

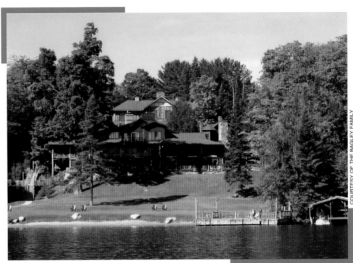

Lake Placid Lodge, 2003

In that case, there were immediate changes that Kathryn had to make and a few existing incongruities to iron out, to say the least. Fortunately, Kathryn and David and Christie reached agreement on all of them. Even though the Lake Placid Lodge had an incredible location, the property had no view. A row of six-foot tall hedges growing at the water's edge blocked the view. Kathryn found a way to "discreetly" mow the hedges down. Next, she removed the televisions and added working fireplaces, tubs that were deep enough to swim in and Adirondack twig furniture in all the bedrooms.

And finally, Kathryn addressed the dining experience at the Lodge. The menus in the restaurant were written in French. "Now I take my hat off to the French training of my English chefs," said Kathryn, "but this was the Adirondacks." So, instead of offering French cuisine, the lodge began offering beautifully prepared meals with a regional flair—sophisticated, but celebrating the flavors and local ingredients of the Adirondacks.

Once over these hurdles, Kathryn was able to concentrate on incorporating the Adirondack culture into the lodge. "The hotel was a guest of nature," said Kathryn. "The guests of the hotel were guests of nature, too. Once I knew that, it was easy to keep focused."

Kathryn wanted to make sure that the lodge's furnishings exemplified the best of the region's creativity and uniqueness. Early on, Kathryn became a champion of the talents of local artists and artisans who drew their inspiration from the mountains and the lake.

The Lake Placid Lodge décor now represents over 100 talented men and women whose artistry and craftsmanship adorn its walls—everything from hand crafted beds and table and chairs, to hand-loomed rugs and clothing, to original paintings and walking sticks. Guests are amazed to find their rooms or cabins brimming with one-of-a-kind masterpieces. And, if they happen to like what they see, they are most probably allowed to purchase the item and bring it home.

Three years into running the lodge, Kathryn bought her own private sanctuary in the Adirondacks—a small cottage on Rainbow Lake where she could wake up to the sounds of lapping water and the cry of the loons. "I didn't move to the area to make friends or socialize," said Kathryn of her new home. Kathryn's passions are, for the most part, solitary—T'ai chi, playing the piano, running, hiking, riding horses, scuba diving, or running with her six-year-old Akita, Sachi.

"I am my job, and my job is me," explained Kathryn. "It's my life, and I love it. I never intended to be a loner. It's just that my job requires so much of me. Now I realize what a blessing that was, especially at the beginning. Since I didn't go out at night or hang out with locals, I never knew what people thought of me, or the Lake Placid Lodge, as David and Christie and I were struggling to make it a success."

Kathryn practices T'ai Chi on the dock

The truth is, the locals were talking about Kathryn and the Garrett's and the Lake Placid Lodge, placing bets about how soon the lodge would close. (After all, there had been six owners there in the last 20 years.) If Kathryn had known, she would probably have understood their cynicism. She'd lived in small towns before.

But Kathryn hadn't come to Placid Lake to make a big splash. "I never did any press releases, never put myself out front in the community," said Kathryn. "I knew if I just did my job well, time would prove me out. I hoped I would be valued and appreciated and respected in the long run. It was the least I owed to the mountains, and to the memory of my first day on the lake."

Although she "never put herself out front," what Kathryn omits to say is that she is remarkably supportive of Placid Lake and its local organizations. If she thinks a local cause is worthwhile, makes sense, and fits her standard of nature triumphing, Kathryn is behind it. From the Adirondack Artists' exhibition to the Lake Placid Institute's awards ceremony for a children's water essay competition, Kathryn has done a lot more than just her job.

Placid Lake means more to Kathryn than just the Lake Placid Lodge itself, or her work—a fact best illustrated by the way Kathryn deals with the lodge's clientele. "Some of them are fish out of water," said Kathryn. "Every time I see a guest like that, I am reminded of my first day here. They think they're coming to the backwoods of 'smalltime' America. They don't know what they're supposed to think or do. My guess is a lot of them are thinking what I was thinking when I first came here."

If she has to be, Kathryn can be a little irreverent with these people. She has no problem telling them to lighten up and get a life. "I love watching their reaction, watching the transformation," laughs Kathryn. "I know they arrive frazzled and tired. Sometimes they arrive in their Gucci loafers in the wrong clothes. I urge them to go for a long walk or a paddle on the lake. I tell them to turn off their cell phones, stop checking e-mails and listen to the loons instead."

Most of the guests get over their initial reaction and are changed by the experience of being on the lake and in the mountains. "They realize they can't be control freaks in a place like the Adirondacks," said Kathryn. "They can't control nature the way they control their businesses or their portfolios. Maybe they slip on a trail and sprain their ankle and, guess what, they have to be carried off the mountain. They've never paddled a boat in their life, yet they expect to be good at it. Then they get stuck out on the lake, get hypothermia and have to be towed back in." In other words, Kathryn's guests start to appreciate the dynamic power of nature.

This is exactly what Kathryn wants them to experience. "The guests may not consciously understand why they came to the lodge in the first place," said Kathryn. "But I suspect they're looking for something deep down inside, a reconnection to some kind of inner source. Once they understand the Adirondack culture, they're soothed by it. Maybe all it takes is a double rainbow after a thunderstorm. Or an early morning walk on the Jack Rabbit Trail. Or a swim in Placid Lake."

To see a guest transformed makes every day Kathryn gives to the lodge totally worthwhile. "If they take it home, that's even better," she says. "There's a shift that's important. They've re-established some priorities. That part of the challenge of the job is the most fun for me. When I see a guest go home transformed, that's the greatest."

Thanks to Kathryn and the Garrett's, the Lake Placid Lodge has been a member of *Relais & Châteaux* since 1997. The lodge has earned a four-star *Mobil* ranking, is in the top 20 of *Harper's Small Hotels* in the U.S., and is ranked in the top 20 Small Hotels and Resorts in the annual *Zagat* Survey. Kathryn is understandably proud of the lodge. In the eight years under her care, it has blossomed from a $70/night shared-bath motel to a $700/night world-class resort—from a first-year gross revenue of barely $300,000 to gross revenue of over $6 million.

"I tried to keep focused on nature and not get in the way of that," said Kathryn. "I thank God the hotel became what it should be. Had the Garrett's not purchased the Lake Placid Lodge, it could well have been something different—a high-rise densely packed hotel without distinction. In my heart, I truly believe anything else wouldn't have worked. The Lake Placid Lodge had to be personal, small, cozy and in tune with Placid Lake and the Adirondacks. Otherwise it would have been somehow sacrilegious. Lake Placid Lodge had such a lofty opinion of itself. It didn't let us do something that would have been the wrong thing to do. It had a mind of its own. It had its say and, in the end, it won."

Just as the Lake Placid Lodge has become synonymous with Placid Lake and the Adirondacks, Kathryn Kincannon has become synonymous with the lodge. But, like all good things, the synergy came to an end. At the end of the summer of 2002, Kathryn moved to Canada to join her fiancé, Chris Irwin, a well-known "horse whisperer" and equine behaviorist.

Kathryn loves exploring the world of the horse industry, but acknowledges she will miss the lake dearly. "Placid Lake has spoiled me," she said. "Never in my life have I felt the desire for roots, until I came here. I needed the lake to prepare me for what lies ahead. David Garrett kept asking me, 'Are you sure you want to leave here?' I tell him it feels really good to make this change. Lake Placid Lodge is in good shape, everything's purring, and we have a good guest list. My next move feels natural. I've done what I set out to do, and I'm at peace. And ready for my next life to unfold."

Kathryn was always a "horse-crazy" kid, and now she understands why. "When I'm with the horses, the world falls away," said Kathryn. "I'm focused and aware—everything else is irrelevant. The horses immerse me in wisdom, wisdom as ancient as the Adirondack Mountains themselves. I'm totally fasci-

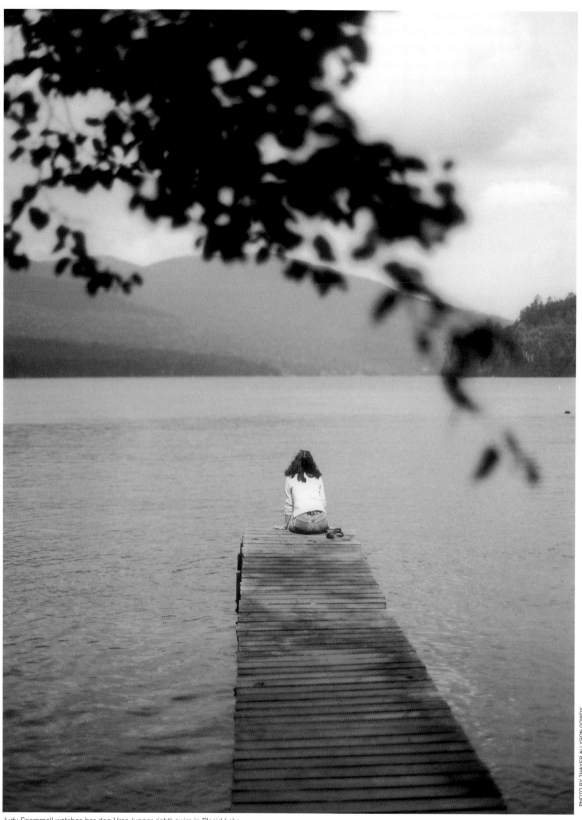

Judy Scammell watches her dog Ursa (upper right) swim in Placid Lake

nated by what my horse can teach me about communication, just as I'm fascinated by what Placid Lake and the Adirondacks taught me about nature—and my own life."

Kathryn learned to love the Adirondacks and Placid Lake. "I did not leave for any reason other than I'm going to something I love more," said Kathryn. "I miss the walks in the woods, the Northern Lights, canoeing under moonlight and T'ai chi on the dock of the lodge—I have a million memories etched in my heart. For the last eight years, Placid Lake and the surrounding woods have been my best friends. They've sung me a lullaby. And believe me, I've listened."

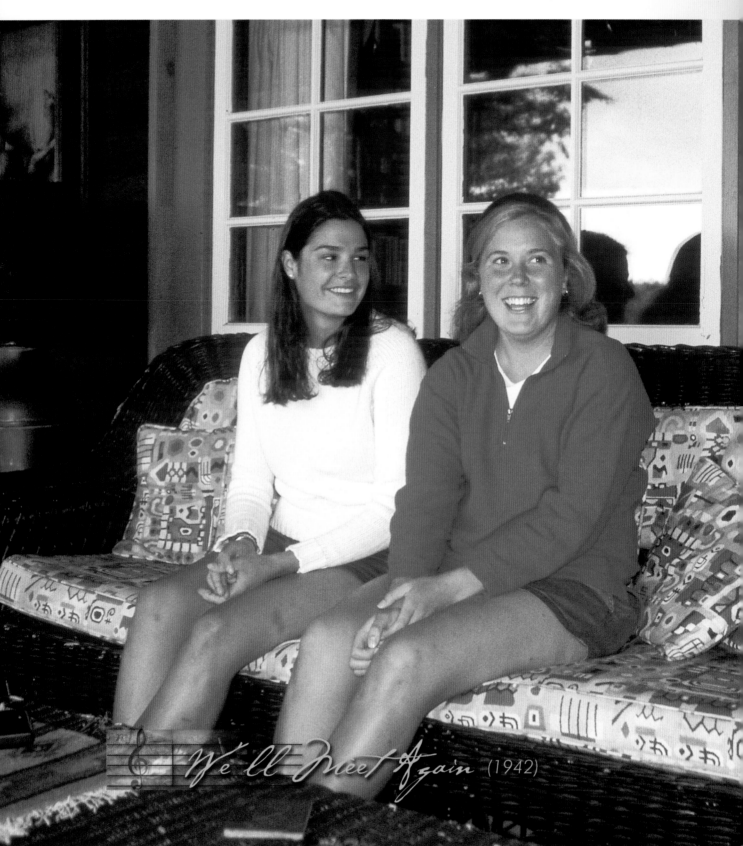

We'll Meet Again (1942)

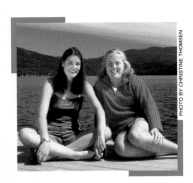

PHOTO BY CHRISTINE THOMSEN

SARAH BAGLEY AND LINDSAY YOST

The Next Generation

Lindsay Yost and Sarah Bagley's friendship was born on Placid Lake when they were both very young. Lindsay is from a dynamic family in Erie, Pennsylvania, who summer on the west shore of Placid Lake in a house called Camp Red Wing that bustles with people. Sarah Bagley, my daughter, grew up in London, England in a dynamic family who summer on the west shore in a house called Camp Midwood that bustles with people. The two camps are within walking distance and the families have known each other for years.

Not surprisingly, more than 20 years on, Lindsay and Sarah are still the best of friends, on the lake and off. Lindsay and Sarah's relationship differs from any they have elsewhere and is likely to last a lifetime.

In addition to being good friends, Lindsay and Sarah are also the next generation of Ladies of the Lake. Unlike the Ladies who precede them, Lindsay and Sarah have more history to write than to tell. Lindsay and Sarah are in their early 20s and life for them is, in some ways, just beginning. Their destiny is unknown, but one thing is certain:

Placid Lake has a hold on them like nothing else. No matter what, Sarah and Lindsay will always be rooted in water.

*L*INDSAY: I remember when we were little. Our parents used to take us hiking and drop M & M® candies on the trail to get us to move. We hated to hike back then. We'd much rather sit on the dock and make paper dolls.

SARAH: Our parents made us take tennis lessons from Jak Beardsworth, the tennis pro at Whiteface Inn. My parents have a video of me pretending to shadow Jak at the baseline. Jak was weaving back and forth and I just stood there, refusing to move. I would much rather be on the dock with Lindsay.

Both Lindsay and Sarah have older brothers, Jayson and Forth, themselves good friends. For almost 15 years, the four of them hung out together in the summer. Lindsay was still in high school when Sarah and the brothers were already off to college. As the youngest, Lindsay was often drawn into age-inappropriate activities. Now, Forth, Jayson and Sarah have graduated from college, they see each other less often, but they are still capable of getting into trouble.

Bagleys and Yosts as youngsters On Midwood's dock

LINDSAY: One night we snuck over to the pond at the Whiteface Club golf course with an inflatable raft. We brought along snorkel masks and long nets so we could retrieve golf balls from the bottom of the pond. Forth fell in. The pond was disgusting and muddy. The night watchman who was doing his rounds came looking for us with a flashlight. Everyone ran into the woods except Sarah, who was stuck there with the raft over her head.

SARAH: Lucky for me, I escaped. The next day we cleaned all the golf balls and sold them for a dollar each from the edge of the golf course until Peter Martin, the golf pro, kicked us off. We used to be terrified of him. To get even, we put messages in the holes on the greens of his golf course, like "Your dog is stuck in a tree."

✧ ✧ ✧

Both Sarah and Lindsay live in camps that are over 100 years old. There are creepy attics and dark crawl spaces where the girls used to play hide and seek. As children, they were often relegated to the top floor, where they devised their own fun, without a television or computer.

(left to right) Sarah and Lindsay with Forth and Jayson. In more trouble on the roof of Red Wing

LINDSAY: My grandparents' camp is pretty small, especially when we're all there together. You can hear everything in the house, even when you're on the third floor. It's a scary place to be: there are animals living in the woodwork. It's always dark up there, and it's very easy to imagine things, which we did. Sarah and I used to be afraid of getting locked in.

SARAH: We did get locked into my bedroom on the third floor one time. Lindsay was spending the night, again—she used to stay over all the time. We were fooling around with the key, which was old, and it broke off in the door. Our brothers were outside the door, laughing their heads off. We were screaming and yelling for ages. Finally my mom heard us and had to call Lindsay's grandfather over to help get the door down.

On rainy days Sarah and Lindsay used to dream up theatrical productions and stage them for their parents and grandparents in the evenings—elaborate affairs that involved homemade scenery and props and the refitting of Midwood's living room with curtains fashioned from sheets.

LINDSAY: We'd practice all day, but the skit we ended up with was never the same one we wrote. We designed programs and invited whoever was in camp to watch us. At Red Wing we used to do this with my babysitter, Jennifer, and called ourselves the "Red Wing Players." This was before the "Midwood Productions."

SARAH: We sang these disgusting made-up songs and made our brothers get dressed up in girls' clothes. Since it was a play, we used props like beer and cigarettes, pretending to drink and smoke. We were probably 10 years old at the time, trying to think of ways to be naughty.

<center>✧ ✧ ✧</center>

Sarah and Lindsay's activities naturally centered on the lake and the boathouse during the summer. Each of them remembers the first time she was old enough to drive a boat and considers it a rite of passage. Sarah and Lindsay learned to water ski by the time they were seven, to slalom by the time they were ten. Together with their brothers, they often skied behind the same boat in tandem.

LINDSAY: I used to swim to the rock every day. I still can't leave camp without taking a morning swim or

honking the horn as we drive out. It's a ritual, like picnics on the island, or going to the Bagley's after dinner or having family meals at Red Wing together. Even though I sometimes think those dinners were too long and full of too much family, I'm sure they're one of the things I'll keep doing with my kids. I love watching my little cousins find the courage and timing to ask to be excused from dinner, just like we used to do.

SARAH: I don't like swimming by myself, because I'm afraid of all the fish, but I swim at night anyway. Forth and I love to jump off the upstairs deck at the boathouse and at least once a summer we

Sarah and Lindsay dress up

jump off Pulpit Rock over on East Lake. We have barbeques with Adirondack crepes and maple syrup that our old caretaker, Roland Sears, makes. We take a boat ride first thing when we get here and last thing before we leave. And Lindsay and I swim across the lake at least once every summer.

<center>✧ ✧ ✧</center>

For both girls, family and family tradition loom large in their lives. Perhaps because they are young women, they spend a lot of time thinking about the way things were and the way they want things to be, about their personal histories and their heritage.

LINDSAY: My great grandmother died before I was born, but I still feel her presence. She was the one who set the rules—which is where a lot of our family tradition comes from. Coming together at mealtime has always been big. So are the cocktail cruises in our Chris Craft, the Red Wing. We even have a song my

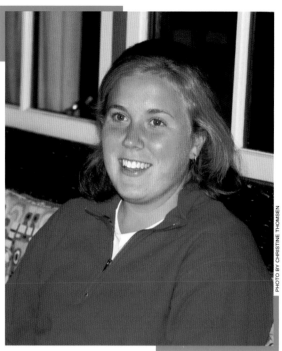
Lindsay on Camp Midwood's porch

Aunt Bunny wrote. We used to sing it and my mom and aunt would cry. Now I know why. Their memories are so rich. It's odd in a way, because many of our family members who come up here live in Erie, except for my uncle. It's not like we don't know each other or see each other back home. But here we come together in a different way, do more things together, and usually appreciate each other more. It's not like everything is perfect. There are always a lot of us up here and that makes for some interesting situations. It makes the times when we are up here alone or can get out in canoe so much better.

SARAH: I like to be up here by myself, but it's the family times I remember most. We've been coming up here for 21 years, my entire life. It's not like Lindsay's family, whose grandparents were here before her, but still, it's a lot of time. When I'm not at camp, I love to look at pictures of our times at camp in our old photo albums. I have such good memories of growing up here. My mom and dad and Forth and I did so many things together, like skating on the lake and camping on the island. We used to have lobster races on Christmas Eve before plunging them into the pot. We always decorated the tree the minute we got in the door, after flying here from London. I love the picnics we have at the boathouse with Roland's crepes, and the dinners in the dining room with a fire in the fireplace. Our family comes from all over and sometimes this is the only place I see them all. Everyone comes back to camp. This place is nothing without family.

✧ ✧ ✧

Both Sarah and Lindsay have a personal experience on the lake they will never forget, one indelibly imprinted in their memories.

LINDSAY: I think about when my Uncle Mac died on the Jack Rabbit Trail behind Camp Red Wing last summer. It was so unexpected. The summer of 2001 will always stay in my memory. Our house was packed with people who hadn't come in a really long time, but had previously summered here. They came for the funeral. So I heard all these stories I never heard before, about my great grandparents and my cousins and relatives in the old photo albums from a long, long time ago. Something amazing came out of my uncle Mac's death. He had always shed a light somehow; he was a charismatic man and he did that again in his death. There were so many people in our house after the funeral. It reminded me that Red Wing is not just my immediate family. After the funeral, we came back to the camp and everyone jumped in the lake. It was unreal. It started with someone older, and in a second, every one threw on their bathing suits and jumped in. You had to be careful where you jumped: it was dark, with only the moonlight to see by. My grandparents were sitting on the dock—you could tell it meant so much to them. The whole weekend was very somber and sad, but this part was uplifting. It reminded me that the lake brings us together.

SARAH: I must have been five years old and my brother, Forth, was six. We were playing in the boathouse one day. There was a bowl of peanuts on the table. I decided to be funny and put a peanut in each of my nostrils, probably to entertain Forth. I snorted one of the peanuts up my nose and couldn't get it

out. My mom came running when she heard both of us screaming and hustled us into the car. She was trying to drive with both of us crying in the back seat. We were just about at the Lake Placid hospital, about ten minutes away, when suddenly the peanut came down my nasal passage into my mouth. I stopped crying and started chewing on the peanut. My brother noticed. 'That's disgusting,' he said, looking over at me. My mother jammed on the brakes, turned around to make sure I was all right and then we drove back the camp in silence.

<p style="text-align:center">✧ ✧ ✧</p>

Because Lindsay's grandparents own Camp Red Wing, Lindsay is separated from the succession of the camp by another generation. She often thinks about the implications of this in terms of her own life. Sarah and her brother are more directly linked to the disposition of their camp, as they are the first generation. Sarah, too, talks openly about what might happen.

<div style="writing-mode:vertical">PHOTO BY SANDRA KISTER</div>

Sarah in Camp Midwood's boathouse

LINDSAY: When I get older, it's going to be different because there are more and more people who will use Red Wing. My brother and I definitely want to keep coming, but we don't know how it's going to work. There's a generation between us who also want to use the camp. Maybe we'll work out some kind of time-share. It's not so easy for us, since we'll be the last ones on the totem pole. Jayson and I sometimes think we might have to get our own place up here when we get older, so we can spend as much time as possible. I hope Sarah and Forth will be here, too. All I know is we'll be here, whether it's at Camp Red Wing or somewhere else, though it wouldn't be the same then. Coming together wouldn't be the same anywhere else. It's hard to predict what will happen.

SARAH: Forth and I always joke that he can live in one house and I'll have the other. The question is who gets which. No, most likely we'll just share the camp, if we can afford it. That's what we want. Forth won't marry anyone I don't like, and I won't marry anyone Forth doesn't like. Financially, we'll let our parents take care of it. (Just kidding.) Both Forth and I know we'll have to support it ourselves some day. And, we know we'll probably have to make sacrifices to keep it. Who knows where our jobs and our lives will take us? I just know I'm ready for keeping Camp Midwood. It means a lot to me.

EPILOGUE

Like the Ladies of the Lake who came before them, Lindsay Yost and Sarah Bagley are drawn to Placid Lake by the solitude of its nature, by the sheer spectacle of Whiteface Mountain, by the lake's pristine water and its changing moods. And, like Sue Riggins, Jane Ackerman, Georgia Jones and the other Ladies in this book, Lindsay and Sarah are consumed with the importance of family, adamant about preserving tradition, and concerned about leaving traces for those who will follow. Both of them respect the lake's memories and care about its future.

But Lindsay and Sarah are also symbols of something larger. Their voices are the voices of women everywhere who are drawn to the power of water, no matter where they live. Like the legendary Vivienne, they are an inspiration to women whose lives are somehow rooted in water.

Lindsay and Sarah will always share a lasting connection with the Ladies before them and the Ladies to come. Placid Lake is part of their personal history and it will always have a hold on them. Lindsay and Sarah may be the next generation of Ladies of the Lake, but they are most certainly not the last.

PHOTOGRAPHIC CREDITS

Christine Thomsen, to whom I extend many thanks, took the majority of the photographs of the Ladies of the Lake. It was a pleasure to work with Chrissy, because of her keen eye and professionalism, and also because of her sense of humor.

Nancie Battaglia shared several of her photographs, most notably the cover shot of a "Lady" on Placid Lake. I appreciate her willingness to work with me, finding the right pictures for the right moments.

Joanna Donk of Inlet Point Photography opened her portfolio to me. Her landscape portraits of Placid Lake and the Adirondacks enhance many of the stories.

Sandra Kister's photograph of Helen Murray in Camp Menawa's dining room ignited my imagination and inspired me to write these stories behind the photographs. I am grateful to Sandra for allowing me to use two of her images.

I also wish to thank several other contributors who graciously agreed to share their photography: Richard Hayes and the Kate Smith Commemorative Society; Dean Stansfield; Pam O'Neil of Arcadia Publishing; David Ackerman; Jennifer F. Norman; and Thayer Allyson Gowdy in San Francisco. Mike Reagan contributed his illustrated Adirondack map, which originally appeared in Bon Appetit.

And to all the Ladies of the Lake who rummaged through their albums and archives to find the perfect photographs for their story, I am much obliged.

BIBLIOGRAPHY

BOOKS:

A History of the Adirondacks, Alfred L. Donaldson, Purple Mountain Press, 1996, an unabridged reprint of the 1921 edition originally published by Century Company, New York

A Lady in the Lake, George Christian Ortloff, With Pipe and Book, 1985

Lake Placid Centennial 1893-1993, David H. Ackerman, The Shore Owners' Association of Lake Placid, Inc., 1993

Lake Placid Club 1895-1980, David H. Ackerman, Lake Placid Education Foundation, 1998

The Adirondacks, Paul Schneider, Henry Holt and Company, Inc., 1997

The Adirondacks Illustrated, Seneca Ray Stoddard, Albany Press, 1874

The Adirondacks Wild Island of Hope, Gary A. Randorf, The John Hopkins University Press, 2002

The Lake Placid Club 1890-2002, Edited by Lee Manchester, Adirondack Publishing Company, 2003

MAGAZINES AND PERIODICALS:

"A Summer Place," Jonathan Friendly, The New York Times, August 7, 1986

"It's Like a Gallery, but You Can Sleep on the Art," Ralph Blumenthal, The New York Times, October 11, 2002

"Second Nature," Lise Stern, Cooking Light, June 2002

WEBSITES:

Adirondack Mountain Club Map

Lake Placid Lodge Brochure

New York State Adirondack Park Agency

The Shore Owners' of Lake Placid Map

The Natural History Museum of the Adirondacks Website

KATE SMITH SOURCES:

1) *Upon My Lips A Song*, Kate Smith Autobiography, Funk & Wagnalls, 1960

2) *"This is My Life Story"* by Kate Smith, Radio, Television and Mirror, 1951

3) *Kate Smith, A Biography, with a Discography, Filmography and List of Stage Appearances*, Richard Hayes, McFarland & Company, 1999

4) *Living in a Great Big Way*, Kate Smith Autobiography, Cornwall Press, 1938

5) *"My Sunshine,"* Richard Hayes, Adirondack Life Collectors Issue, 2002

6) Kate Smith Commemorative Society

About the Author

KATHLEEN BAGLEY was born in 1946 and educated in Minnesota. She worked as an inner-city teacher in Minneapolis and Norfolk, Va., a commercial banker in Virginia, New York and London, and a real estate developer in Connecticut before devoting herself full time to her husband and two children, and to her writing. Kathleen has written widely and twice attended the University of Iowa's Writers' Workshop. Her first novel, *Brink*, was a semi-finalist for a Heekin Foundation Grant. She is currently working on her next book, *Women Out of Water*, stories of expatriate women around the world. She has traveled extensively around the globe and lives in London with her husband, Colt. Kathy and her family have summered and seasonally wintered on Placid Lake in the Adirondack Mountains of New York state for more than 20 years.

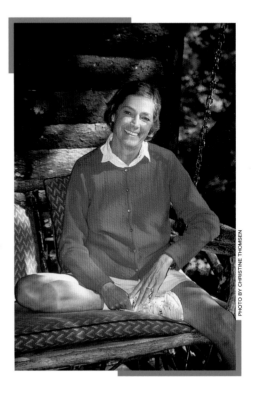

PHOTO BY CHRISTINE THOMSEN

About the Photographer

The photographer CHRISTINE THOMSEN was born in Denmark and moved to the U.S. in 1976. A graduate of SUNY Plattsburgh, Christine demonstrated an excellence in black and white photography and decided to pursue a career in photography. She has resided in the Adirondacks since 1988 and now lives year round in Saranac Lake, where she has a studio. Christine was an active member of the Adirondack Artists Guild and her work has been exhibited in many local galleries. She recently was awarded First Place in Adirondack Life's Black and White Photography Contest.

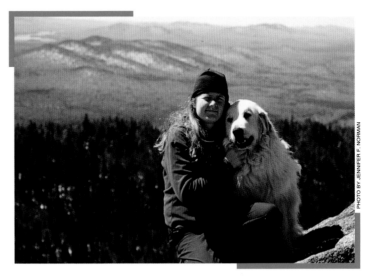

PHOTO BY JENNIFER F. NORMAN